NOTRE DAME
BASEBALL GREATS

From Anson to Yaz

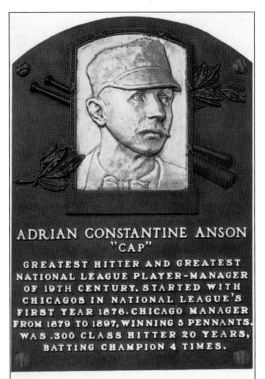

ADRIAN CONSTANTINE ANSON
"CAP"

GREATEST HITTER AND GREATEST
NATIONAL LEAGUE PLAYER-MANAGER
OF 19TH CENTURY. STARTED WITH
CHICAGOS IN NATIONAL LEAGUE'S
FIRST YEAR 1876. CHICAGO MANAGER
FROM 1879 TO 1897, WINNING 5 PENNANTS.
WAS .300 CLASS HITTER 20 YEARS,
BATTING CHAMPION 4 TIMES.

NATIONAL BASEBALL HALL OF FAME & MUSEUM
Cooperstown, New York

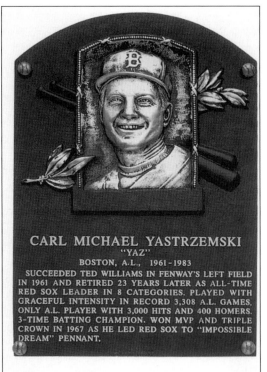

CARL MICHAEL YASTRZEMSKI
"YAZ"
BOSTON, A.L., 1961-1983
SUCCEEDED TED WILLIAMS IN FENWAY'S LEFT FIELD
IN 1961 AND RETIRED 23 YEARS LATER AS ALL-TIME
RED SOX LEADER IN 8 CATEGORIES. PLAYED WITH
GRACEFUL INTENSITY IN RECORD 3,308 A.L. GAMES.
ONLY A.L. PLAYER WITH 3,000 HITS AND 400 HOMERS.
3-TIME BATTING CHAMPION. WON MVP AND TRIPLE
CROWN IN 1967 AS HE LED RED SOX TO "IMPOSSIBLE
DREAM" PENNANT.

NATIONAL BASEBALL HALL OF FAME & MUSEUM
Cooperstown, New York

NOTRE DAME BASEBALL GREATS

From Anson to Yaz

Cappy Gagnon

Published by Arcadia Publishing,
an imprint of Tempus Publishing Inc.
Charleston SC, Chicago, Portsmouth NH,
San Francisco

Printed in Great Britain.

Library of Congress Catalog Card Number: 2004102499

For all general information, contact Arcadia Publishing:
Telephone 843-853-2070
Fax 843-853-0044
E-mail sales@arcadiapublishing.com

For customer service and orders:
Toll-free 1-888-313-2665

Visit us on the Internet at www.arcadiapublishing.com.

CONTENTS

ACKNOWLEDGMENTS

This book is dedicated to my father, Russell T. Gagnon, and my grandfather, Patrick H. Keavey and my baseball research inspirations, L. Robert Davids, and Tom Shea. All of these men helped start me on the journey which culminated in this book.

Many other persons have been of invaluable assistance. Professor Tom Stritch recommended me to legendary sports publicist Charlie Callahan for the job in Notre Dame Sports Publicity which opened my eyes about Notre Dame Baseball. SABR members Tom Shea, Tom Hufford, Bob Hoie, Dick Thompson, Bob Bailey, Joe Simenic, Bob McConnell, Peter Morris, Dick Beverage, Bill Carle, Cliff Kachline, and many more have provided loads of research assistance. SABR members Luke Salisbury, Gerry Beirne, Jon Daniels, Bill James, Steve Krah, and Larry Roth have been great friends and inspired me.

Notre Dame Baseball Coaches Pat Murphy and Paul Mainieri restored the glory of Notre Dame Baseball, and have been helpful and supportive with my research. Mainieri has become a close friend as well. One of my most prized possessions is the 2002 College World Series Ring presented me by Coach Mainieri. Chuck Lennon, Executive Director of the Notre Dame Alumni Association and a former .300 hitter for the Irish, has also been a big supporter. Lennon has a great baseball pedigree. His grandfather was on the Lennon Team, of Joliet, Illinois, which won the Brothers Championship of the World on September 7, 1890.

The staff of the Notre Dame Archives have been unflagging in their support, beginning with Peter Lombardo in the late '70s and continuing with Charles Lamb and Peter Lysy right up until this manuscript was submitted. Richard Sullivan of the Notre Dame Registrar's Office is an old friend who was also quite helpful with documentation. Notre Dame men Bill Guilfoile and Jim Gates, working at the Baseball Hall of Fame were Hall of Famers as well as friends.

I am also grateful to John Thorn and Pete Palmer for their *Total Baseball*, and David Neft, Richard Cohen, and Michael Neft for their *The Sports Encyclopedia: Baseball*. Thorn is a research giant. Palmer is all of that and very unselfish in sharing his research.

Rich Wolfe has been a baseball buddy and friend for four decades. Before he turned into a prolific writer of sports biographies, he and I talked baseball for a few thousand hours and went to baseball games and batting cages all over the eastern half of the United States.

INTRODUCTION

My father and grandfather were knowledgeable baseball fans, so my Gloucester, Massachusetts upbringing got me started in the right direction. I got some great baseball presents (my mother gets the credit for those). Ethan Allen's "All Star Baseball" game introduced me to table games and whetted my appetite for more information about the great players of the past. My first baseball book gift was the Turkin and Thompson *Baseball Encyclopedia*.

The first two baseball books I read, at the Sawyer Free Library, were Harry Grayson's *They Played the Game* and Reichler and Danzig's *History of Baseball*. I collected baseball cards, from bubblegum packs. By the time I started playing APBA, the greatest of all baseball table games, I was hooked on the National Pastime. When I was 10, my father would ask one of the men at his work or in his bridge club to name a Major League team and have me rattle off their starting lineup and pitching rotation.

My father and grandfather often spoke about the two Major Leaguers from Gloucester. Stuffy McInnis and Cy Perkins both attended Gloucester High School shortly after the turn of the century and each played with Connie Mack's Philadelphia A's. Hanging on the wall in a local barbershop was a large photo of Babe Ruth sliding into Perkins. Once, when my father took me to a different barbershop, he pointed out Stuffy McInnis as he was leaving the shop. This is pretty impressive stuff for a worshipful young fan.

Stan Musial was my favorite player because I liked his "All Star Baseball" card. The more I grew to know about "The Man," the more I realized that I had chosen an exemplary person for my sports hero.

I started buying *The Sporting News*, *Sport Magazine*, and *Baseball Digest* at "The Waiting Room," a downtown Gloucester newsstand, devouring all the baseball information. I avidly read the backs of baseball cards, retaining biographical and statistical data like a sponge. By the fourth grade I knew that the fraction $2/7$ converts to .286 in the decimal system because these were batting averages. Baseball was educational.

A dozen years later, while working as a student assistant in the Sports Publicity Department at the University of Notre Dame, I came upon a yellowed sheet listing 40 some players purported to have attended Notre Dame and later played Major League baseball. Having covered Gloucester High School sports for the *Gloucester Daily Times*, I boldly wrote a letter to *Baseball Digest*, stating that I had written an article about Notre Dame men who'd played Major League baseball. I was stunned when I got a letter back from Editor Herb Simons, telling me

that he would pay $50 if I submitted the article within a week. That meant I had to actually write the article. I worked feverishly to meet the deadline. I was the happiest guy in America when I saw my article in print, with the title ("Why the Majors Cheer, Cheer for old Notre Dame") on the cover. My father bought all the copies in Gloucester.

In the March 5, 1977 edition of *The Sporting News*, Bill Madden wrote a column about SABR (the Society for American Baseball Research), an organization of persons committed to the research and study of baseball history. SABR's founder, L. Robert Davids, lived in Washington, D.C. Because I had moved to the D.C. area a few months before, I was soon on the phone with Bob's wife Yvonne, getting invited to the next "newsletter mailing day." In those years, Bob would prepare the monthly newsletter for the 500+ member group and convene a handful of us to sit in his dining room to fold, stuff, seal, stamp, and sort the mailing, all the while discussing baseball history. (Bob wouldn't let us call it trivia because baseball was too important to be called "trivial.")

When Bob asked about my research interests, I decided I would do further study on my *Baseball Digest* article. Bob went to the Library of Congress most Saturdays. It was there that he taught me how to use microfilm of old newspapers to do primary research. He also taught me how to look up obituary notices to begin a search into the life of former players.

During my early days in SABR, I learned that among the many baseball biographical research giants Tom Shea stood the tallest for his knowledge of the college connections of Major Leaguers. Tom's friend and protégé, Dick Thompson, introduced us and we carried on a great correspondence right up until Tom's death. I received invaluable assistance from Tom and Dick.

Because of labor strife, greedy players, short-sided owners, and players' lack of commitment to the fundamentals and history of the game, I have lost much of my interest in current Major League baseball, but the college game contains the excitement I once found at the Major League level. After doing in-depth research on the Notre Dame Big Leaguers, I proclaimed that Notre Dame had the strongest group of Major Leaguers of any college. Each time I would make this claim, someone would toss in their own choice. These challenges caused me to begin research, assisted by Shea and Thompson, on all colleges so I could test my claim.

After more than two decades of research, I have a good understanding about which colleges have produced the most and best Major League baseball players. Southern Cal, Texas, and Arizona State lead in numbers of players and Major League statistics. Another group of schools (Michigan, Alabama, Holy Cross, St. Mary's of California, Pennsylvania, Ohio State, and Illinois among them) have made great contributions over long periods of time. Stanford, Miami, and L.S.U. have won a lot of college games in recent years, but this book will demonstrate that for overall accomplishments the Fighting Irish, as in football, are clearly #1. Notre Dame men have made greater and more varied contributions to baseball than persons affiliated with any other college.

These baseball contributions began 140 years ago and continue to this day. I hope this modest book (and my immodest claims) will cause readers to correct and improve on this material. I will be pleased if supporters of other schools contact Arcadia Publishing to get their own school's accomplishments in print.

ONE

The Founding of Notre Dame Base Ball

According to Arthur J. Hope, C.S.C. (*Notre Dame One Hundred Years*, University Press, Notre Dame, IN, 1943) Edward Frederick Sorin was born in France on the sixth day of February (Babe Ruth's birthday), 1814. Sorin was ordained a priest in the Congregation of Holy Cross twenty-four years later. Three years after his ordination, he was on a ship, with six Brothers of the Congregation, sailing to the wild frontiers of America. The non-English speaking Sorin came to the New World to help the Bishop of Vincennes, Indiana bring the Catholic faith to this "Western" state, which had joined the Union only two years after Sorin's birth.

In November of 1842, Sorin trekked to South Bend to take over a 600 acre plot of land and open a college. Ever the visionary, Sorin sent a letter to his Religious Superior in France, stating that he was going to build a college that would grow "on a large scale." He said that this college "cannot fail to succeed." He named the College, in French, after the Mother of Christ. He appended to this title, the view from the location from where he founded the college: Notre Dame du lac, Our Lady of the Lake. The State of Indiana issued Notre Dame a charter on January 15, 1844.

During the middle part of the 19th Century, America was developing its two greatest institutions, democracy and baseball. During Sorin's time, the game of Base Ball (sic) was still evolving from various bat and ball games, likely emanating from the English game of Rounders. By the 1830s, the "New York Game" had taken precedence over the "Massachusetts Game." In 1845 Alexander Joy Cartwright, often called "the man who invented base ball" compiled the first set of rules for the game.

Sorin understood nothing about baseball, but he knew from the European model that a boys' boarding school should have a vigorous exercise program. From the earliest days of the college, Notre Dame Students were active in swimming, sailing, cycling, skating, and cricket. In the mid-1860s Base Ball started to take hold. It flourished at Notre Dame because of the encouragement the boys received in playing sports and because of the excellent Brownson Hall Playing fields, located between the Administration Building and St. Joseph Lake. Initially, boys played for campus glory. In the late 1870s opposing teams visited the campus.

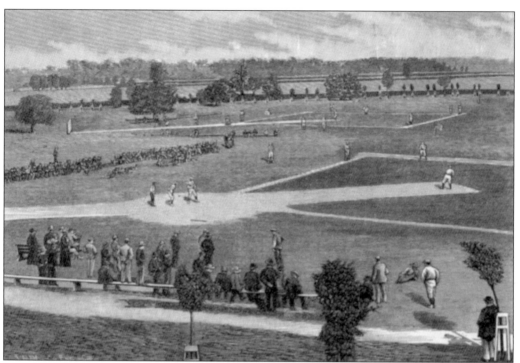

NOTRE DAME'S EARLIEST PLAYING FIELDS.

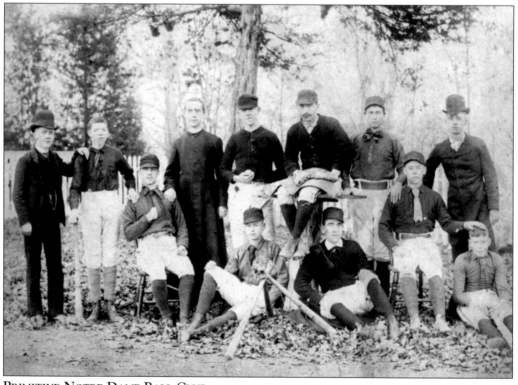

PRIMITIVE NOTRE DAME BALL CLUB.

In the late 1880s, the first Notre Dame teams ventured off campus. There were many Base Ball teams on campus, involving a high percentage of the student population. Teams were composed of the "seniors" (the college-age students), the "juniors" (the high school-age students) and the "minims" (the elementary school boys).

An item in the 1920 edition of *The Dome*, the yearbook, captured the feelings about baseball on campus in those early days: "The secret of Notre Dame's success in baseball can be easily traced to the system of the school itself. A stranger to Notre Dame on a spring afternoon will find that every one of Notre Dame students, from the minims of St. Edward's hall to the college seniors, is playing baseball. There are baseball diamonds everywhere. Even the members of the faculty surrender dignity long enough to play 'sides' with the red-blooded students."

An 1869 article in the student weekly magazine, the *Scholastic*, listed the base ball teams on campus with their "members" (in parentheses are the years the team won the campus championship):

Juanitas	26	*(1866–1868, 1875)*
Star of the West	28	*(1870–1872)*
Enterprise	21	*(1869)*
Star of the East	30	*(1874)*
Atlantic	20	
Young American	18	
Washington	22	
Eureka	20	
Excelsior	—	*(1873)*

This total of 185 players comprised about 90 percent of the students on campus!

Two of the star players for the Juanitas, who arrived during their second championship season were the Anson brothers, Sturgis and Adrian, of Marshalltown, Iowa. On June 12, 1868, the *Scholastic* contained a poem about the championship Juanita team. Two sections of the poem refer to the boys from Marshalltown:

The Gay Juanita Boys:

"When short stop Anson caught that foul,
Buncum! The captain cried;
And well he might, for nary fowl
Can safely near him glide.

Bold Anson holds the centre field;
His eye upon the bat;
As well might ball elude his grip
As mouse escapes the cat."

Adrian, later variously called "Cap," "Pop," or "Uncle Anse" would become the most prominent baseball person of the 19th Century. Anson was a larger than life figure from the beginning of the Major League game. He was one of the original players (1871) of the National Association. He was one of the youngest players and one of the largest. He was one of the most versatile, playing every position and managing. His .352 average was the fifth highest for the five years the National Association was in existence.

When the National League was formed, in 1876, Anson was one of the first big stars. He played 21 years with the team now known as the Chicago Cubs. It was first called the White Stockings (because of their foot wear) until 1893; the Colts (because of young players) until 1897; and the Orphans (after Anson was dropped by owner Albert Spalding) for 1898.

Anson was player-manager for his final 18 years with the team. He was renowned as a hitter, field general, umpire baiter, innovator, orator, and, sadly, opponent to the integration of baseball.

In his autobiography, *A Ball Player's Career* (Era Publishing, Chicago, 1900), Anson wrote, "I was as wild as a mustang and as tough as a pine knot, and the scrapes I managed to get into were too numerous to mention. The State University (Iowa) finally became too small to hold me and the University of Notre Dame in Indiana, then noted as being one of the strictest schools in the country, was selected as being the proper place for 'breaking me into harness', providing that the said 'breaking in' performance could be successfully accomplished anywhere."

Anson quoted Mark Twain from his essay "Base ball in the Sandwich Islands," ". . . base-ball . . . is the very symbol, the outward and visible expression of the drive and push and rush and struggle of the raging, tearing, booming, nineteenth century." This quote is a good metaphor for the type of young man who came to Notre Dame in the 19th Century.

Regulations of the University.

1st. All the Students of this Institution are required to attend the exercises of public worship with punctuality and decorum. They shall assist at Mass on Sundays and Wednesdays. Catholic Students shall go to Confession every month.

2d. As soon as the bell announces the beginning or the end of a College Exercise, every one shall repair in silence to the discharge of that duty to which he is called.

3d. The time of recreation excepted, silence must be inviolably observed in all places.

4th. Students must show themselves obedient and respectful toward the Professors and Prefects of the Institution, never absenting themselves from the place in which they ought to be, without permission from proper authority.

5th. Students must carefully avoid every expression in the least injurious to Religion, their Professors, Prefects or Fellow Students.

6th. Students are not permitted to visit private rooms.

7th. The use of tobacco is forbidden.

8th. Intoxicating liquors are absolutely prohibited.

9th. Compensation for all damage done to the furniture, or other property of the College, will be required from the person or persons causing such injury.

10th. No branch of study, once commenced, may be discontinued without permission of the Prefect of Studies.

11th. No one shall leave the University grounds without the permission of the President or Vice-President.

12th. Any breach of pure morals, either in words or actions, must be reported forthwith to the President or Vice-President.

13th. Whether in class or recreation, when permitted to converse at table, or during their walks, Students should endeavor to improve the purity of their language, and cultivate urbanity of manners. A few years in College would be profitably employed, if nothing else were learned than to converse and behave with the dignity and propriety of gentlemen.

14th. No one shall keep in his possession any money, except what he receives weekly from the Treasurer, on Wednesday, at 10 o'clock, a. m.

15th. On the first Wednesday of every month, "Certificates of Good Conduct" and of "Improvement in Class" are issued by the Faculty to such Students as deserve them. On either side of the President's chair, and conspicuous to every visitor, are the "Tables of Honor," presided over by the Vice-President and the Prefect of Discipline. At these are seated twenty-two of the Students whose conduct has been most exemplary during the preceding week. They are elected by the unanimous vote of the Professors and Prefects.

16th. In winter, on Saturday, at 4 o'clock, p. m., the Students must wash their feet. In summer, this regulation is rendered unnecessary by the rule which requires the Students to bathe, in common, twice a week, in Saint Joseph's Lake.

17th. On Sunday and Wednesday mornings, the Students must place upon their beds, wrapped up, their soiled linen of the previous half week. On Monday morning, the Students of the Senior and Junior Departments repair, in ranks and in silence, to their Dormitories, whence they take their Sunday clothes and carry them to their trunks. And on Saturday, at half-past three o'clock, they go in the same manner to the Trunk Room, and bring their Sunday clothes to their Dormitories. The Students will be reviewed at eight o'clock on Sunday and Wednesday mornings, with special reference to their personal neatness.

18th. Stationery, etc., will be delivered to Students as follows: On Mondays and Thursdays, at half-past twelve o'clock, to the Students of the Senior Department; and on Tuesdays and Fridays, at the same hour, to the Students of the Junior Department. Every Student should have a memorandum book in which to enter all his receipts and expenditures, and his notes for recitation in class, and for conduct during his stay in College. Books prepared expressly for this purpose can be obtained from the Secretary.

19th. Students who may have failed to give satisfaction in the Class Room, or who shall have been guilty of misconduct, or breach of rule, will be sent to the Detention Room during the recreations or the promenades, and required to prepare their lessons, or perform such tasks as shall be assigned them.

20th. Those Students who read sufficiently well and audibly, will occupy the Reader's Stand, in their turn, in the Refectory. An alphabetical list of Public Readers will be posted in a conspicuous place, and every one named in it will read for one day, in order, at dinner and supper. At the end of each meal, any Student is liable to be called upon to give an account of what he has heard read.

21st. Senior Students will be permitted to read or study from eight to nine o'clock, p. m.

22d. Every month, all the Students must write to their parents and guardians, and have their letters corrected by the Secretary of the Faculty, previous to their being mailed. All letters sent or received may be opened by the President or his substitute.

23d. When a Student is sick, he will obtain permission from the Prefect of Health to go to the Infirmary, and will observe the regulations of that place until his recovery.

24th. No book, periodical or newspaper shall be introduced into the College, without being previously examined and approved by the Prefect of Studies. Objectionable books found in the possession of Students, will be withheld from them until their departure from the University.

N. B. The happiness, no less than the improvement of Students, is so closely connected with the good order and even rigid discipline of the College, that no young gentleman of good sense, who has at heart his own welfare and the accomplishment of his purpose in entering the Institution, can fail to discover the importance of a strict observance of the foregoing Rules. If the authorities of the University exhort to exhibit a sincere and unwavering zeal in keeping these Regulations, they demand of Students nothing more than the promotion of their own interest.

. There are in the Institution several Societies, whose Constitutions and By-Laws have been approved by the Faculty, such as the Saint Vincent de Paul's, Arch-Confraternity, Saint Aloysius' Literary and Historical, Holy Angels', Saint Cecilia, and Philharmonic Societies, with which Students are authorized and recommended to unite themselves.

EARLY CAMPUS RULES OF "ONE OF THE STRICTEST SCHOOLS."

Through the 1880s the White Stockings featured one of baseball's best all-time infields, with Anson, Fred Pfeffer, Tommy Burns, and Ned Williamson. Anson's team won five pennants in seven seasons, featuring the "Stonewall Infield." As a Manager, Cap posted three of the top winning percentages of all time (.798 in 1880, .777 in 1885, and .726 in 1886). Another White Stocking star of those years was outfielder Billy "The Evangelist" Sunday, who also grew up in Marshalltown, Iowa.

Anson took 14 players to Hot Springs, Arkansas in 1886, in what is generally considered the first Spring Training (although a couple teams made short tips to New Orleans in earlier years). Anson's stated goal for his time in the South was ". . . to boil out the alcoholic microbes." Anson was the first man to accumulate 3,000 hits, the first to hit four doubles in a game, and the first to hit five home runs in two games. No position player has come close to matching Anson's 26 seasons as a Major League regular.

His playing demeanor and batting style were described in a June 1890 article in *The Sporting News* as "His forte is his great reliability in time of need, his steady nerve and rare, good judgment when the game is trembling in the balance. In that respect, he is head and shoulders above any other player in the League. Capt. Anson stands with his feet rather closely together, with his left leg slightly in the lead. Tightly grasping his bat—and he uses one so heavy that few of the boys can swing it—he taps the home plate twice from force of habit, hoists it up to his shoulder, but does not permit it to sink over his back, and then coolly and calmly waits for the ball he has determined to hit. His favorite ball is just at the shoulder, and the way he can rip the cover off a ball at that height is a terror to his opponents. . . ."

In an 1886 *Sporting News* article, by W.I. Harris said ". . . in spite of his 'kicking' and his bulldozing of umpires . . . [Anson] is universally popular. His value as a player, captain, and manager cannot be overestimated, as may readily be judged by the able way in which he has, during the past three years, brought his almost experimental teams (called the Colts because of

their youth) to the front. His methods are more of the driving than the persuasive kind, and the rigor with which he holds players up to their duty does not make him over-popular with them. And yet few men who ever worked for Anson have other feelings toward him than intense admiration and respect." Harris went on to say that Anson was a great talker. "There are four subjects on which he will argue with anybody: baseball, politics, billiards, and his trip around the world."

Anson was known for colorful quotes. "A chipmunk can be taught to field, but hitters are born, not made." After being criticized by Pitcher Pink Hawley, for sticking around too long, Anson retorted "If I had the money you think I have, I would buy your release from Pittsburgh, trade you for a yellow dog and shoot the dog."

ADRIAN "CAP" ANSON.

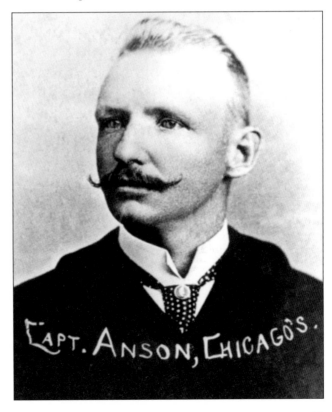

CAPT. ANSON, CHICAGO'S.

Anson was vocal in his opposition to Negroes playing against White competition. According to Robert Peterson in *Only the Ball was White*, Big George Stovey of the Newark Little Giants was due to pitch against the White Stockings, in an exhibition, on July 19, 1887. Stovey did not pitch because of a reported "illness." It was not until a year later that it was reported that Anson had refused to put his team on the field if Stovey pitched. According to Merl Kleinecht, writing in the 1977 *Baseball Research Journal*, at least 55 Blacks played during the first two decades of professional baseball. Two of them, the brothers Moses and Welday Walker, actually played for Toledo, in the American Association, when it was considered a Major League. By 1900, there were no Blacks playing in organized baseball. In his later years, Cap managed and occasionally played for "Anson's Colts" a team in the fast Chicago Park Leagues, where he played and coached against teams led by Rube Foster, the legendary founder of the Negro Leagues.

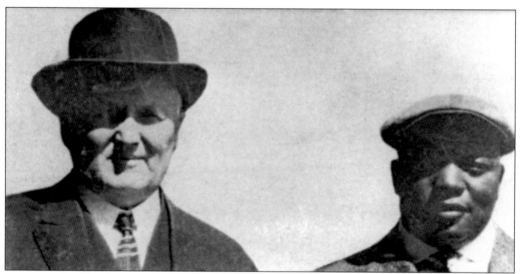

ANSON AND FOSTER.

According to research done by Bob Davids, Anson appears on many "age-based" statistics. He was the fourth oldest player to hit a double (45-5 on September 19, 1897), the third oldest to hit a triple (45-4 on September 10, 1897), and the third oldest to steal a base (45-5 on October 3, 1897). He had the most stolen bases (90) and the sixth most home runs (21) after the age of 40. On October 3, 1897, in his final game, he hit two home runs against St. Louis, making him the oldest Major Leaguer to hit a home run.

When Anson was dropped by Owner Albert Spalding, he was baseball's career home run leader, until Dan Brouthers passed him in 1898. Cap was still 10th on the home run list until Babe Ruth bumped him, in 1920.

In an amazing reversal of his 27-year custom, he issued a statement in September of 1897 strongly defending umpires. He suggested that umpires be assigned at the beginning of the season and rotated among all teams. He said, "They should not be abused for doing their job."

Over a 20-year span, only five Major League players appeared in 92 percent or more of their team's games, a testament to their durability (and playing ability):

Player	Years	Games	Missed	Percentage
Pete Rose	*1963–1982*	*3099*	*80*	*97.5*
Cal Ripken	*1981–2001*	*3158*	*115*	*96.5*
Cap Anson	*1876–1895*	*2054*	*135*	*93.8*
Hank Aaron	*1954–1973*	*2964*	*214*	*93.3*
Carl Yastrzemski	*1961–1980*	*2967*	*257*	*92.0*

Anson had a loud voice and theatrical presence, which later helped him in his vaudeville career, which included performing in plays written by Ring Lardner. His start in Vaudeville was November 14, 1910. He had made his acting debut, in Harlem, in 1888.

Tragedy dogged Anson after his playing career ended, but he turned down all offers for a baseball benefit. He served a term as City Clerk in Chicago, but later ran unsuccessfully for a couple different political offices in Cook County. His lowest moment came when huge losses in a billiard parlor caused him to "go broke," even having his home foreclosed. Eighteen months after his death, the National League honored him by dedicating a large baseball monument over his grave in Chicago's Oakwood Cemetery.

Balloting for the Baseball Hall of Fame began in 1936 with two separate elections. In the vote of baseball writers, five immortals (Ty Cobb, Babe Ruth, Honus Wagner, Christy Mathewson, and Walter Johnson) were elected with 75 percent of the votes cast. In a second vote, by a smaller group of writers, to select the "old timers," Anson received the most votes, but fewer than the number required. He was later selected by the "Old Timers Committee," and was one of the first 26 members enshrined, when the Cooperstown Building was completed in 1939.

After Anson's death, newspapers across the country praised his life and career. "The Chicago Inter Ocean" had one of the most colorful tributes: "Yesterday was a cold day for base-ball. That grand old man, Captain Adrianapolis Chicago Anson, was umpired out by Father Time. . . ."

George J. E. Mayer enrolled at Notre Dame shortly after Anson. According to John Thorn, Mayer was a founding director of the Kekiongas of Fort Wayne. This team would later become the Fort Wayne Kekiongas, one of the original, though short-lived teams in the National Association. The Kekiongas played in the very first game in the National Association.

Mayer has a couple interesting tidbits in his file in the Notre Dame Archives. According to the May 20, 1876 *Scholastic*, Mayer invented a "patent for a contrivance for preventing snatchers from taking bodies from graves." A *Scholastic* note from January 30, 1875 mentions that Mayer was married to a Miss Churchill of Rockford, Illinois.

SABR member David Fleitz adds a more lurid detail. Apparently Elizabeth Churchill was the long-time mistress of Albert Spalding, as detailed in Spalding biographies. Churchill/Mayer wed Spalding in 1900, after the death of Mrs. Spalding. Between dropping Anson, for 1898, and adding Mrs. Mayer two years later, Albert Goodwill Spalding did not show Notre Dame men much of the spirit of his middle name.

Michael J. Brannock was a pitcher-shortstop for the Star of the West team at Notre Dame, in 1869. Brannock's Notre Dame highlight was pitching the "juniors" (high school age students) to a 37-11 defeat over the "seniors" (college age students), in 1869.

Mike played three games at third base for the Chicago White Stockings in the 1871 inaugural season of the National Association. He also played two more at the hot corner in 1875. Joseph Blong and his brother Andy attended Notre Dame at about the same time as Brannock. Blong played with the St. Louis Red Stockings of the National Association, during the 1875 season. Andy was the President (Business Manager) of this co-op team. When the National League came into being, in 1876, Joe pitched and played the outfield for the St. Louis Browns during its first two seasons.

William "Bill" Krieg was a student at Notre Dame in the 1870s. He made his Major League debut, as a catcher, for the Chicago/Pittsburgh team of the Union League, in 1884. He later played for Chicago (1885) in the National League, Brooklyn (1885) in the American Association, and Washington (1886–1887) in the National League. Krieg was one of the great Minor Leaguers of the 19th Century, winning three batting titles. Bill James considers Krieg the top Minor League player in the 1880s. He hit .352 for Milwaukee to lead the Western League in 1892. He hit .452 for Rockford to lead the Western Association in 1895, and won again with .350 the next season. He also won home run titles during those two seasons with Rockford, with 11 and 15 respectively. He was a career .335 hitter in the Minor Leagues.

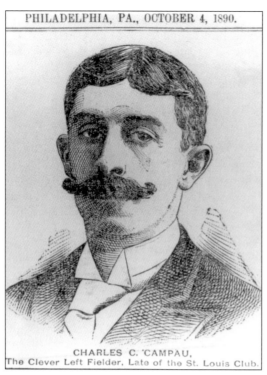

CHARLES C. CAMPAU.
The Clever Left Fielder, Late of the St. Louis Club.

CHARLES CAMPAU. "Count" got his nickname from his regal look.

Charles Columbus "Count" Campau, came to Notre Dame around the same time. From one of the founding families of Detroit, Campau was one of a score of his family members (some named Campeau) at Notre Dame in the second half of the 19th Century. He was a great hitter; slugger; base stealer; manager; umpire; and colorful personality. He played five years in three different cities (Detroit, New Orleans, Binghamton) and seven years in the Western League; six in the International/Eastern league, and five in both the New York State League and Southern Association.

According to Minor League baseball expert Bob Hoie, Perry Werdon is considered the greatest Minor League player of the 19th Century. Based upon statistics from the 19th Century only, Campau looks like a strong second best.

Player	G	AB	R	H	D	T	HR	SB	BA
Count Campau	1380	5,567	1,274	1,719	280	144	129	575	.309
Perry Werdon	890	3,737	915	1,372	245	59	140	282	.367

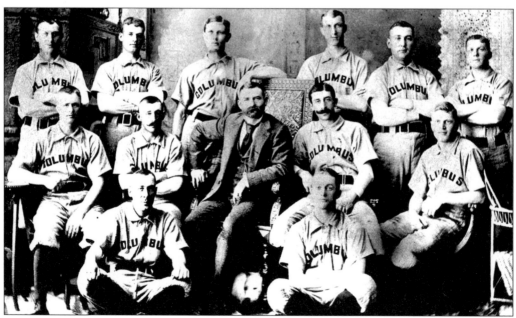

1892 COLUMBUS TEAM. Campau is in the middle row, second from right.

In 1888, Count played ahead of future Hall of Famer Big Sam Thompson. Despite playing in only 70 of his teams games (eighth best on the club) Campau was third on the team in stolen bases, with 27. Future Hall of Famer Dan Brouthers was second in team steals, with 34, in 129 games.

The 1890 St. Louis Team in the Major League American Association produced an oddity. Three outfield regulars each hit well over .300 and each had more than 25 games as team manager:

Player-Manager	Games	B.A.	W-L	Pct.
Tommy McCarthy	133	.350	13-13	.500
Chief Roseman	80	.341	32-19	.628
Count Campau	75	.322	33-26	.559

Campau led two different leagues in homers in that 1890 season, a feat unlikely to be duplicated. His three homers for Detroit led the International Association and his ten homers for St. Louis led the American Association.

CAMPAU'S OLD JUDGE TRADING CARDS. These were the earliest baseball trading cards, and they were packaged with tobacco rather than bubble-gum.

Albert John "Bert" Inks grew up in Ligonier, Indiana, about an hour southeast of Notre Dame. He and his brother Will played on campus teams at Notre Dame in the late 1880s with Bert pitching his team to the campus title. By this time, baseball players at Notre Dame were part of the University Baseball Association, usually enrolling half of the student body. Bert made his pro debut in 1890, dividing time among teams in three leagues. He was 14-5, as the top hurler for Fort Wayne in the Northwest League, in 1891, while his brother Will was 7-2. For good measure, Bert also led the team in hitting (.373), earning a late season trial with the Brooklyn Bridegrooms, where he was their only left handed pitcher. He had his best pro season next year, going 21-10 with Binghamton, of the Eastern League.

Bert's best Major League season was 1894, when he was 11-10 with Baltimore and Louisville. He was always a strong hitter, with a lifetime Major League average of .300 (75/250). He hit .345 with Binghamton in 1893.

Bert pitched in three games for Philadelphia, in 1896, in his final Major League season. The Phils had three future Hall of Famers (Dan Brouthers, Nap Lajoie, and Ed Delahanty) stationed at first base that year. Willie McGill ended his Major League career with Philadelphia in the same season. Also on the Phils pitching roster was Cornelius Cecil "Con" Lucid. Lucid's obituary in the Houston newspapers makes prominent mention of his time at Notre Dame. Unfortunately, there is no mention of him in any of Notre Dame's records, so he is no more than a "suspect" for this work.

Bert coached the Wabash College "Presbyterians" in 1905. In 1907 he opened the Crystal Theater, the first movie theater in Ligonier. Movies were a big novelty then. A 1935 ad for the Crystal Theater proclaimed, "Money spent on good movies is well invested. It pays big dividends in mental health and happiness." He operated the theater for 34 years, until his death.

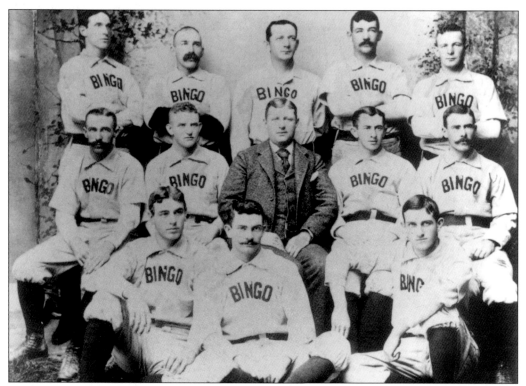

THE 1892 BINGHAMPTON (NY) BINGOS. Bert Inks is in the front row, far left. Hall of Famer Wee Willie Keeler ("Hit 'em where they ain't")is in the middle row, fourth from left.

While Bert's Major League career was modest, it meant a lot to future Baseball Commissioner Ford Frick when he was growing up. In his autobiography, *Games, Asterisks, and People*, Memoirs of a Lucky Fan (Crown Publishers, New York, 1973) Frick wrote "We had another authentic hero in those days, too. He was an idol whose fame reached beyond the confines of village and county, across state lines into Illinois and Ohio, even into faraway Pennsylvania and New York. He was a burly right-handed pitcher named Bert Inks, and he pitched in the National League from 1890 to 1896. . . . Not a great record, really, but sufficient to enshrine him in memory as our first real and personal contact with the shining world of grown-up professional baseball. Bert knew John McGraw and Hughie Jennings and Connie Mack and Ned Hanlon personally. He called Wilbert Robinson and Willie Keeler and Kid Gleason by their first names. He told us tales of the pitching prowess of Cy Young and Amos Rusie and Kid Nichols, and of the batting genius of Hughey Duffy and King Kelly. Believe me, Bert Inks was 'big stuff'. He rated first rung on the ladder with Levi Crume, the local Civil War hero, who fought at Shiloh and Chickamauga."

The fourth edition of *Total Baseball* (Penguin Books, New York City, 1995) lists Bert's true name as Albert Preston Inkstein. A Jewish man at Notre Dame in the 1880s sounded like a good angle, but this allegation proved to be incorrect, according to the Inks family. In the course of checking out this item I visited Ligonier, where the city limits has a sign welcoming visitors to "the first Jewish settlement in Indiana." Bert is buried in the family plot with all the other members of the Inks family.

While Bert was a student at Notre Dame, in 1887, Notre Dame began its varsity Football program by enlisting the support of the University of Michigan, which was then the academic and athletic college leader of The West. Michigan sent its football team to Notre Dame. On their first day on campus the Wolverines taught eleven athletic students the fundamentals of play. On the second day, their veteran team defeated the Irish by two touchdowns, 8-0 (touchdowns being worth four points at that time).

Five years later, Notre Dame turned to Michigan to inaugurate their varsity baseball program, but this time Notre Dame was well versed in the game. Notre Dame had already enrolled seven big leaguers (Anson, Brannock, Blong, Krieg, Campau, Willie McGill, and Inks), but there was no one of that caliber currently in residence. Not wishing to see a repeat of the thrashing that Michigan's Footballers had issued, Notre Dame expanded their eligibility pool, bringing back Major Leaguer Willie McGill to pitch. At this time, there were approximately 450 students enrolled at Notre Dame, with around 200 in the college (Senior Department), 150 in the Prep Program (Junior Department) and 100 in the Elementary School (the Minims).

Willie was having some arm and conditioning trouble, so he was available for the game. The *Scholastic* reported; "The home team, being rather weak in the points, secured the services of Willie McGill, who used to be a student of the University several years ago. When the Michigan men faced him, their confidence began to sink, and after the first inning the game was practically won."

What the article didn't mention was that Michigan threatened to get back on the train and return to Ann Arbor if Notre Dame did not pull McGill out of the game. Michigan protested that there were "five pros" on Notre Dame's team. The hosts called that bluff by refusing to pay the travel guarantee, so the contest was on. Michigan was not unfamiliar with the use of ineligible players. Three days earlier, at Wisconsin, the Wolverines faced a professional pitcher hired just for the day. In that game, athletic purity prevailed, 7-4.

McGill surrendered only three hits in the 6-4 Irish win over the Wolverines, and tallied an equal through his own swatting. He struck out 12 of the dispirited opponents. Actual Notre Dame student James Fitzgibbon hit a three run homer for Notre Dame. "Kurtz," the catcher, was a mainstay, handling all his chances flawlessly and getting three hits. Chassaing made a game saving catch in center field. When Notre Dame awarded monograms at the end of the one-game varsity season, McGill, Kurtz, and Chassaing did not receive them, lending support to 60 percent of Michigan's charge of "five pro's."

William Vaness "Kid" or "Wee Willie" McGill had begun his professional baseball career in 1889. He was about to begin his third Major League season when he defeated the Wolverines. He was unique in the annals of baseball history. At 15 years of age, he was a professional pitcher. He was more than four months short of his 16th birthday when he pitched a no hitter, for Evansville of the Central Interstate League. McGill limited Davenport to three bases on balls and one hit batsman. On May 8, 1890, when he made his Major League debut, with Cleveland of the Players' League, he was 16 years and 6 months. He was the youngest Major Leaguer to pitch a complete game; the youngest to hurl a shutout; and the youngest regular rotation pitcher. At 17, in the American Association (then a Major League), he became the youngest to win 20 games.

Life in the fast lane may have come too early for the McGill. He never knew a stranger and seldom left a party early. Newspaper accounts frequently used euphemisms like "high living," "undisciplined" and "malaria" to account for his frequent absences and occasional playing lapses. Despite poor training habits, (ironic for a man who made a later career as a coach and athletic trainer), and being vertically challenged, Willie lasted a long time as a professional and semi-pro, pitching in the fast Chicago leagues 20 years after his pro debut.

Willie now sleeps the big sleep in Crown Hill cemetery of Indianapolis, one of the most storied in the country. He shares his final resting place with many famous Hoosiers including President Benjamin Harrison and Vice Presidents Charles Warren Fairbanks, Thomas Andrews Hendricks, and Thomas Riley Marshall. Other celebrities resting in Crown Hill are Eli Lilly; founder of the drug giant; Richard Jordan Gatling, inventor of the precursor of the modern machine gun; novelist Booth Tarkington; James Whitcomb Riley, the "Hoosier Poet"; Fred Duesenberg, the automobile manufacturer; and legendary bank robber John Dillinger (who killed a police officer in South Bend in his first big bank robbery). Also in Crown Hill is Ovid Butler the principal founder of Northwestern Christian University which was renamed in his honor and for whom Willie once coached baseball. While Coaching Butler, McGill was instrumental in the development of Oral Hildebrand, who would later pitch for the Cleveland Indians.

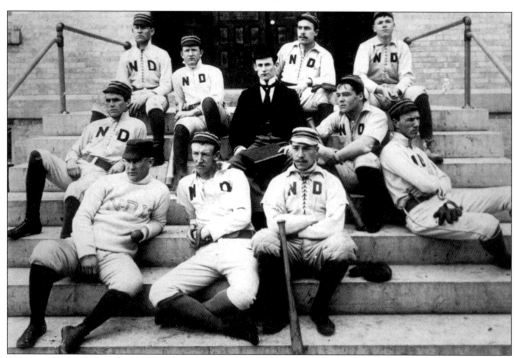

NOTRE DAME'S FIRST VARSITY CLUB, 1892. Pitcher Willie McGill is in the front row, left.

In 1995, the Cleveland Indians won their first American League title in 41 years setting up a World Series match with the Atlanta Braves. Much was been made about Cleveland ending their long drought (and the "Colavito Curse"). Since the advent of divisional play in 1969 the only American league East team not to win a title had been the Tribe. There were some stories written about the 1995 Series being a replay of 1948, when the Braves were five years away from leaving Boston for Milwaukee, but not much was written about one of the most noteworthy aspects of the Series match up: the pairing of the two "Native American" teams, and, as you might guess from the inclusion here, there is a Notre Dame connection to the saga of these two "Indian" teams. A man from Notre Dame, Louis M. Sockalexis, may lay claim to being the inspiration for the naming of the Cleveland American League team.

Cleveland was not always a bad team. They won the 1948 World Series (which any Cubs, White Sox, or Red Sox fan can tell you, is pretty darn recent) and the 1920 Series. The Indians Series hero in1920 was spitballer Stan Coveleski, who won three games. Fishing was the only sport Coveleski engaged in during his later years in South Bend, but for his Hall of Fame career and for adopting South Bend as his home, the city fathers named their beautiful new ball park after him, hoping that his Polish heritage would help sell the ball park to South Bend's West Side Democratic voters.

During the 19th Century, Cleveland did not fare as fell. It is universally acknowledged that the Cleveland Spiders of 1899 was the worst team in the history of the game. Cleveland was called the Spiders from 1889 through 1899 while playing in the National League. Cleveland had a good excuse for its dismal performance in 1899; the owner had depleted the team of all its talent in order to stock another team he owned.

There was a third year player on that dreadful 1899 team whose career is recalled through the name now worn by the Cleveland team, and thus hangs our tale. When Cleveland resurfaced in 1901, as one of the original American League teams, they were called either the Bronchos or the Blues, taking the name from the color of their socks, like teams in St. Louis, Chicago, and Boston had done. (The South Bend Minor League team of the 19th Century was called the Green Stockings or "Greens").

The 1897 Spiders team sported some pretty fancy talent. Cy Young was their star pitcher, and the best pitcher in baseball for a long time. In a 14-year period from 1891 through 1904, Cy averaged more than 28 wins a season. No wonder they named the best pitching award after him! Their best hitter was Jesse Burkett, another future Hall of Famer, who "slumped" to .383 in 1897 after hitting over .400 each of the previous two seasons. For his first thirteen seasons in the Majors, Lou Criger caught Cy for three different teams. Lou was from Elkhart, Indiana, 17 miles east of Notre Dame.

Burkett also scouted for the Spiders. He knew the team needed another strong outfielder. He had his eyes on Lou Sockalexis, a Penobscot Indian, who grew up in Oldtown, Maine. Burkett had been the coach of the Holy Cross college team in their pre-season workouts while Sockalexis was learning his baseball trade there, so he knew that Lou could play ball. Sockalexis was such a marvelous baseball player that while he was playing semi-pro ball in the Maine Knox County League he allegedly became the model for the Frank Merriwell baseball stories. Lou was coached for a time by Gilbert Patten who wrote those heroic novels (under the name of Burt Standish).

At Holy Cross, Sockalexis, who reportedly often yielded to temptations of the flesh and bottle, was befriended by Michael Powers, the team catcher. The two men had played semi-pro ball throughout upstate New York and New England during the summers. Powers, highly respected by all who knew him, had recruited Lou for Holy Cross. In the fall of 1896, Powers transferred to Notre Dame, where he immediately became a campus leader and the baseball captain. Apparently because of some difficulties at Holy Cross and his respect for Powers, in February of 1897 Sockalexis left the Crusaders and followed Powers to Notre Dame. Although Sockalexis was then 25 years old and had been at Holy Cross for two years, he qualified only for the prep program at ND where he was registered as a "special student." This designation was the 19th century equivalent of an athletic grant-in-aid.

Like Jim Thorpe, who would come along in another decade, Sockalexis was one of the greatest athletes in the country. He could run like a deer. He could play football. He had the ability to win any track or field event. He ran the hundred yard dash in10 flat. He is reputed to have thrown a baseball over 400 feet in a game against Harvard.

Lou quickly established himself as the best player on the Notre Dame team during pre-season workouts. By mid March it was obvious that the Irish were going to have a good team and that Lou Sockalexis was going to be the star and centerfielder. Alas, Lou was not to play in a varsity game for the Irish. The *South Bend Tribune* of March 18, 1897 reported "The two disorderly drunks arrested yesterday afternoon were students from the University of Notre Dame where the news was carried by telephone at an early hour last evening. On hearing of the conduct of the two young men the university authorities ordered their effects packed and sent to them with the information that their presence at Notre Dame was no longer desired." Showing the racial insensitivity of the time, the paper wrote "One of them was Sockalexis, the noted young Indian base ball player. . . . The other young man . . . stood high in social circles in this city. For the sake of what he has been and what he may still be his name is not published." A *Scholastic* item had previously reported that "the appearance of Sockalexis and Chassaing in the training quarters has put new life into the other candidates, and made the hearts of the local fans glow with joy unbounded." Since "Chassaing" did not appear in any games for 1897, I think we can deduce the name of Lou's drinking pal.

Nearly fifty years later, William Hindel, a Notre Dame teammate, recalled Sockalexis in an interview with H. G. Salsinger: "Had he never tasted whiskey he would have lasted a long time in the Majors and left a record that generations could shoot at without ever matching it." Hindel remembered the night that caused the expulsion: "They loaded up on 'Old Oscar McGroggins' and wandered about in search of entertainment. The visited an establishment conducted by Pop Corn Jennie and wrecked the place . . . he (Sockalexis) became so provoked that he flattened two of the coppers with perfectly delivered rights to the jaw. . . ."

After the dismissal, Lou turned in his books for a $10 refund and borrowed $16 from Notre Dame for train and cab fare to Cleveland. It has been reported that Burkett and the Cleveland Spiders had already signed Lou to a contract to report after the Notre Dame season ended. Lou was quickly the star of the Spiders, playing right field and batting third. He also proved to be a huge drawing card.

Initially, opposing team fans would taunt him with derisive war whoops. Soon those taunts became cheers as his outstanding play, powerful hitting, and awesome throwing won over even the opponents. Writers would occasionally refer to the team as the "Indians" (there was another Native American on the roster, but Lou was the star). Team nicknames were not fully established in those days. Sixteen years later, when the Notre Dame football team went to West Point to play Army the New York papers called them "the Catholics" and "the Hoosiers." Under Rockne, they were sometimes called "the Norsemen." Permanent team names did not occur until sportswriter nicknames stuck with the public.

After a couple of months of play, Lou was one of the top players in the League, hitting around .330. Lou also proved to be an "honest Injun," as he later wired Notre Dame the $26 he owed the school.

During a rousing evening of reverie, around the Fourth of July, Lou once again succumbed to firewater. For all practical purposes his career was over. He played only sparingly after that. He started dropping routine fly balls. The papers talked about his "dalliances with fair maidens" and his bouts of drinking. The *Providence Journal* of August 31, 1897 quoted Sockalexis as saying "I was made a good deal of by the sport in Cleveland, and things came to fast for me. I have cut it all out now and am anxious to get back into the game." The *Journal* also reported ". . . curved balls are not the only benders that have kept the Redman down." The *Washington Evening Star* of August 14, 1897 wrote "The great trouble of the American Indian in his crusade against rum . . . is that he fails to call for a cab at the proper time. Sock paid fine after fine with cheerful regularity, but he kept on forgetting the cab and now he has been suspended."

Although he played briefly the next two seasons and tried a little Minor League ball, he was finished shortly after the turn of the century. He died in 1913, at the age of 42. His death certificate said his occupation was "woodsman" and he died of acute alcoholism. The Cleveland team kept trying new names, including the Molly McGuires, but none took hold with the fans. Then along came a new star, Napoleon Lajoie and the team became known as the Naps. As Lajoie's career wound down, he was first stripped of his Manager job, then benched, and finally traded, so it was necessary to come up with a new name for the team. (Another Notre Dame man was involved in this transition. Joseph "Dode" Birmingham was the Cleveland Manager who benched the great Lajoie in 1911.)

In 1915, teams did not come with nicknames already attached so the *Cleveland Plain Dealer* decided to pick a new name for the home team. The name chosen was "Indians," such was the greatness of Sockalexis 18 years earlier. Luke Salisbury, a distinguished baseball historian, wrote *The Cleveland Indian*, a fictionalized account of Lou's meteoric rise to stardom and introduced mythological features to his life. Brian McDonald wrote *Indian Summer*, a fine biography of the Abenaki Adonis, one of Lou's nicknames.

The Indians and the Braves carry the banner of a proud race of people who have sent more than a couple dozen men to the Major Leagues. These great players have included Hall of Famer Chief Bender and stars like Rudy York and Allie Reynolds, but none of these men created the stir that Lou Sockalexis did nearly a century ago.

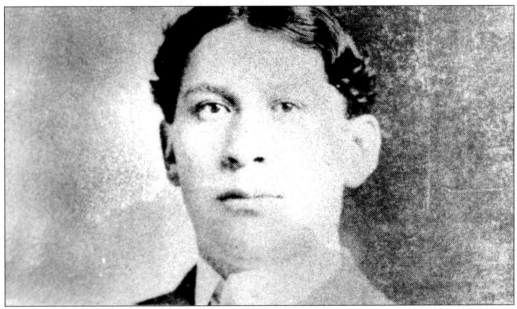

LOU SOCKALEXIS. "Sock" was the first Native-American Major League baseball player.

Sockalexis was not the only tragic figure from the 1897 Notre Dame squad. John Henry Shillington was the shortstop on the team, and he was expelled from Notre Dame for missing curfew ("it was necessary to sever his connection with the university").He joined the Navy and was aboard the USS *Maine* when the battleship exploded in Havana Harbor on February 15, 1898. That incident brought about cries of "Remember the Maine" and led to American intervention in Cuba, and the Spanish-American War. On Memorial Day, 1915, Joseph Daniels dedicated a monument on campus to Shillington and gave a speech to 1,000 students. The red granite monument has a marker cast in metal recovered from the sunken battleship. A 10 inch mortar shell rests atop the base. Shillington wrote a friend while serving on the *Maine:* "I often think of Notre Dame. I can picture her daily, a tear is often shed away. . . ."

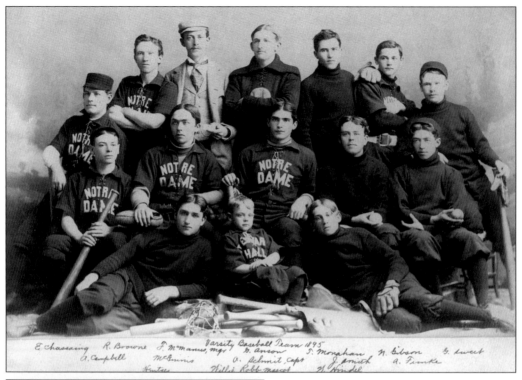

E. Chassaing R. Browne T. McManus, mgr. Varsity Baseball Team 1895 T. Monahan N. Gibson G. Sweet
A. Campbell McGinnis O. Schmidt, capt. J. Smith A. Funke
Hunter Willie Robb, mascot W. Hindle

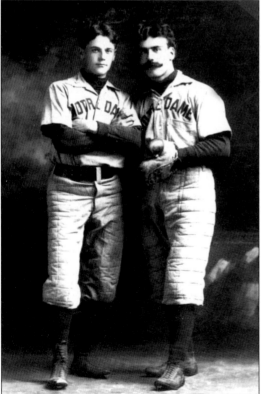

1895 NOTRE DAME TEAM. Norwood Gibson is in the back row, second from right. William Hindle is in the front row, far right. Edme Chassaing, the husky looking lad on the far left, never earned a varsity letter at Notre Dame despite being around the team for over a six-year period.

PITCHER NORWOOD R. GIBSON AND CATCHER MICHAEL "DOC" POWERS. Gibson (left) was a 1901 Chemistry graduate of Notre Dame. He would go on to play four years with Boston of the American League, only two years fewer than the six he played for Notre Dame, where he earned five varsity monograms (20-9, with four saves). A spitballer, he was the number four starting pitcher on both the 1903 and 1904 pennant-winning Boston Pilgrims. Gibson used his 1903 World Series money to buy a large tract of land in Tennessee, upon which he intended to plant fruit trees. Gibby was an Instructor General and Analytical Chemistry at Indiana University in 1907 and an Instructor of Chemistry at Wabash College, in 1908.

James Edward "Red" Morgan was a fine collegiate player who made his 1906 Major League debut by replacing Hall of Famer Jimmy Collins as the Red Sox third baseman.

The circumstances of Morgan's birth and death make interesting tales. He was born on October 6, 1883, in the town of Neola, Iowa. There were only 200 residents of Neola at that time, but another one of them born in 1883 (August 22), Jerome Willis "Rome" Downs, also played the infield in the American League and also was nicked "Red."

Despite being only 16 years old when he arrived on campus, Morgan was the starting third baseman for Notre Dame in 1900. He moved to first in 1901 when Angus McDonald graduated. Morgan was a spirited guy and the team's leading slugger. Just when he should have been entering his prime at Notre Dame, he transferred to Georgetown University. Morgan played semi-pro ball for Plattsburgh (NY) during the summers along with many other college players who earned money in upstate New York or in the semi-pro Vermont League. Several Georgetown players played up there and they may have induced Morgan to move on. Morgan played four additional years of college baseball and also starred in two years of football for the Hoyas (or Hilltoppers as they were also called).

For those SABR members who track down biographical information on former players, Red Morgan remained a mystery for many years. Nothing was known about his whereabouts from 1930 or so. SABR biographical researchers take great pride in finding death dates of former players. By the late '70s Morgan was presumed long dead, but that did not stop super researcher Bill Haber from attempting to locate Morgan. After decades of looking, Haber finally traced Morgan to New York City, where he died at the age of 97 (not far from Haber's own home).

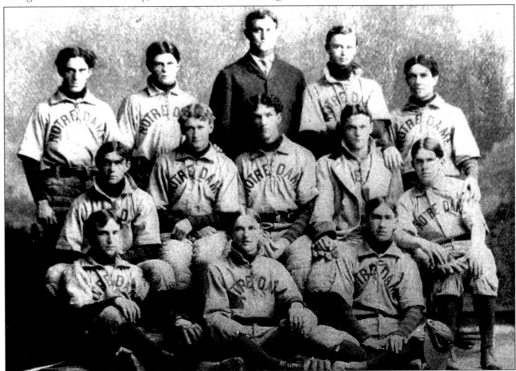

1900 NOTRE DAME TEAM. This ball club had four future Major Leaguers on its 12-man roster. James "Red" Morgan is in the back row, second from left. Phillip "Peaches" O'Neill is in the middle row, second from left. Norwood Gibson and Bert Keeley are second to right and far right in the middle row, respectively. Note that college clubs of the era likely had only eight position players, three pitchers, a back-up catcher, and one infield substitute; one or more of the pitchers may also have played in the field.

The 1900 Notre Dame Baseball Team was loaded with talent. Morgan and Pitchers Gibson and Bert Keeley and catcher Peaches O'Neill would later play in the Majors. Shortstop Bobby Lynch was one of the team's stars and would have a nice Minor League career. John "Pop" Farley was one of the stronger hitters and a four year letterman in football.

Despite all this talent, Angus McDonald, the first baseman, was the team Captain, an honor in those days usually reserved for the best player. McDonald was a four-year baseball star and three year member of the football team, quarterbacking the 1899 team.

It would have been logical to project a professional baseball career for Angus, except he had bigger plans in mind. Beginning in the Accounting Department of the Southern Pacific Railroad, Angus worked himself up the ladder to the Presidency of the Railroad, in 1932, serving in that role until his death in 1941. Prior to McDonald, the only man who held the title longer was their first President, Leland Stanford, whose namesake university has produced some pretty decent baseball over the years.

Bill Yenne, in *Southern Pacific* (Bonanza Books, New York, 1985) wrote "It was in the darkest hour, 1932, that Angus D. McDonald came to the helm of the Southern Pacific. A quiet, unsmiling, former football player from Notre Dame…McDonald walked daily from his Nob Hill home down to the company's headquarters at the foot of Market Street. There he faced the difficult decisions and made the difficult cuts in maintenance and manpower that ultimately saved the company."

Yenne credits McDonald with pulling the Southern Pacific out of the Depression, as the only major U.S. railroad not to go into receivership. During McDonald's tenure, the Southern Pacific Railroad became the third largest industrial corporation in the United States, trailing only AT&T and the Pennsylvania Railway. Because the Southern Pacific also owned the Morgan Steamship Line, it was the nation's only coast to coast transportation system.

McDonald became a loyal Notre Dame alumnus, serving on the Board of Trustees and giving the Commencement Address in 1931. In the same year, Pope Pius named him a Knight of Malta.

Michael Riley "Doc" Powers was the star of the Notre Dame Baseball Team in 1897 and 1898, but more than that, he seemed to exert a moral influence over those around him. Even as a college student, his peers wrote about him with awe and admiration. The *Scholastic* reported ". . . the unquestioning obedience and cheerful cooperation of his team under all circumstances show his ability as a captain, but deeper, truer even than this, confidence in him as an athlete, is the honest admiration we all hold for 'Mike' Powers the man."

On August 4, 1905, Powers caught Eustace James "Doc" Newton during the few weeks that Powers was with the New York Highlanders (Yankees). This was the only time that the Majors Leagues had a physician battery. Powers earned his MD during his first few professional seasons. The *Chicago Tribune* once reported, "Doc Powers is a handy man to have around a ball team. He can pull a tooth, set a leg, prescribe for any ill baseball flesh is heir to, take a turn behind the bat, and then sit down and write about it."

Doc became one of the most tragic figures in baseball history, dying as a result of injuries or a medical condition suffered or made worse during the inaugural game at Shibe Park, Philadelphia, April 12, 1909. According to research done by Paul Greenwell ("The Forgotten Casualty"), the death of Powers should be recorded as a playing fatality.

Doc Powers was the A's catcher in the inaugural game for Philadelphia's Shibe Park, on April 12, 1909. He died 17 days later. According to research done by Paul Greenwell ("The Forgotten Casualty"), the death of Powers should be recorded as a playing fatality.

Because medical diagnoses were not far advance in 1909, we will never know the complete story of Powers' death. In the 7th inning, he dove into a railing trying to catch a foul ball. He complained of a bruise, but finished the game. Afterwards, he asked for a rubdown, complaining of a "stitch" in his side. The trainer felt a lump "as large as a fist" in Powers' side, beneath his ribs. Powers doubled over in pain, which eventually forced him to the hospital. The trainer blamed the injury on the large belts and buckles worn by players in those days. The first diagnosis at the hospital was acute indigestion. As his condition worsened, an operation was

performed to remove a gangrenous condition from his intestines. Seventeen days after the game, Powers passed away. The death certificate lists the cause of death as "acute cardiac dilatation," but a century later there remains a question whether his death resulted from a playing injury or from natural causes.

Greenwell pointed out that Doc Powers had been Eddie Plank's personal catcher and close friend. Plank skipped two pitching turns because of Powers' death, possibly costing him a 20 win season. He finished with 19. Greenwell also points out that poor play by the A's during this period may have cost them a chance for the pennant, as they finished 3½ games behind the Tigers.

The *Philadelphia Inquirer* headlined the sports page on April 30, 1909: "Doc Powers called by the inexorable umpire. 'You're out', so said the umpire of umpires to Dr. Maurice R. Powers at 9:14 yesterday morning, ending the struggle which the Athletics' famous catcher has made against insurmountable odds." The paper also reported that he was paid ". . . such homage as an eminent statesman or clergyman might receive . . . it is convincing proof of the nobility or baseball that it was able to draw to itself . . . such a man as Dr. Powers." The *Chicago Inter-Ocean* summarized ". . . (Dr. Powers) who is said to have done more than anyone else to dignify the profession of baseball by his personal conduct during his years with the Athletics."

MICHAEL "DOC" POWERS.
Doc was one of the most tragic figures in baseball history.

On June 30, 1910 Connie Mack held a "field day" with all the proceeds given to Powers' widow. More than 12,000 fans came to honor Powers. Several "athletic contests" were held. Harry Lord beat a bunt to first in 3.2 seconds; Pat Donahue won the most accurate throwing contest; Eddie Collins equaled the "world record" in circling the bases (14.2 sec.), beating Jimmy Austin and Tris Speaker; Harry Hooper won the long throw (356' 4") beating Boston teammate Speaker by 10 feet.

In *The National Game* (National Game Publishing Co., St. Louis, 1910), Alfred Spink published a poem (unknown author) that was written about Mike Powers after he died:

"Red Cross Mike"

You fans all knew of Red Cross Mike
Who played the game to win.
But always played it on the square
And fought through thick and thin.
There never was a whiter man
That caught behind the plate,
Who kindly cheered his comrades more
And fixed an ailing mate.
When someone met a liner
And was struggling hard for air
Of all who helped the stricken man,
"Doc" Powers first was there.

'Work hard, old man, work hard', said
Mike, when things were going ill,
And by his true and steady work,
He'd pull his team uphill—
To victory. But the fans cheered "Doc"
With all their might,
He'd always give credit
To a teammate, for the fight
Calm in the midst of tumult,
When the shouting split the air,
Doing his best in every play,
"Doc" Powers still was there.

We'll have another catcher
Who will play in Powers' place;
We'll have another catcher,
Who will fight to win the race.
But now "Doc" has gone and passed beyond
The umpire's strident call;
No more he'll rise to duty,
When we hear the words. 'Play Ball'
But though he's left a team to mourn
And miss his kindly air,
Within the hearts of countless friends
'Doc' Powers will be there.

Henry Joseph Thielman attended Notre Dame during the 1900–1901 school year. He was a member of the Notre Dame Football squad. In a 1900 football team photo, Thielman is the most handsome and dapper player on the squad. This team is famous because it was coached by the legendary drop-kicker, Australian Pat O'Dea, who starred at the University of Wisconsin. Two of the starting backs were Louis "Red" Salmon and John Farley. Salmon and Farley were stars on the football and baseball teams. Salmon was named a third team Walter Camp All American in 1903, the first Notre Dame Football Player named on any All American Team. After becoming a C.S.C. priest, Rev. "Pop" Farley achieved such fame as a dormitory rector that a residence hall was named in his honor.

Thielman made his Major League debut, with the New York Giants, in 1903. After being traded to the Cincinnati Reds, he finished the year as their number three pitcher, winning nine games and losing 15, 12 of them consecutively. In 1903, he led the Jersey City team to the Eastern League championship, with a 23-5 record. During that season he twice pitched and won two complete doubleheaders, defeating Newark and Baltimore.

Thielman completed his academic and dental studies at Manhattan College, the University of Pennsylvania (where he coached baseball in 1906), and at Philadelphia Dental College. He became a dentist but was still playing professional baseball after hanging up his "tooth." Like many of his peers, Thielman used his baseball playing to pay his way through college and graduate school.

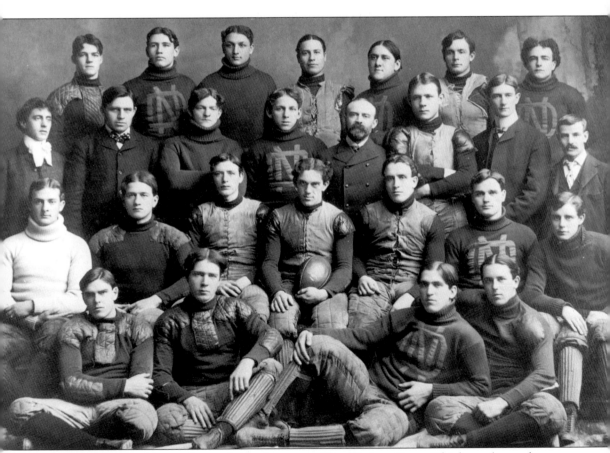

1900 FOOTBALL TEAM. Some of the players are identified as: Henry Thielman (second row, left), John "Pop" Farley (second row, center), Louis "Red" Salmon (third row, third from left), and coach Pat O'Dea (third row, second from right).

HENRY JOSEPH THIELMAN. Thielman (left) and fellow Giants pitcher and Hall of Famer Christy Mathewson (far right).

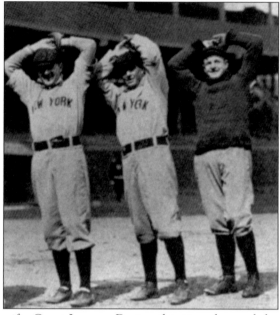

With the average Major League salary today approaching two million dollars not even the medical profession can provide the earnings that Major League baseball commands, so it is difficult for us to imagine what it was like a century ago for "diamond docs."

In 1913, Thielman set out for a vacation in Portland. While visiting, he set up a dental practice. He decided to resurrect his baseball career even though he had not pitched professionally since 1908. He made the pitching staff of the Portland Colts of the Northwest League, winning his first three games without a loss. He then moved across town to the faster company of the Portland Beavers of the Pacific Coast League. During this time, he used the name "Harry Todd" so none of his dental patients would be aware of his "moonlighting." He later said "some of my clients may not like the idea of having their teeth fixed . . . by a baseball player." After three games with the Beavers, he hung up his glove for the last time. He spent the rest of his life practicing dentistry in New York City, where his patient list allegedly included boxing great Jack Dempsey.

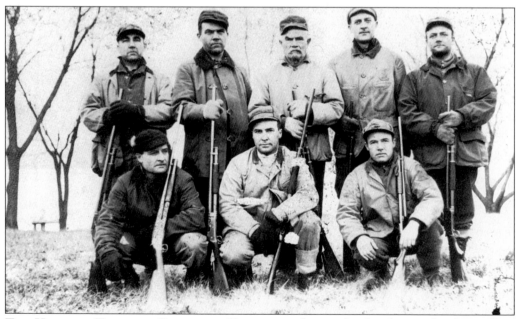

THE HUNTING THIELMAN BROTHERS. Henry came from a family of seven brothers, all of whom were hunters. His brother John "Jake" Thielman was a National League contemporary. Henry was also noted as an outstanding trap shooter.

John Gabriel Walsh was the Notre Dame Second Baseman in 1901. He was one of the top hitters, with an average around .400 (records are incomplete). On May 3, 1901, he scored five runs in a rout of Purdue. Despite his fine playing record, Walsh did not earn a Notre Dame monogram. This happened several times in the first two decades of Notre Dame Baseball, usually because the player signed a pro contract before completing an academic year or because there were allegations or proof that the player was a professional. Walsh was a "one gamer" in the Majors, playing third for the Philadelphia Phillies on June 22, 1903. He had no hits in three at bats and handled two chances in the field. He batted in the fifth spot in the order.

Philip Bernard "Peaches" O'Neill was a star catcher for Notre Dame. The Scholastic of March 23, 1901 described how O'Neill got his nickname. "O'Neill will be behind the bat again with his big yellow glove and his big mellow smile, to cheer up the rooters with his jolly 'Peaches! Old hoss!' " After some Minor League and semi-pro ball, and a cup of coffee with the Cincinnati Reds, O'Neill returned to his hometown of Anderson, Indiana and began a 50 year practice of law, specializing in insurance, banking, and railroad cases. O'Neill served as the pre-season Baseball Coach of Indiana University (1903), Purdue (1905), and DePauw (1907).

As a reminder for how new our country is, about 100 years ago, O'Neill went to play ball in "Guthrie, Indian Territory" (now Oklahoma). In 1905, he played with the semi-pro Youngstown "Ohio Works" team, which won the championship of the Protective Association. In pre-season games for the 1906 Sioux City Packers of the Western League, O'Neill led the team in batting (16/25, .640). An arm injury sent O'Neill to the practice of Law.

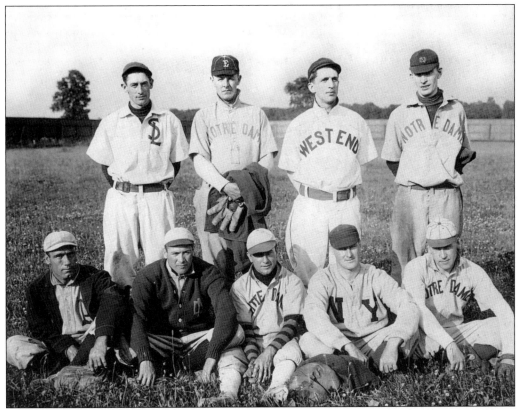

NOTRE DAME ALUMNI BASEBALL TEAM, 1908. Baseball was the most successful sport at Notre Dame until Knute Rockne's time. Each year at commencement, an alumni team would play the varsity in front of a thousand or more fans. Seated in the front row are Doc Powers (on left) and Harry Curtis (second from right).

An anonymous poem in the June 13, 1908 issue of the Notre Dame *Scholastic* talks about the Notre Dame Baseball Team of 1900.

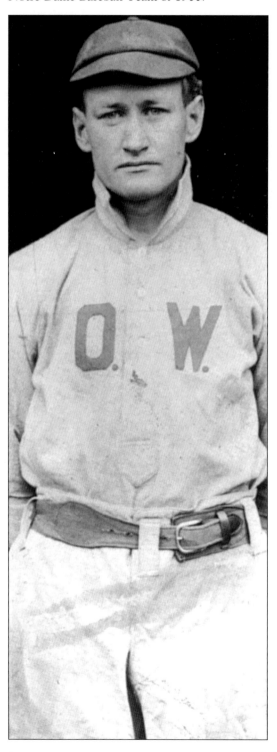

The years have not been many,
But the days were crowded so
With surging and receding
Of life's constant ebb and flow;
Experience has doubled
On the circuit of my years
Till remoter than a farther time
The recent past appears:
Fair days that memory hallows
When the evening lights burn low,
Days of Gibson and O'Neill seem long ago.

And fancy paints a picture
Of the frequent hard-fought field,
With a baseball team whose spirit
Never to defeat would yield.
There was Morgan, Lynch, and Daly,
With McDonald on first base,
Farley, Fleming, and Cap "Dunny,"
Memory greets each strong, tanned face.
But the starts of that fine company,
The big things of all the show,
Were my "Gibby" and my "Peaches" long ago.

Was there ever such a battery.
Full of ginger, juice or pep!
Whichever name you give it,
Still these men will hold their rep.
The years may come and vanish,
Each with its "fighting team,"
And the loyal N.D. rooter
Of a better team will not dream.
And the pitchers and the catchers
To all will seem, I know,
As my "Gibby" and my "Peaches" long ago.

So there's comfort in the knowledge
That a time we hold so dear,
Though gone, is still remembered
As a laurelled, glorious year.
Old team for which I shouted,
You are type of what may be;
For every team that struggles
As you did for old N.D.
Remembered, praised and cherished,
Your names will ever glow—
O my Gibson and O'Neill of long ago!

"PEACHES" O'NEILL.

Francis Joseph "Shag" Shaughnessy was a significant figure in two sports for two countries and rightfully earned the title as the "Man who saved the Minor Leagues." He was a two sport star for the Irish, playing end on the 1901–1904 Notre Dame teams, being team Captain in 1904. He set a football record in 1904 which can never be broken. He recovered a fumble against Kansas and returned it 107 yards for a touchdown.

Shaughnessy was a catcher at Notre Dame, but played outfield during his professional career. In 1908 the Philadelphia Athletics sent Shag to Reading (PA) for future Hall of Famer John "Home Run" Baker.

Shag started playing pro baseball using the alias "Shannon" in 1903. From 1909 until 1925, with two years out as a Lieutenant in Canadian Military Service he was a playing manager somewhere in the United States or Canada. He won six pennants, in four different leagues, as a Minor League Manager.

In 1933, with the Depression hurting Minor League attendance, Frank came up with the "Shaughnessy Plan" which saved the Minor Leagues from extinction. At the time, he was the General Manager of the Montreal Royals. As he later explained it, "Most of the teams in the International League were losing money. One of the clubs was way out in front and the fans were losing interest. The other clubs started to lose money and became panicky. They began selling their good players and the others began losing interest. We had to find some way to make it worthwhile for the players to put out and fight for four places instead of just for the pennant." Frank served as President of the International League from 1936–1960.

He coached college football at three universities (Clemson, Washington & Lee, and McGill) and also coached pro hockey in Canada. Shaughnessy is credited with introducing the forward pass to Canadian College Football, in 1921. The Shaughnessy Cup was the trophy presented, in 1969, to the winner of the McGill-Loyola Football Competition. Shag had coached the football teams at both schools.

Shag often spoke about his desire that his adopted home of Montreal would someday have a Major League franchise.

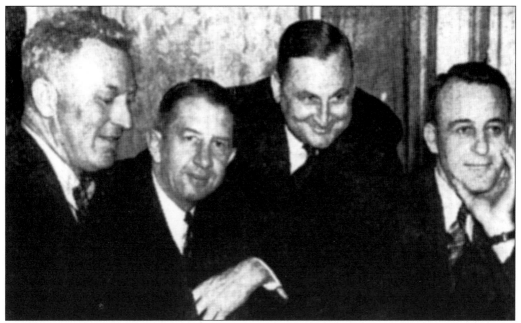

DINEEN DINNER. This April 20, 1938 photo was taken at a testimonial dinner honoring former Major Leaguer Bill Dineen. From left to right, are Frank Shaughnessy, Hall of Famer Eddie Collins, Jack Corbett, and Hall of Famer "Sunny Jim" Bottomley.

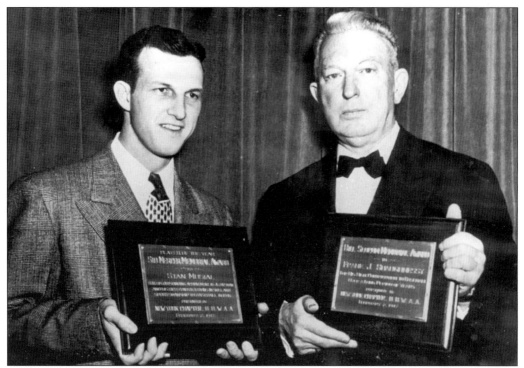

STAN MUSIAL AND FRANK SHAUGHNESSY. Shaughnessy (right) receives a plaque for long service to the game. Hall of Famer Stan Musial is on the left. Musial's son Dick ran track at Notre Dame, graduating in the class of 1962. One of Dick's classmates was Ronnie Como, whose father, like Musial, escaped humble ethnic origins in Pennsylvania to make a name in the crooning business.

College players were not always welcome in the Majors. An editorial (by E.L.R.) in the January 28, 1905 edition of the *Scholastic* described this state of affairs. "Formerly the college player was practically ostracized by the leaguers, and this injured his chances considerably, as it meant the absence of that support and encouragement so necessary to a beginner. Today, however, this prejudicial barrier has almost disappeared, and as a result, the collegians are getting into the ranks." The student writer went on to highlight some of the collegians who were starring in the Major Leagues, including Christy Mathewson of the Giants, and Notre Dame's former battery of Norwood Gibson and Doc Powers.

Two
The Golden Age under the Golden Dome

Notre Dame first rose to national baseball prominence in 1908, when their 20-1 record included seven games in nine days on an Eastern road trip. Just as the Notre Dame football team did not achieve national recognition until they got their first major intersectional win, defeating West Point in 1913, the baseball team did not gain East Coast respect until this pioneering road trip. From the first decade of the 20th century through the early 1920s, Notre Dame sent a steady stream of players to professional baseball and the Major Leagues.

Harry Curtis was Notre Dame's first bench coach, in 1908 and 1909. After four more years of professional players doing pre-season coaching (Ed Smith in 1910 and 1912, Red Kelley in 1911, and Cy Williams in 1912), Notre Dame hired Jess Harper for the 1914 season. Until Jake Kline was hired, for the 1934 season, the Baseball Coach was either a football or basketball coach, working in his second sport.

From 1906 through 1924, Notre Dame compiled a record of 287-95-2 (.751), with no losing seasons.

"STEAMER" FLANAGAN.

James Paul "Steamer" Flanagan spoke often to his family about attending Notre Dame briefly, after beginning his schooling at Wyoming (PA) Seminary. Although there are no school records to confirm this, we are listing him as a "suspect" for the Irish. He made his Major League debut in 1905, batting .280 in seven games with the Pittsburgh Pirates. The Bucs expected big things of Flanagan, putting him in center field and hitting him in the third spot in the order, ahead of Honus Wagner. Flanagan came to the Pirates attention after having two strong years at Springfield (MA) in the Connecticut League.

Flanagan made an off-season trip to Havana, with several Major Leaguers, including Earle Mack. His observation was that "John McGraw could never play baseball in Cuba." Flanagan said, "If a player doesn't like a decision, he can kick about it for just one minute. Then a big gong in the scorer's box is rung. And if the player does not return to his position and play ball immediately, a patrol wagon is run on the grounds and the recalcitrant played is loaded up and taken to the city jail."

The Flanagan family tells a story about a young boy Flanagan befriended when he starred for Springfield. The youngster would yell out "Hey Steamer, can I hold your bats for you and be your batboy?" Steamer would always yell back, "Sure, kid, come on in." A generation passed and the young boy came to the Flanagan house in Wilkes Barre. When Flanagan answered the door, there stood (future Hall of Famer) Rabbit Maranville. He said, "Is that you, Steamer?" Flanagan answered, "Sure kid, come on in." According to the Flanagan family, it was a joyous reunion.

Edward Marvin Reulbach remains one of the most overlooked great pitchers in baseball history. He came to the Majors, with the Cubs, in 1905. His Major League debut was May 16, 1905. He lost to the New York Giants, at the Polo Grounds, 4-0, despite yielding only five hits. Nine days later, he won his first game, 9-4, over the Philadelphia Phillies. He came on in relief in the second inning, and gave up five hits and no runs. His pitching ledger in 1905 showed 18 wins, a 1.42 ERA, and only 208 hits in 290²/₃ innings (6.42/ 9 innings).

Reulbach prepped for the Majors in two colleges and several semi pro leagues. He began at Notre Dame in 1901. During the three years he was at Notre Dame, he also pitched for Sedalia, in the Missouri Valley League, allegedly under the assumed name of "Lawson." While at Notre Dame, Reulbach was described by the *Scholastic*, as the "star [out]fielder." He was declared ineligible for the 1902 college season by a decision of "the Faculty." Reulbach had been one of the team's top hitters in the pre-season exhibition series with the White Sox. Ed also played interhall football and basketball. During the 1904 college season, six hits was the most Reulbach allowed in any game. He also broke Notre Dame's single season record for strikeouts. On June 7, 1904, Reulbach was elected team Captain for the 1905 season, a very popular selection according to the *Scholastic*.

He spent the rest of 1904 pitching for the Montpelier-Barre Hyphens in the Vermont State League, using the alias "Sheldon." He was referred to as "the Boy Wonder." The *St. Louis Globe Dispatch*, of July 30, 1905, contained an interview with White Sox catcher Hub Hart. Hart said that Reulbach was highly paid for his play in the New England Summer Leagues. According to Hart, Reulbach was supported by a wealthy individual from Hinsdale, New Hampshire, who paid him $125 per week and $2.50 per strikeout, and $50 for pitching out of his regular turn.

ED REULBACH.

After the season, Reulbach enrolled at the University of Vermont. He was 4-0 for Vermont, winning his final game, 1-0, against Syracuse, on May 12th. Ed was also the team's cleanup batter and played left field when not pitching. He was 11/36 as a batter. Four days after his final game with Vermont, Ed made his Cub debut.

Reulbach was one of the most dominant pitchers in the league for his first five seasons. He won consecutive winning percentage titles in the 1906-1908 pennant-winning seasons, a feat matched only by Lefty Grove. The Cubs were in the World Series in each of those three years. In the second game of the 1906 Series, Ed limited the cross-town White Sox to one hit, yielding only a single to Jiggs Donohue.

Reulbach was a big strapping pitcher. He completed several iron-man feats. On August 24, 1905, he defeated Tully Sparks, 2-1, in a 20-inning game. Reulbach won 17 consecutive games (1906-07). This was the post-1900 Major League record until broken by Rube Marquard (1911-12). The streak ended after four wins in 1907, when Deacon Phillipe bested him 2-1, on June 29. It remains the fourth longest streak. Ed pitched 12 low-hit (five hits or fewer) games in 1906.

Late in 1908, Ed set the National League record (44) for most consecutive scoreless innings. On September 26, 1908, Reulbach became the only pitcher ever to throw a double-header shutout. This is an accomplishment unlikely to be duplicated. This feat was critical to the Cubs drive for the pennant, because their pitching staff had been depleted. Ed's offer to pitch both games allowed Frank Chance to rest the weary arms of is staff.

On May 30, 1909 Ed pitched an 11-inning win over the Reds. He would not lose again until August 14. During his 14-game streak, he defeated every team in the League, including five wins over the Brooklyn Superbas. Brooklyn was his favorite opponent, having fallen to him nine times in 1908! A November 1913 article in *Baseball Magazine* judged Reulbach's 1909 streak as the most impressive in baseball history. In 14 games, Ed surrendered only 14 runs, giving up three on one occasion, while pitching five shutouts and five one-run games. Ed was the only 20th Century National League pitcher with two winning streaks longer than 14 games. Reulbach defeated "Iron-Man" Taylor, 2-1, in an 18-inning complete game. On June 30, 1909, Ed defeated future Hall of Famer Vic Willis, 3-2, in the first game ever played in Pittsburgh's Forbes Field. More than 30,000 fans witnessed the game.

Reulbach was traded to Booklyn late in the 1913 season. In his first 16 innings with the Superbas, in two relief appearances and a complete game shutout spread over six days, he gave up only two hits. He won the 1914 season opener against the Boston Braves, the eventual World Series Champions.

He won 21 games for Newark, including the opening day win over future Hall of Famer Chief Bender and a 12-inning win over former Cubs teammate, and future Hall of Famer, Three Finger Brown. Ed pitched the final game in the Federal League, on October 3, 1915. Ed's Newark Peps defeated the Baltimore Terrapins, 6-0, at Harrison Park (NJ), in the second game of a double-header.

Reulbach was Secretary and one of the founders of the short-lived Baseball Players' Fraternity, an association of Major League players (1914-15). One of his suggestions was for Major Leaguers to sign a pledge of total abstinence from alcohol. It's not known if that motion received a second.

Reulbach received much more support from his colleagues for his work to raise player salaries. In a February 4, 1934 article in the "Brooklyn Daily Eagle," Frank Reil told how Reulbach helped Jake Daubert gain a huge raise from the Dodgers. It seemed that owner Charlie Ebbets offered team Captain Daubert a $500 raise for the coming season. Daubert told Reutbach, in an excited manner while the team was en route to Chicago. According to Reil, Ed smelled a plot and told Jake not to sign until he had given him the signal." Reulbach figured that when the train arrived in Chicago, the Federal League would offer Daubert "big money."

Ebbets kept bumping his offer to Jake, and Ed withheld the signal, until finally the offer reached $9,000 for five years, a $5,000 raise per year. Reulbach himself was offered a big contract, possibly as an incentive to get him to induce his teammates to sign, but Ed declined. Later, when Ebbets learned that Reulbach was a ringleader in the "players' movement to raise salaries," he released the pitcher. Perhaps not coincidentally, no other National League team signed Reulbach, who inked a contract with Newark, of the Federals.

Ed finished his baseball career, in 1917, with Providence of the International League. His later years were not happy ones. He had a son he doted on and groomed to be a pitcher. Reulbach missed part of the 1910 season to be at his son's bedside during an attack of diphtheria. His son died, in 1931, after a long illness. Ed spent a fortune trying to save his son's life. A *Chicago Tribune* article, of December 29, 1932 referred to him, in his 50th year, as a sad and lonely man.

Ed gave up fewer hits than innings pitched for each of his 13 years in the Majors. No pitcher in the Hall of Fame accomplished that feat. Christy Mathewson and Cy Young each also did it 13 times, but pitched 17 and 22 seasons. According to Johnny Evers, in an undated quotation, Reulbach was "always five years ahead of his time in baseball thought." Evers spoke of Reulbach's "fadeaway pitch." He said also that Reulbach used the pitching technique of "shadowing," which described hiding the ball in the windup and delivery.

In an April 27, 1920 column for his Bell Syndicate, writer Hugh Fullerton wrote about a recent meeting with Reulbach, where Ed revealed a secret he had held for two decades. Reulbach asked Fullerton to look closely at his left eye. Reulbach pointed out the eye was "a trifle smaller . . . a trifle duller, slightly lacking in the sparkle of the other." He said that it was that eye weakness which made him occasionally wild (11 hit batsmen and four wild pitches in 1908 despite overpowering opposing hitters) and weak defensively on balls hit to his left. "There were times when the weak eye was worse than usual, especially on hot, gray days, or when the dust was blowing from the field. Lots of times . . . the sweat and heat would effect the good eye and I'd have to figure where the plate was." Reulbach said none of his teammates ever suspected, and he did not inform even his own catchers, so they could give him a special target to aim for. He said that outfielder Jimmy Sheckard once caught him reading, with glasses, but "he was a good old scout and kept quiet about it."

According to J.C. Kofoed, writing in Baseball Magazine, in a 1921 article, Reulbach pitched two one-hitters; six two-hitters; and 13 three-hitters in his career. In a January 24, 1924, Kofoed wrote, "[Reulbach] to our mind, was one of the greatest pitchers that the National League ever produced, and one of the finest, clean-cut gentlemen who ever wore a big league uniform… He had a grand fast ball and a wiz (sic) of a curve, and when he was going right—which was most of the time—he was almost unbeatable." In a January 1967 column in *Baseball Digest*, Chief Meyers compared Reulbach's high kick to that of Juan Marichal.

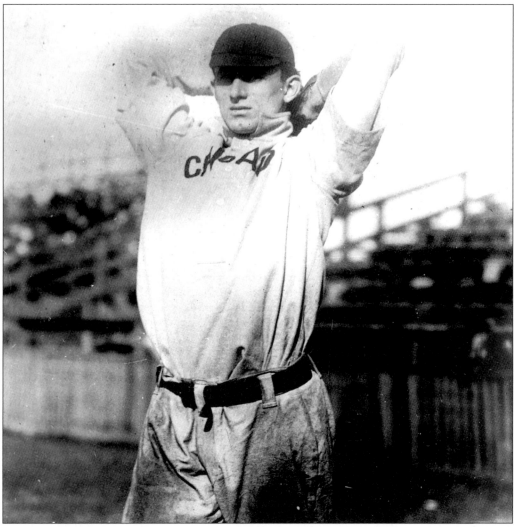

REULBACH.

One writer, in an obituary notice, stated that Ed had the "biggest curve ball in either League." Reulbach was described as a "statuesque" pitcher. Despite a wonderful Major League record (whose stats compare favorably with Sandy Koufax, except for strikeouts), Reulbach has never received even a single vote for the Hall of Fame. His 5.33 hits per nine innings in 1906 is still the third lowest of all time. His career has been largely overlooked, probably because he was always overshadowed by teammate Three Finger Brown during the pitching oriented Deadball Era.

Reulbach was one of the favorites of *Baseball Magazine*. He was featured in many articles. He was referred to as "one of the brainiest players" and the "possessor or the finest curve ball in either league." He authored several articles about what was then called "the inside game." The legendary John J. Ward wrote a nine-page article about Reulbach, in 1912, titled "The Shut Out King."

In 1945, Reulbach copyrighted something he called "the Leadership Development Plan." Ed felt that the then important position of "captain" should be rotated among all nine players, one inning at a time, as a means to develop qualities of leadership among young people.

Henry Theodore "Hank" Olmsted's obituary refers to his spending his freshman year at the University of Notre Dame. Hank also sent a letter to Hall of Fame Historian Lee Allen (June 18, 1964) in which he states that he spent "one year at Notre Dame." His widow remembered him talking fondly of his time at Notre Dame. As of this time, no records have been found to support this claim, but I am taking the liberty of including him as an undocumented "suspect" because of his own words on the subject.

Hank had a fine Minor League career after his three games with the 1906 Boston Red Sox. He won 64 games with Denver during the 1908-10 seasons. Perhaps the highlight of Olmsted's career occurred before a game when Hank was pitching for the Denver Bears. President Taft, the first sitting President ever to throw out the "first ball," presented Hank a loving cup in honor of his great season with Denver.

If this was not Hank's career highlight, Mrs. Olmsted may have provided a good choice for the other. She stated that before they were married he had dated the actress Ethel Barrymore on several occasions.

Olmsted worked as a Chiropractor after his professional career ended. He said that a Chiropractor once saw him having difficulty trying to lift his arm and insisted that he could help him. According to Olmsted, "Never having heard of this prof(ession) I was stunned when he cured it. Thinking of a Major League training spot I perfected myself and graduated from Palmer College of Chiro." This was a very important profession for baseball in the early days because orthopedic medicine and the treatment of arm injuries in pitchers were not well developed at that time. Chiropractors with an understanding of baseball were sought after.

Hank opened a practice in Jackson, Michigan. He worked with players from the University of Michigan and Michigan State. He became a Big 10 Umpire. Olmsted reported that he treated George Uhle of the Tigers and helped him regain some of his arm strength. Olmsted claimed that he also worked on baseball greats Ty Cobb and Babe Ruth.

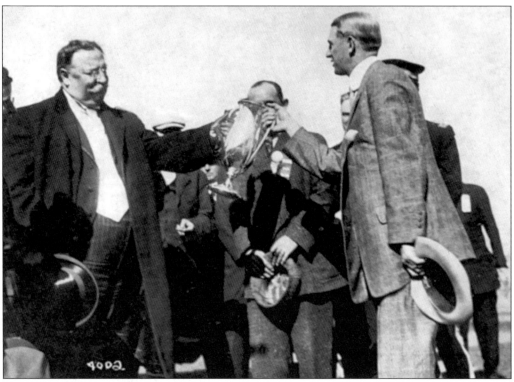

PRESIDENT WILLIAM HOWARD TAFT AND HANK OLMSTED.

Con Lucid, Steamer Flanagan, and Hank Olmsted are not the only persons claiming Notre Dame in their background for whom no documentation can be found. At about the time same they were beginning their Major League careers, there was a young man born in Mishawaka, the city just east of South Bend. Harry Albershart would eventually move to Hollywood where he would be featured in many movies as a cowboy star. The studio came up with a more dashing screen name for him. As Allen "Rocky" Lane, he first portrayed Red Ryder and later starred in many movies, being named one of the top 10 money making western stars for both 1951 and 1953. Later, he was the un-credited voice of "Mr. Ed." His movie bio indicated that he was a three sport star at Notre Dame. None of this background can be verified.

Joseph Leo "Dode" Birmingham and John Joseph "Red" Murray both enrolled at Notre Dame in 1905. The two boys were childhood friends, growing up in Chemung County, New York. Murray was born in Pennsylvania, but moved to Elmira. Birmingham was born in Elmira but spent some of his early years in Pennsylvania.

Both played semi-pro ball in and around Elmira, before heading off to college. Murray first enrolled at Lock Haven State College, playing football, basketball, and baseball. Birmingham went to Cornell, where he played football.

Murray came to Notre Dame as a catcher, a position where he could use his powerful throwing arm. Birmingham, who also had a strong arm, was a centerfielder. Both men had great speed. Birmingham dropped out of school after one semester, after a bout with malaria. Murray went on to become the star hitter and fielder of the 1906 team. He signed with the St. Louis Cardinals immediately after the college season ended, making his Big League debut on June 16. Red showed good power in his short trial, clouting nine doubles and seven triples in only 46 games.

While Red was with the Redbirds, Dode was playing for Amsterdam-Johnstown-Gloversville of the New York League. He hit .303 and stole 25 bases. He made his Major League debut with the Cleveland Naps on September 12. He hit .317 in 10 games to close out the season.

The following year, the two Elmirans were starting outfielders in the Majors. Dode's defensive prowess forced future Hall of Famer Elmer Flick to move from center to right field. Murray held down left field for the Cards.

The 1908 season was a breakout year for both men. Cleveland finished only a half game behind the pennant winning Detroit Tigers. Although the Cards finished in the National League basement, Murray, now playing right field, hit seven home runs for the second year in a row—a lot of power for the "dead ball" era. He also stole 48 bases, to finish second to Honus Wagner.

In the off-season, Red was traded to the New York Giants in a blockbuster trade. The Giants parted with pitcher Buggs Raymond and future Hall of Famer Roger Bresnahan, Manager John McGraw's favorite player and the person figured most likely to follow McGraw as Giants' Manager. Murray was installed as their clean-up batter and right fielder and proved to be the key ingredient for the Giants, playing on four World Series teams (1911, 1912, 1913, and 1917).

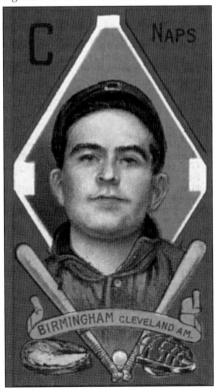

JOSEPH BIRMINGHAM.

Despite impressive batting, base running, and fielding statistics for the next seven seasons, Murray remains one of the least-recognized star players of the dead-ball era. MacMillan's wonderful 1976 book *A Baseball Century: The first Hundred Years of the National League* states "On the legs of Josh Devore, Buck Herzog, Fred Snodgrass, Arthur Fletcher, and . . . 'Laughing Larry Doyle, the Giants raced to a pennant in those years." Manager John McGraw's juggernaut of 1911–1913 did feature a very balanced, speedy lineup, winning three consecutive NL pennants. Strangely, the author left out that it was Red Murray and Fred Merkle who tied Snodgrass for the team stolen base lead in those years, and it was only Murray who competed for the League titles. The immortal Lee Allen similarly slighted Murray in his 1950 book *100 Years of Baseball*. Allen wrote "This (stolen base) epoch extended roughly from 1910-1912. Allen then listed "Greyhounds" Bob Bescher of the Reds, Doyle, Snodgrass, and Devore of the Giants, and Max Carey of the Pirates as the "Creators of this terror on the paths." Where was Red Murray? During that three year span, Red pilfered 143 sacks, second only to Bescher's 217, and far surpassing Allen's other "greyhounds."

During his prime with the New York Giants Murray was arguably the top NL right fielder. He assumed even more importance to the Giants, while producing RBIs as their clean-up batter. From 1909–1912 he ranked third in the N. L. in total RBIs, trailing only Future Hall of Famer Honus Wagner and Sherry Magee. Murray and Wagner had the most Major League home runs (21) from 1907 through 1909. Murray's home run title in 1909 was achieved with only seven round trippers, but he hit .046 of the league's 151 homers for a much higher percentage than Roger Maris achieved in 1961 and nearly as high a percentage as Barry Bonds had when he hit 73 homers in 2002 (Barry hit .0247 of the National League's home runs in 2002. Multiplying that by two because there are now twice as many National League teams would put Barry's percentage at .0494).

Murray played for the irascible John McGraw. One story oft reported told of a time that McGraw ordered Murray to lay down a sacrifice bunt. The independent thinking Murray instead hit a home run. As the story goes, McGraw became so irate at this refusal to follow orders that he fined Murray $50.

Since 1900, only 13 players have finished in the Top Five in Major League Home Runs and Stolen Bases in the same season. Willie Mays (1955) and Hank Aaron (1963) are the only players to accomplish this feat in the past 70 years. Only three men did it twice: Honus Wagner (1907 and 1908); Red Murray (1908-1909); and Ty Cobb (1909 and 1910). This is a true power-speed number.

Murray possessed one of the most powerful National League throwing arms. Writing in *Baseball Magazine,* in April of 1924, J.C. Kofoed said, "My general recollection of the powerful whipped National League outfields of the comparatively recent past was that (Mike) Mitchell, (Red) Murray, and Owen Chief Wilson were equipped with about as powerful arms as anyone in the league." Red led the NL in assists in 1909 (30) and 1910 (26). He was second in 1913 (24); third in 1907 (25); and fourth in 1908 (22). From 1907 through 1910, he was the only Major League outfielder to accumulate more than 100 assists. On September 10, 1913, Pitcher George McQuillen hit a "single" to right field. Murray threw him out at first base, erasing the sure base hit. Coincidentally, Joe Dode Birmingham, Red's childhood and lifelong friend from Elmira, had one of the strongest throwing arms in the American League at this same time.

When Red was patrolling right field in the Polo Grounds, the press often called the area "Murray Hill." On August 16, 1909, Murray made a game-saving catch, called the greatest in Forbes Field history. It occurred only seven weeks after the opening of the Pirates ballpark. Christy Mathewson was pitching the late-season game between these pennant contenders. Heavy thunderclouds threatened throughout the game. At the moment of the leaping fingertip catch, blinding lightning lit up the sky and "the accompanying crash of thunder fairly jarred the earth." John McGraw called the catch the "greatest and most dramatic" he ever saw. The catch was later featured in "Ripley's Believe it or Not."

CONNIE MACK LETTER. During World War II, Red Murray volunteered his services in several capacities to assist the war effort. Among the many letters of support he received was this one from Connie Mack.

AMERICAN BASE BALL CLUB
OF PHILADELPHIA

TWENTY-FIRST STREET AND LEHIGH AVENUE

February 25, 1943

TO WHOM IT MAY CONCERN:

I have known John J. Murray for many years and know that he possesses all the fine qualities that make the real gentleman. He has always borne a splendid reputation and his character is above reproach.

I take great pleasure in recommending him for any position he may be seeking.

Sincerely yours,

Connie Mack

CONNIE MACK.

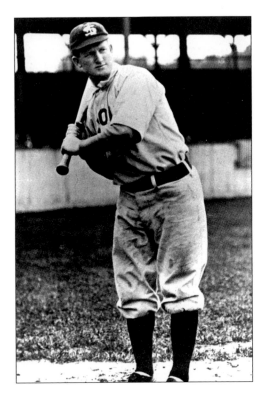

RED MURRAY. Murray as he looked in his St. Louis Cardinals uniform.

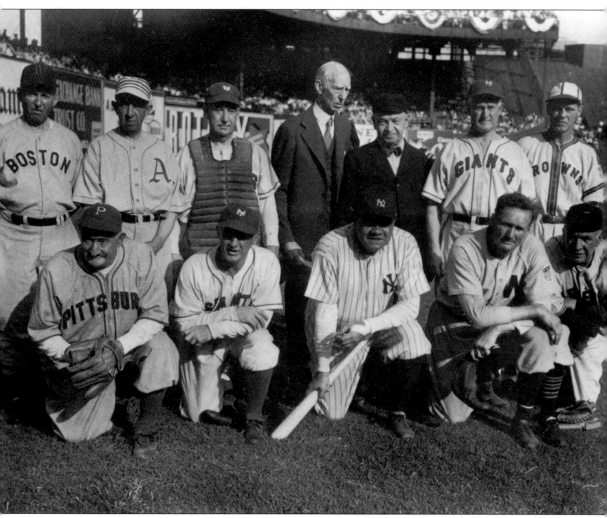

RED MURRAY AND ALL-STAR TEAM. On Thursday, August 26, 1943, Red Murray was in the greatest lineup baseball had ever seen. The Polo Grounds was the site of a War Bonds baseball game. More than 40,000 fans came out to see some of baseball's greatest stars play an exhibition game. Eight hundred thousand dollars was raised at the game. In the front row, from left to right, are: Honus Wagner, Frankie Frisch, Babe Ruth, Walter Johnson, and Tris Speaker. In the back row, from left to right, are: Harry Hooper, Eddie Collins, Roger Bresnahan, Connie Mack, Bill Klem, Red Murray, and George Sisler. Everyone in the photo except Murray is a member of the Baseball Hall of Fame.

In his seven years as a regular Murray 16 times led his competing NL outfielders in RBI, HR, Assists, and/or Stolen Bases. J.C. Kofoed said: "Red Murray was for years noted as one of the greatest outfielders in the National League. His throwing arm was the best ever, his ground covering ability and sureness of eye were classic. Furthermore, he was remarkably fast as a base runner, and . . . noted as a batter as well."

In 1911, New York Giant fans presented a "Happerson Jack Rabbit" automobile to Murray, in appreciation of his play. Red's mechanic and driving instructor was the legendary Barney Oldfield. Unfortunately, Red went hitless in 21 at bats against the Philadelphia Athletics in the 1911 World Series causing criticism from the New York press. Irving Howe, AL Statistician, noted Murray rebounded well and "made Lajoie jealous" in 1912. Red also made seven putouts in game seven of the 1912 World Series, including two that were described as "spectacular."

In 1916, Murray was coaxed out of retirement to play for Toronto, of the International League. Toronto was managed by Red's childhood pal, Dode Birmingham. Red ended his Major League career with some pinch-hitting appearances with the Giants in 1917.

Murray subsequently owned and operated a battery and tire store for two decades, served as a Democratic Alderman for three years, and was the recreation director for Elmira, NY for 18 years. In 1950 he was voted Elmira's greatest baseball player of the half century.

Murray and Birmingham were among the first group inducted into the Elmira Baseball Hall of Fame, in a 1961 ceremony held at Dunn Field. Murray died of leukemia after a short illness, in 1958. His obituary ranked him "with Mel Ott as one of the two greatest right fielders in New York Giant history."

Red's pal Dode had his own highlights. He scored the only run in perhaps the greatest game ever pitched. On October 2, 1908, Future Hall of Famers Addie Joss and Big Ed Walsh were locked in a scoreless duel. Dode, who had good luck against Walsh, blooped a single to center. He was nearly picked off first, but continued to second and slid in safely for a stolen base. When the ball caromed off his shoulder, he moved to third. Birmingham then distracted Walsh by taking a long lead off third. When Walsh uncorked a wild pitch, Dode scored the game's only run and Joss had the first "perfect game" of the 20th Century.

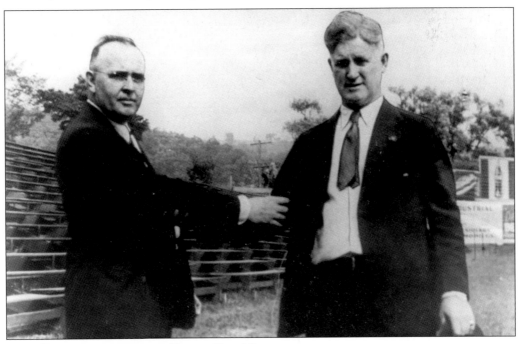

DODE BIRMINGHAM AND HIS FRIEND RED MURRAY.

While his friend Murray was gunning down runners in the National League, Dode was doing the same in the American. He finished second, to Ty Cobb, in assists in 1907 and 1908, with 28 and 20. He had 15 in 1909 and 24 in 1910. Only Cobb had more American League assists in that four year period, although Cobb played in many more games than the injury-prone Birmingham.

Dennis VanLangen located a notation about a throw Birmingham is alleged to have made in Sportsmans' Park, against the St. Louis Browns. Allegedly, Birmingham, with an "arm of steel" gunned down Bobby Wallace, trying to score on a sacrifice fly, with a 370-foot throw to the plate on the fly. According to VanLangen, the throw was so spectacular that the game was stopped so a tape measure could be brought out to measure the distance.

Always a brainy player, Birmingham served as an "advisor" to Manager George Stovall, in 1911. He received two votes for League MVP in 1912 despite hitting only .255. Near the end of the 1912 season, Dode was named Manager, the fourth manager in two years for "the city of dead hopes for base ball managers" (*The Sporting News*). At 28, he remains the third youngest man to manage in the American League (behind Roger Peckinpaugh and Lou Boudreau). He piloted Cleveland to a 21-7 record to finish the season, including seven wins in eight games against the Athletics and Red Sox, the World Series Champions of the past and current season. Dode also added speed to the defensive lineup and at the top of the batting order, dropping Lajoie down a spot.

He also won an argument with Charles Somers, Team President, to begin training camp in Pensacola (FL) one week earlier than usual for 1913. He reduced by a dozen the number of players he took to camp, to have more time with fewer players, to get them in shape and familiar with his coaching. He led them to a third place finish in 1913, earning himself considerable acclaim.

Among his innovations was the "safety squeeze" bunt, which he called the "bunt and run." He perfected the play with himself at the plate and either Joe Jackson or Ray Chapman on third.

Birmy also was an early proponent of a base running maneuver which took advantage of first basemen he perceived as "thick skulled." With runners on first and third, and the right Neanderthal on first, Dode would have the runner on first take a long lead drawing a throw. While the non-scholar first baseman was chasing the runner toward second, Dode would have his man on third streak for the plate. Contemporary accounts named Larry Rossman and Babe Borton as two first sackers with the requisite aptitude.

He became most famous for benching the great Nap Lajoie, the future Hall of Famer (and former Manager) for whom the team was now named. Birmingham could not sustain his fast start, and after a dismal 1914, he was fired early in the 1915 season. At this time, Major League Baseball was in the midst of legal battles with players who bolted to the Federal League and did not honor their American or National League contracts. After his firing, Birmingham sued Cleveland, claiming he had an "ironclad" contract. The result of this suit is not known but it was reported that his job as Player Manager for Toronto was partly to salve his feelings.

Dode was a player manager for several years in the Minors, winning the 1919 Eastern League Pennant with Pittsfield. He scouted for the Indians. He touted William Hallahan, from nearby Binghamton. Rebuffed in this recommendation, he quit on the spot. He later became only too happy to point out the Major League success (102 wins) of Wild Bill Hallahan, who was signed by the St. Louis Cardinals.

Harry Albert Curtis came to Notre Dame to play football. On October 6, 1906, Curtis gave a drop-kicking exhibition "not seen on Cartier Field since the great Pat O'Dea coached the 1900 team." Curtis reputedly hit 25 of 30 from the 45 yard line. Because of a hand injury, Curtis never suited up at fullback for the Irish gridders. In those days, there were no specialist players; even the kickers had to have a regular position.

Curtis had already been a kicking star at Syracuse, being named an All American. According to *Football Facts and Figures*, by Dr. L. H. Baker, Curtis kicked 15 "goals after touchdowns" (extra points) in a November 5, 1904, 144-0 rout of Manhattan College. Curtis was 15-17 on those kicks. He also scored two touchdowns from his fullback spot, giving him 25 points on the day. Touchdowns counted for five points in those days. This kicking performance was all the more remarkable because of the rain and snow, which made the ball slippery.

HARRY CURTIS.

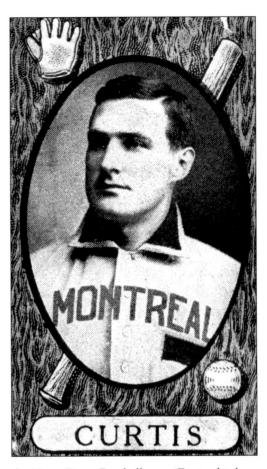

CURTIS

Curtis turned to his second sport and caught for the Notre Dame Baseball team. During his lone season (1907), he was labeled the best man Notre Dame had ever had behind the plate as well he should have been, since he had already played three years of Minor League baseball. During the 1908 season, Curtis served as the first "bench coach" at Notre Dame. The *Scholastic* described his hiring: "A bench man is what Notre Dame has needed for some time. Formerly some 'big leaguer' was engaged to coach the team, and just when he was needed most he would be compelled to leave in order to join his team on the spring training trip."

Before the 1905 season, when George Huff took the helm for the University of Illinois, no college had ever employed a bench coach. Before that time (and for another 5-10 years at most other colleges), anyone listed as "coach" was either a professional player hired as the pre-season teacher of baseball, or was the player-coach or captain of the team. In 1909, Curtis assumed the position of Notre Dame's Manager of Athletics (and Assistant Football Coach). This position was the forerunner of Athletic Director. Prior to that time, college athletics was a more informal affair, with student managers arranging schedules and making travel plans.

Boston Braves outfielder Chick Stahl was the first pro "coacher" for the Irish, in 1900. Bobby Lynch was the next pro player to train the Irish, during the 1903 season. Lynch had been the team captain in 1902, before beginning a Minor League baseball career.

Notre Dame had no pre-season coach for 1904 and 1905 and had poor records to show for it. Harry Arndt conducted the pre-season workouts in 1906. He was a logical choice, since he was the first Major League player born in South Bend. He was an infielder with the St. Louis Cardinals at the time he directed the Irish. Arndt died of tuberculosis in 1921 and is buried in Cedar Grove Cemetery, on the Notre Dame campus.

The 1908 Notre Dame team Curtis coached remains the best the school has ever produced. Compiling a 20-1 record against the top competition, they were acclaimed as the "Champions of the West." There were five future Major Leaguers on the team: Bert Daniels on first; George Cutshaw on second; Ed McDonough behind the plate; and Frank Scanlan and Jean Dubuc on the mound. All were in the Majors within two years.

On May 27, Indiana University ventured to South Bend to play for the unofficial state championship and bragging rights. A student writer of this period wrote a poem about this rivalry of the "Western" teams (the Big Ten was then called the Western Conference):

"Champions of the West"

When you come to tell the story
of the season's varied glory,
and the laurels that contributed to bristle up our crest,
don't forget the proclamation
that our baseball aggregation
won the right to wear the title of the
Champions of the West

In 1908, baseball was the biggest game at Notre Dame. Football wouldn't make a major impact until the following year, and Knute Rockne's upset win at West Point was still more than four years away. With a reported crowd of 1,200 for this baseball game, it would seem that most of the campus and many visiting fans were on the campus, since the ND student body at this time numbered less than 1,000.

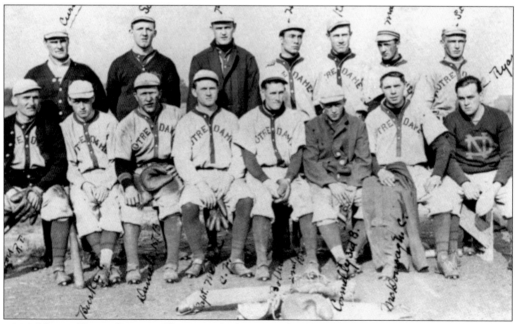

1909 NOTRE DAME SQUAD. This team had 14 members and one coach. Six of the players and the coach (Harry Curtis) would later play in the Major Leagues. Those six were Bert Daniels, Red Kelley, Clem Clemens, Ed McDonough, Frank Scanlan, and Billy Burke. On April 24, 1909, Notre Dame shut out St. Viateur's College, 4-0. St. Viateur was led by star pitcher Eddie Stack and shortstop and third batter Alex McCarthy. The year before, Kelley played for St. Viateur. McCarthy would follow him to Notre Dame in the fall of 1909.

Indiana jumped off to a 4-0 lead with a three-run third inning. Cutshaw scored Notre Dame's first run, after doubling and stealing third. He knocked in two more in the bottom of the seventh with a single, but, in the bottom of the ninth, the visitors were clinging to a 4-3 margin. Mr. D.E. Lytide, a reporter for the *Scholastic*, provided the account of what followed:

<center>"The Game of the Season"</center>

<center>

This isn't any cooked-up yarn; 'tis plain, unvarnished fact;
Twelve hundred witnesses can swear the narrative's exact.
Moreover, there's the scorecard for that now historic date
Of May the twenty seventh, in the season of Nineteen Eight.
You see there are occasions when e'en Fancy is outdone,
When fiction isn't in it with the truth—and this is one;
For poet ne'er imagined such a wild ecstatic road
As upward pealed from Cartier Field, when
Cutshaw
Tied
The Score.

</center>

<center>

The game had been an uphill fight 'gainst "Indiana State,"
The Gold and Blue had somehow failed to strike their normal gait.
Just back from conquering the East, with victory full flushed,
It surely looked as if their hopes of triumph would be crushed.
A rally in the seventh filled our rooters' souls with glee,
But till the very last our foes rejoiced in "4 to 3."
Our ninth. Two out. A man on third. Came Cutshaw to the fore;
Two strikes were called—then Bedlam bawled, for
Cutshaw
Tied
The Score.

</center>

<center>

The end came quick. Another hit; the hero cantered home,
And blasts of vocal dynamite just rocked the Golden Dome.
Well might the rooter split his throat and fling on high his hat;
He'll grow older before he sees another game like that.
The moral of the day's so clear that they may read who run;
Enduring pluck means oft in life as here, a lost game won.
Play out your game for all you're worth, though hope seems nigh death's door,
For just observe, twas steadfast never helped
Cutshaw
Tie
The Score.

</center>

Cutshaw
2nd B. Brooklyn
Nationals

GEORGE CUTSHAW.

RED MURRAY AND GEORGE CUTSHAW. The two stars as they appeared on four-inch square "blankets," premium gifts like today's baseball cards.

Burton Elwood "Burt" Keeley made it to the Washington Senators in 1908. That season featured the closest pennant races, in both leagues, in baseball history. The Tigers, Indians, and White Sox ended within 1.5 games of each other in the American League and the Cubs, Giants, and Pirates ended within a game of each other in the National. The end of the 1908 baseball season featured some amazing iron-man pitching performances. Four hurlers threw complete game doubleheaders in the final month of the season. In the American League, on September 25, Detroit's Ed Summers pitched a complete double-header win over the A's. On the 29th, Ed Walsh of the White Sox pitched a complete double-header win over the Red Sox. These wins were needed to keep their team's pennant chances alive. In the National League, on September 26, Notre Dame's Ed Reulbach of the Cubs pitched a complete double header against the Dodgers, allowing no runs, the only double-header shutout ever pitched.

The man who paved the way for the Summers, Reulbach, and Walsh games by completing the first doubleheader, on September 14, was Burt Keeley, of the Washington Senators,. He split two games with the A's. A week earlier, his teammate Walter Johnson tossed three shutouts in four days against the New York Highlanders (Yankees).

Burt's college highlight came on April 19, 1900. He pitched Notre Dame to an 8-5 win over the Columbia Giants. The Giants were the top "Colored team" of the day. It is a tribute to Keeley's pitching and the strength of the Notre Dame team that they were able to defeat such stars as Charlie Grant, Harry Buckner, and Grant "Home Run" Johnson. Charlie Grant was the light-skinned Negro star who New York Giants Coach John McGraw allegedly tried to sign for his Major League team, intending to pass him off as an American Indian.

Jean Arthur "Chauncey" Dubuc had a versatile athletic career at Notre Dame, in professional baseball, and in his post-playing years. He started in basketball. During the 1907 season, he had a 5-1 record, losing 2-1 to Minnesota. He can hardly be blamed for the loss, since he gave up only one hit and one walk and struck out 16 Gophers. He also contributed three base hits. He was one of the betters hitters on the team and often played the outfield when not on the mound. The 21-2 1907 season remains the second best record in Notre Dame history. The following year, Notre Dame improved to 20-1 and Dubuc upped his record to 8-1.

BURT KEELEY.

The only Notre Dame loss in 1908 was a 6-3 setback to the University of Vermont on the first road trip to the East ever taken by a Notre Dame team. There is an irony in this loss. Notre Dame had few students from Vermont, but Dubuc (of St. Johnsbury) was one of them. Vermont was led by future Major Leaguers Larry Gardner and Ray Collins.

This road trip was extremely significant. Until that time there was a feeling that the best teams in the East were better than their Western (i.e. Midwestern) counterparts, even though the 1902 Illinois team, led by future Major Leaguers Jake Stahl and Carl Lundgren had a similarly successful trip. Most of the media, who handed out the national honors, were located in the East. After the Notre Dame road trip through the East demonstrated that Notre Dame could play with the strongest teams in the East, a student captured the importance of these games in a poem in the *Scholastic*:

"Notre Dame and The East"

O Say, have you heard the late news, fans,
The King of the West, Notre Dame,
Has taken the East on its wagon,
And won for itself pow'r and fame.
The folks all awoke with a start, fans,
Their stock of good sense has increased;
They never quite knew
What a West team could do,
Until N.D. invaded the East.

The old N.D. team is a beaut, fans,
As loyal, as valiant, as true,
As any that e'er tossed a baseball
In the fight for the Gold and Blue.
They've won for us honors out West, fans,
And new lands and teams they have fleeced.
The world saw their light,
And the West looks more bright
Since old N.D. invaded the East.

So, cheer them, yes, shout for the team, fans;
You ought to, they merit your praise.
They're winners, they're champions always,
They've turned on N.D. the world's gaze.
Hurrah! For the Varsity squad, fans,
And lower your shouts not the least.
We love the old team,
Cheer them, fans, they're a dream,
That old team that invaded the East.

–George J. Finnigan, '10

Dubuc intended to return to Notre Dame for the 1909 season, but a Chicago news report changed those plans. Like a lot of collegians in those days, Dubuc played semi-pro ball using an alias (Lou Gehrig and Eddie Collins, two Columbia men, who would become Hall of Famers, played as Lou Lewis and Eddie Sullivan). *The Chicago Tribune* reported that the local "White Rocks" battery for the next day was going to be "Williams" and "Manning." Just in case anyone was unaware of the ruse, the *Tribune* included the correct names in parenthesis—Dubuc and Scanlan. Ray Scanlan was Dubuc's catcher at Notre Dame. Shortly after this was published, Notre Dame ruled their best pitcher ineligible. As soon as he peeled off his White Rocks uniform, Dubuc began to receive contract offers from Major League teams. He accepted the offer of the Cincinnati Reds.

In September he lost a three-hitter and a four-hitter. He beat Hall of Famer Iron Man McGinnity on September 25, while the Giants were moving to the pennant. His final game was a loss to Ed Reulbach of the Chicago Cubs. This was a fitting match. Both attended Notre Dame; each used aliases for semi-pro ball; and both had Vermont connections (Reulbach finished his college career at the University of Vermont).

Dubuc accompanied the Reds to Cuba in the off-season, winning three of four decisions. For the calendar year, he won more than 20 games as collegian, semi pro, Major Leaguer, and barnstormer. The Reds were so pleased with him that during the Spring of 1909 they sent Louis Heilbroner to scout Notre Dame with instructions to "find another Dubuc."

After a bout of malaria curtailed his next season, Dubuc was released. He turned up in Montreal, a perfect spot for the French-speaking Dubuc. He was 21-11 and opened a successful business, the Palace Bowling Alley and Pool Room.

In the off-season, the Detroit Tigers purchased Dubuc's contract. On January 20, 1912, Dubuc wrote Tiger own Frank Navin a letter declining their contract offer. In his well-reasoned letter, he pointed out that his business was going well and he could not afford the Tigers' offer of $2,250 for seven months because he made $2,200 for five months for Montreal and his business also did well. He pointed out that he would have to hire someone to run his business if he left Montreal. He countered by asking for $2,800. The exact outcome is not known, but he did begin a five-year stay in Detroit in the Spring of 1912.

He was an instant star with the Tigers, winning 17, including an eleven game winning streak, and losing only 10. On July 6, he pitched a one hitter against the White Sox, with Buck Weaver getting the only hit. A month later, he two-hit the New York Highlanders (Yankees).

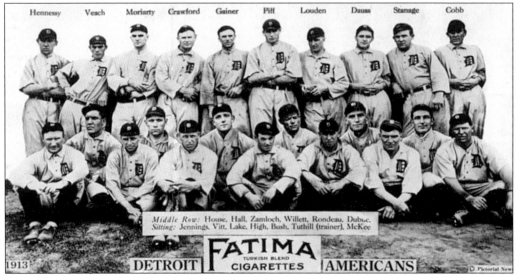

JEAN DUBUC AND THE 1913 DETROIT CLUB.

He went 16-14 the next year, losing a two hitter in July and winning a two hitter in September. On September 22, future Hall of Famers Eddie Plank and Herb Pennock combined to defeat Dubuc, 1-0, to clinch the American League pennant for the Philadelphia Athletics, on their way to the World Championship.

After the season, Dubuc pulled another bargaining ploy on Navin. He reported in November that the Paris Club of the French Union Ball League had approached him and offered a $3,000 increase and a five-year contract to be player-coach for their team. The *Philadelphia North American* reported that Dubuc was one of the few diamond stars who could say "work the corners . . . in the language of the frog absorber."

On January 20, 1913, the Detroit papers reported that Dubuc spurned Navin's offer of $4,000. Navin's public reply was "The Detroit club is not a mint . . . the salaries our stars are trying to get from us are entirely out of the question." It was also reported that Dubuc was playing hockey in Montreal and planning to coach the Notre Dame Baseball Team in the spring. The financial outcome of this dispute is not known, but when the Tigers opened their new ballpark, Navin Field (aka Briggs Stadium, aka Tiger Stadium), Jean Dubuc was on the mound.

Many stories were written about Dubuc's marvelous pitching that year. F.C. Lane, Editor of *Baseball Magazine*, called him "The Slow Ball Wizard" for his mastery of the off-speed pitch: "He is without question the greatest master of this difficult art since Mathewson discovered the secret of his fadeaway." The November 1913 issue of *Baseball Magazine* featured a photo of Dubuc, wearing a tee-shirt and in his pitching motion. The photo revealed the "tremendous muscular development" of his pitching arm. Ty Cobb also spoke about Dubuc's pitching specialty in his 1914 book, *Busting 'Em*: "Home Run Baker" has great trouble in hitting Dubuc, of Detroit, because he is a slow ball pitcher."

Dubuc dropped to 13 wins in 1914, but won 17 again, with five shutouts, in 1915. After a 10-10 mark in 1916, he was released to Salt Lake City.

Because of his superb hitting, Dubuc was often used as a pinch hitter in the Majors. He was mediocre in this role (16-93), yet his batting figures while pitching were very impressive (134-559, .240). Manager Ty Cobb even used Dubuc in the outfield on five occasions in 1912 and 1913. Dubuc hit four homers in the Majors. On July 23, 1912, Dubuc was the right fielder and leadoff batter for the Tigers. Cobb batted third and played center; Sam Crawford was the left fielder and hit cleanup.

Dubuc won 22 for Salt Lake City and batted .279. The following year he was 10-10 and hit .303. The Red Sox picked him up after the Pacific Coast League ceased operations because of World War I. He pitched in only two games. His only World Series appearance, in the last World Series won by the Red Sox, was as a pinch hitter.

John McGraw acquired Dubuc for the 1919 season. The innovative McGraw made Dubuc one of the first relief pitchers. Until that time, the best starting pitchers also served as their team's "closers," for those few games which starting pitchers did not finish. Among his 36 games pitched, were 31 in relief, which led the league. He won six, lost four, and saved three (a high total for that era). He allowed only 119 hits in 132 innings, which helped him to a 2.66 ERA.

Post-season barnstorming was a common way for players and teams to make money in those days. On October 10, the Giants went to St. Johnsbury, Vermont to take on a team of local players. This remains the only time a Major League team has ever appeared in St. Johnsbury. Dubuc got the 10-4 win, over Dana Fillingim of the Braves, who was loaned to the locals for the game.

McGraw released Dubuc after the season, so he signed on with the Toledo Mud Hens in the American Association. He was a third baseman, outfielder, pitcher, and first baseman. He hit .292, won nine games, had a 2.72 ERA, and served as Team Captain and Assistant Manager to Roger Bresnahan. Roger elevated him to Manager at mid season.

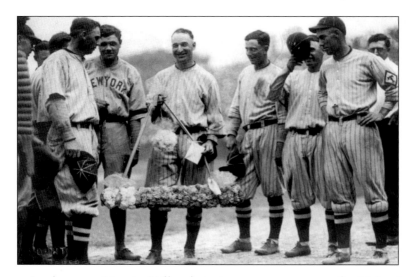

JEAN DUBUC AND BABE RUTH. As a Detroit Tiger scout, Dubuc received a bonus for signing future Hall of Famer Hank Greenberg.

In those pre-Marvin Miller days, it was very common for Major League team owners to schedule revenue-producing game when there was an off-day and a convenient opponent.

On September 15, 1920, the Mud Hens faced the Yankees, in Toledo. Despite Babe Ruth hitting two homers for six RBIs, his former Red Sox teammate came in to pitch a scoreless 10th inning and single in a run, giving the Mud Hens an 8-7 win, much to the pleasure of nearly 12,000 fans.

Eight days later, Rube Benton testified before the Cook County Grand Jury investigating the 1919 World Series. He was asked if he had seen a telegram indicating that the World Series was fixed. "Yes, I did" was his answer. "I don't know who sent it, but it came to Jean Dubuc, who was barnstorming with us. It simply said 'Bet on the Cincinnati team today'. I supposed it came from Bill Burns who had been close to Dubuc a few weeks before the Series when both were living at the Ansonia Hotel in New York City. Chase was getting telegrams, lots of them, just before and during the World Series. I didn't see them but I am sure Hal was betting heavily on Cincinnati. I couldn't go on the witness stand and swear to it but it is my belief he won as much as $20,000 on the Series."

On November 11, 1920, *The Sporting News* published an article titled "Why Dubuc was Dropped." McGraw was quoted that he dropped Dubuc after the 1919 season because he "constantly associated" with Bill Burns. According to McGraw, Burns and Hal Chase had something to do with the Giants' failure to beat the Reds in 1919. Several sources indicated that Dubuc was banned from baseball for his "guilty knowledge," but this was disproven by his later career in the Minors and his work as a Major League coach and scout.

In 1921, Dubuc played in two semi-pro leagues in Montreal, the Atwater Twi-Light League and the Montreal City Baseball League. League totals were not recorded, but Dubuc hit .386 and posted a 17-8 record in 47 games for which box scores could be located. There were several former Major Leaguers in this league, including Chick Gagnon, Ivy Wingo, Del Bisonette, and Gloucester's Stuffy McInnis.

Dubuc's final year as a player was 1926, when he was the Playing Manager of Manchester (NH) of the New England League. In limited action, he hit .311 and won two of four decisions. Clyde Sukeforth was his catcher. Fifty-six years later, Sukeforth remembered Dubuc as being the team's best pitcher, at age 37. "It was a pleasure to catch him. Marvelous control, constantly changing speeds. As a kid, I read about his 'slow ball' and on occasions it was very slow but it was thrown for effect, not to be hit. To a great extent he was responsible for present day pitching, changing speeds. Previously it was pretty much power, everything thrown hard."

After the '26 season, Dubuc was hired by Brown University as Baseball Coach. He also coached the Brown Hockey Team in 1928 and 1929. He later introduced professional hockey to Rhode Island.

Robert Henry Bescher played right halfback for the Notre Dame preps against South Bend High School on October 26, 1901. He scored one (five point) touchdown in the 11-6 win. Four years later, he was the star halfback for Wittenberg (OH) College, scoring 17 touchdowns and doing all the punting. Baseball was his first love however and he went on to become one of the greatest base stealers of all time.

He pilfered 740 cushions in his professional career. He was the only man to steal at least 67 bases in three consecutive seasons (1910-12) until Ron Leflore and Omar Moreno duplicated the feat 68 years later. Bescher also held the top three National League base stealing totals until Maury Wills established a new standard (104) in 1962.

From 1909 through 1916, Bescher finished in the top six in National League stolen bases each year. He was in the top eight in runs scored in six of those years and also in the top seven in walks on five occasions.

In 1911 Bescher received four votes for National League MVP (the same total as Hall of Famer Three Finger Brown, who won 21 games). In 1912 he finished in fifth place in the voting, far ahead of Hall of Famer Christy Mathewson, who won 23 games.

Bescher was a rare player who threw left handed and switch hit. Because he drew a lot of walks, Bescher had a good on base percentage throughout his career. He was one of the bigger players of his day and one of the fastest. Some experts rated him faster than Ty Cobb, and a superior base stealer. Bob Davids did a lot of research on caught stealing totals, which were not recorded in those days. He found that Bob's 1912 performance, with 67 steals in 77 attempts was the second best of any player in that era, behind only Max Carey's 1922 season (51 out of 53). While Bescher was nabbed only 10 times, Cobb was gunned down 34 times, with six fewer steals, during the 1912 season.

Bescher had a fine Minor League career playing nine years in the high minors after his Major League career ended. He is one of a small group of players who had more than 1,000 hits in both the Majors and the Minors.

On April 10, 1918, the *Louisville Courier Journal* described Bescher: "He has always been…a hustling ballplayer. He is a whirlwind on the base paths . . . as a fielder he has no superiors."

ROBERT BESCHER.

Arthur Joseph "Tillie" Shafer showed his first baseball potential in 1904, for the St. Vincent's College Saints. He hit a three run homer, which might have defeated Santa Clara for the California Inter-Collegiate Championship, were it not for the hitting and fielding of Hal Chase of the Bronchos. Chase would go on to have one of the most controversial Major League careers, alternately being a good hitter, base runner, manager, and exemplary fielder, as well as being arguably the most crooked player in the game's annals. One of Shafer's teammates with St. Vincent's was Fred Snodgrass, then a catcher, but an outfielder later when he was a Giant teammate of Shafer.

After two years, with the Saints, Shafer went to Notre Dame, at the urging of his parents. He tried out for the football team, but quit, after having his bell rung in the first scrimmage, according to his son, Art. He was a sprinter and broad jumper in the fall. After leaving Notre Dame, before the baseball season ("it was too cold"), Shafer headed back to his home state to attend Santa Clara. Shafer would also spend some time at Stanford.

John McGraw signed Shafer, after spotting him in a college game. In February, 1909, Shafer headed off to Marlin Springs, Texas for Spring Training with the Giants. A Los Angeles paper described him as the All American boy-type: ". . . he is possessed of so much confidence. He is entering the game more for the love of play than financial returns, as he is the son of wealthy parents. Shafer is a fine type of the young ball player, with striking physique and a natural nose for the diamond. He has never been known to touch tobacco or liquor and enters upon a professional career in great physical condition."

Shafer was handsome like a matinee idol and often received scented notes from admiring female fans. According to legendary baseball historian Fred Lieb, this led to the nickname "The Pink Notes Kid." Possessing what was then called "good breeding" was quite a contrast to the semiliterate, brawling types who predominated on many of the ball clubs of that time. One of the Giants of that rough and tumble school was Cy Seymour, who promptly nicknamed Shafer "Tillie." Ladies nicknames were often given to players thought to be too handsome or genteel. This nickname stuck with him throughout his Major League career.

To the astonishment of most of his teammates, Tillie did not engage in the wild life style that his looks, fame, and money would have provided.

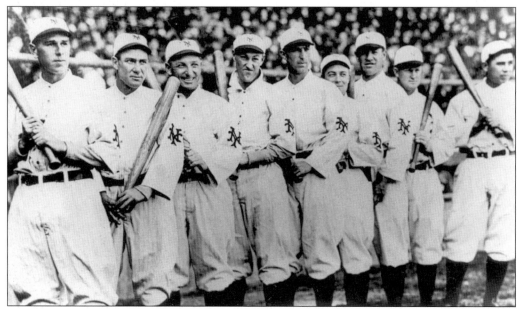

TILLIE SHAFER WITH GIANTS. Shafer is sixth from left, Jim Thorpe is behind him, and Red Murray is next.

Shafer had a prominent role in Japanese Baseball history. The first team of American professional baseball players to travel to Japan was the 1908 Reach All American Team. In the summer of 1908, he was on the Santa Clara College Baseball Team which defeated Keio University, 9-4, in a game played in Hawaii. Shafer was the shortstop and cleanup batter for the Bronchos. Three years later, Keio planned to make a tour of the United States. In preparing for the trip, Keio wanted some American coaching. They hired Shafer, the New York Giants top sub, and Fuller Thompson, his boyhood friend, who would make a few appearances with the Braves after returning from Japan, making Shafer the first Major Leaguer to travel to Japan to coach baseball.

According to Yoichi Nagata, esteemed historian of Japanese baseball, the two men from Los Angeles arrived at Yokohama port on December 24, 1910. They coached the team at the Kobe Higaski Yuenchi grounds, located near Sannomiya Station in Kobe, from December 27 through January 18. What the two taught was made into a book, *The Art of Keio Baseball*, which was handed down for generations among Keio players, who understood that they were being taught John McGraw's scientific baseball, through Shafer and Thompson. Shafer was amused that his pupils took great delight in learning to shout and yell like Big Leaguers. A Keio player commented, "We respect them as sportsmen and gentlemen, nourished by baseball." Ironically, Shafer's gentlemanly demeanor would be the cause of his sudden and early departure from the Majors.

During the U. S. Tour, one of the losses suffered by Keio, was to Notre Dame, 9-5, on June 6, 1911. The game account in the *Scholastic* was headlined "Notre Dame Beats Japs," with a sub head of "Oriental Ball Club Displays class at American Game." Perhaps Shafer was responsible for the observation that "The Orientals displayed a knowledge of the American national pastime that surprised the local fans. They showed the effects of careful coaching and training and played one of the best games seen on the local lot this season" . . . and "Stellar base running was not out of their line either and many of them used the hook slide to perfection. The visitors had the drop on the protégés of Coach (Red) Kelly, in the coaching department."

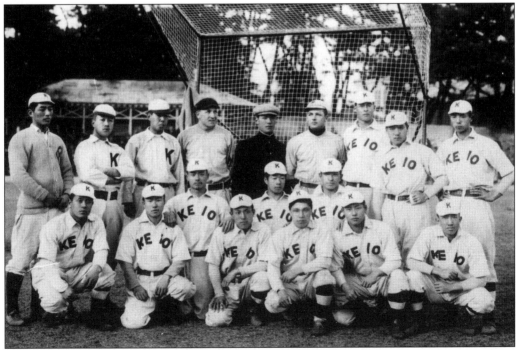

TILLIE SHAFER (STANDING, FOURTH FROM RIGHT) WITH KEIO UNIVERSITY TEAM.

ED McDONOUGH.

After taking off the 1911 season, Tillie returned to the Giants for 1912. He played all over the diamond, primarily subbing for Art Fletcher at short. He hit a solid .288 and stole 22 bases for the pennant-winning club. McGraw was convinced that Shafer was ready for a starting role for 1913, but the Giants were too talented for him to replace anyone. He spent the year splitting time at third with Buck Herzog, backing up Larry Doyle at second and Fletcher at short, and also filling in for his old buddy Snodgrass in center field. Despite having no regular position, Shafer batted 508 times, led the team in walks, tied for the team lead in homers (5) and triples (12), batted .287, and pilfered 32 cushions. At a reported age of 24 (probably 27), he looked like McGraw's third baseman for many years ahead. This was not to be.

Shafer quit baseball for good and the Giants took a tumble, because McGraw had traded fiery Buck Herzog and now had nobody reliable at the hot corner. In a 1917 interview with the *Los Angeles Times* Shafer explained why he quit the Majors. "Christy Mathewson is one of the finest men I have ever met and he would be welcome at any time in my home. I can't say that much about many of the professional ball players whom I met." When he turned down $12,000 and repeated pleas to return to baseball, Shafer stunned baseball. "Professional baseball isn't a normal life for a young fellow and I want to live normally among the friends who take you for your worth and not for what they can use you for. Every year of baseball carried me farther from the life I liked best. So I quit."

Edward Sebastian McDonough made his Major League debut with the Philadelphia Phillies three days before his Notre Dame teammate, Dreams Scanlan. As good as Ed was, he was not the first team catcher on his own college team. Ray "Dike" Scanlan was the first team catcher. After the 1909 college season, Ray was selected as the catcher on the All Indiana College All State Team; Ed was the second team selection. During 1913, each caught in the New York State League and faced each other when Syracuse (Dike) and Albany (Ed) met.

Ed played for one year (1912) with Chicago of the United States League, which tried to establish itself as a third Major League. Meticulous research by Frank Phelps credited McDonough with a .340 batting average for that season. McDonough was a Playing Manager in the New York State League from 1913 to 1915.

Frank Aloysius "Dreams" Scanlan was one of the greatest hurlers in Notre Dame history, posting a 19-3 record (.864), with 22 complete games and seven shutouts, from 1907-09. Dreams was from a baseball playing family. His older brother, William "Doc" Scanlan, was one of the Brooklyn Superbas (who had not yet acquired the name "Trolley Dodgers") top pitchers of the first decade of the 20th century. Ray "Dike" Scanlan was Notre Dame's top catcher at a time when one back-up, Ed McDonough, was a future Major Leaguer and a second back-up, Clem Clemens, was moved to the outfield so he could get some playing time. Dike had a short Minor League career. Younger brother Ambrose, was also a pitcher, but was not able to break into the Notre Dame rotation and had only a brief Minor League trial.

Dennis D. Scanlan, the father, owned an ice packing plant. The boys all worked chopping and hauling ice, for which they attributed their arm strength. Like many star college players of the time, Dreams Scanlan played some semi-pro ball, for a Gary steel mill, using the alias "Brophy." Ray used the alias Ray Wilson when he played for Providence of the Eastern League, in 1909. Ray also used the alias Manning, when he played for the "White Rocks" in the Chicago Park Leagues. Ray was the top athlete in the family, playing end on the Notre Dame football team and forward on the Irish basketball squad in addition to his backstopping.

THE SCANLAN FAMILY, WITH AMBROSE AND DREAMS IN THE BACK AND DOC AND DIKE IN THE FRONT.

Scanlan and Jean "Chauncey" Dubuc were probably the top one-two punch in Notre Dame Baseball history. During the 1908, 20-1 season, Scanlan (10-1) and Dubuc (8-1) accounted for 90 percent of the teams' wins. Scanlan's ten wins were not bettered by a Notre Dame pitcher for another 80 years, despite much longer seasons.

Writing in the May 9 issue of the "Notre Dame Scholastic," George J. Finnigan, '10 captured the strength of the two hurlers:

"Our Twirlers"

When "Chauncey" twirls, there's joy at Notre Dame,
There's ne'er a doubt that we will win the game;
No matter what the team, it's all the same
When "Chauncey" twirls.

When Scanlan twirls, the visitors look sick;
They shake with fear when they take up the stick;
They go to bat, but sit down mighty quick
When Scanlan twirls.

JEAN DUBUC.

BILLY BURKE.

William Ignatius Burke made a big impression on the baseball reporter for the *Scholastic* when the 1909 season was reviewed. "Billy Burke was the matinee idol, with the classy form he injected about a kilowatt of energy into the sphere and sent it to the backfield, describing cubical parabolas and arched epicycloids of such intricacy as would have made the spiral Archimedes look like a straight line." We can assume that Billy had a great curve ball and that this student writer excelled in engineering classes. Burke came to Notre Dame after first playing a year for St. Charles College and then Seton Hall.

The left-handed Burke pitched an astounding five shutouts and picked up a save during his lone season at Notre Dame. His first six games, covering 38 and one third innings, yielded only 17 hits; six walks; and no runs. He fanned 49. His consecutive scoreless streak reached more than 42 innings, before Minnesota touched him for a run on May 28.

Billy's best pro season was 1911, when he pitched for the Montreal Royals of the International League. He won 16 games, pitching an iron-man 288 and a third innings in 43 games. The staff ace was Jean Dubuc, who preceded Burke at ND by one year. Dubuc pitched 263 and two thirds innings in 38 games, winning 21. They were handled by Harry Curtis, Dubuc's Notre Dame catcher and Burke's Notre Dame coach.

Alexander George McCarthy fashioned a nice Major League career as a utility infielder with the Pirates and Cubs. He was first spotted by Notre Dame when he played short for St. Viateur College. McCarthy transferred to Notre Dame, along with teammate Red Kelly. When the Notre Dame varsity played two practice games with the South Bend Bronchos, the local pro team pirated Alex off the squad. He was "abducted" according to the student writer in *The Dome*, the Notre Dame yearbook.

Alex immediately outplayed the incumbent shortstop, forcing Maximillion Canarius to the outfield. At the end of the season, both men were with the Pittsburgh Pirates, with Alex playing short and future Hall of Famer Max Carey, with a more pronounceable name, playing the middle garden. In McCarthy's three games with the Bucs, he played short, with Honus Wagner moving over to first base.

McCarthy's best season with the Pirates was 1912 when he hit .277 as the regular second baseman. In those days, Honus Wagner was the best player in the National League and on the way to becoming the All Time Major League shortstop. Alex has a key link to the Flying Dutchman. From 1903, when he first became a regular at short, until the end of his career, in 1917, Honus Wagner saw 48 different players spell him at shortstop. With 98 appearances, McCarthy was far and away the #1 relief man for the greatest shortstop the game has ever produced.

After his Big League career ended, in 1917, McCarthy played 10 more seasons in the high minors, primarily as a third baseman. He managed for three seasons, winning the Three I League pennant, with Springfield (IL), in 1926.

Upon the death of Wagner, in 1955, McCarthy spoke glowingly of his former teammate. "So many athletes are admired for their ability alone, but not as men . . . it wasn't so with Honus. His character and morals magnified his great ball playing. I was 15 years younger than Honus and some of the favors he did for me I'll never forget."

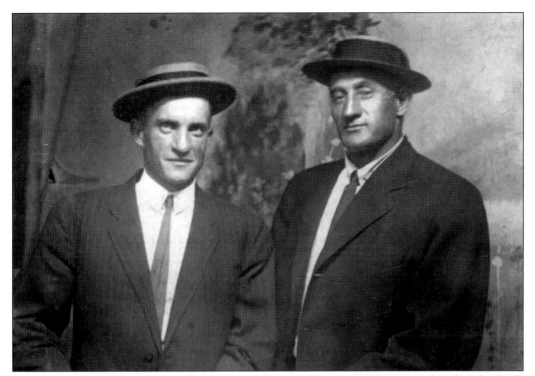

PIRATE SHORTSTOPS ALEX MCCARTHY AND HONUS WAGNER. Wagner tied with Babe Ruth for second-most votes, behind Ty Cobb, at the initial Hall of Fame induction. Wagner is generally considered the greatest shortstops in the history of the game. Wagner's baseball card is the most valuable of all. He did not want his image used to promote smoking to children, so he demanded that his card be discontinued. As a result, few remain in circulation.

Notre Dame has some fine shortstops in its history. Harry Durkin led the Irish in homers (with four) in 1951 and had a fine Minor League career before becoming a prominent attorney. Harry donated his time as the attorney for the Association of Professional Ballplayers of America, a group dedicated to helping former players who come upon hard times. Harry was usually the most loquacious member of his class, unless Regis Philbin was in the room.

Tommy Carroll came along right after Durkin. Pat Pesavento and Paul Failla came to Notre Dame as quarterbacks but earned their fame at shortstop. Craig Counsell has become the most successful Major Leaguer of the former Notre Dame shortstops. J.R. Brock, the grandson of a Major League catcher, and Alex Porzel starred for the Irish in the 1990s.

Despite all this, however, the Notre Dame shortstop who contributed the most to Notre Dame was John Shea, of Holyoke, Massachusetts, the starting shortstop for the 1905 and 1906 teams. He wrote the words, and his brother Mike wrote the music for the "Notre Dame Victory March." John later became a Massachusetts state senator, and Mike became a parish priest.

THE 1947 PHILADELPHIA ATHLETICS. Earle Mack (son) is in the front row, fourth from left, next to his father, Connie Mack (in his trademark suit).

Earle Thaddeus Mack (born as McGillicuddy), spent a few months at Notre Dame before following his father, Connie, to the Major Leagues. His first Major League appearance (October 5, 1910) was catching future Hall of Famer Eddie Plank in a complete game, getting a single and triple in four at bats. He later was a two-game sub for future Hall of Famer Home Run Baker at third base. He also spent several years as a Minor League player and Manager, winning two pennants. As a Minor League Manager, Earle discovered, and sent to his dad's team, Cy Perkins (of Gloucester) and Jimmy Dykes.

In 1924, Connie felt that the time was right for Earle to become a Coach with his Philadelphia Athletics. Twenty years later, Connie told the Associated Press that Earle would succeed him, "Earle is going to be the next manager of the Athletics, if they ever have one, and he'll probably do a better job than his dad." One of Earle's later claims to fame was being "benched" as Assistant Manager by his dad for being "too old." Earle was 55 and Connie was 82! Earle was succeeded by his protégé Dykes.

In November 1954, 92-year old Connie Mack sold the team he brought into the fledgling American League in 1901. At the conclusion of the sale, to Chicago businessman Arnold Johnson, Earle Mack was reported to have left the meeting in tears.

There was impressive political blood in the Mack family. Connie Mack, Jr. married a beauty who was the daughter of United States Senator Morris Sheppard. When Sheppard died, in 1941, he had served 39 consecutive years in Congress. Connie, Jr. had eight children. Connie III, the only one who used the Mack name, later became a prominent U.S. Senator from Florida.

George William Cutshaw was voted by SABR as the top defensive second baseman of the 1910–1919 decade. Cutshaw earned this honor over such luminaries as Johnny Evers and Larry Doyle. George led National League second baseman in one of the five primary defensive categories on 18 occasions, 12 better than the middleman of Tinker to Evers to Chance. His .980 fielding percentage in 1919 ranks among the top marks of that half century.

Charles F. Faber rated Cutshaw as the fifth best defensive second baseman in National League history, trailing only Bill Mazeroski, Red Schoendienst, Manny Trillo, and Frankie Frisch. Faber credited Cutshaw with the top defensive mark for any National League fielder during 1914, 1915, and 1918. Faber's statistical analysis also proclaimed that Cutshaw's 1915 season was the 7th best National League defensive performance of all time, regardless of position.

George played briefly for Anson's Colts during 1909. On April 13, he was the leadoff batter for the Colts, with his 57-year-old manager batting cleanup, in an exhibition game against the New York Giants. Shafer was at second, batting second, with Murray in right, batting third, for John McGraw's team.

During 1911, Cutshaw was selected the Pacific Coast League's All Star second sacker. He led the league with 89 stolen bases. This performance in the top Minor League earned him a trip to the Brooklyn Superbas. George starred at second for Brooklyn for the next six seasons.

Initially he batted second in front of future Hall of Famers Casey Stengel and Zach Wheat, but later he batted cleanup behind Wheat and in front of Stengel. From 1913 through 1917, Cutshaw produced nine more runs than Wheat, his more acclaimed teammate. Cutshaw was also slighted in comparison to first baseman Jake Daubert, in 1913. That year, Daubert won the Chalmers Award as the National League's most valuable player. Daubert won the award on the strength of his league leading .350 batting average, but Cutshaw tallied six more doubles, six more triples, five more homers, 28 more runs batted in, and 14 more stolen bases. Daubert had four more runs scored. Cutshaw also played the more difficult position.

On August 14, 1913 Cutshaw hit two inside the park home runs against the Chicago Cubs. He won the 1916 game, which clinched the pennant for Brooklyn. He hit "what should have been an ordinary single to right field. The ball rolled out to the bottom of the wall and then acted as though it had sprouted monkey glands. It began to climb upwards, unbelievably as that sounds. Just as it reached the top of the wall, it teetered momentarily and then lazily toppled over the fence for a game-winning homer."

On January 8, 1918 Brooklyn traded Cutshaw and Stengel to the Pittsburgh Pirates for future Hall of Famer Burleigh Grimes. Grimes later became known as the last Major League pitcher grandfathered to throw the spitter, after the pitch was outlawed.

During his 12 Major League seasons, Cutshaw, called "brainy," excelled at the hit and run and base stealing, in addition to fielding. He stole home six times. Prior to the home run era ushered in by Babe Ruth, the sacrifice bunt was a big offensive weapon. Even middle of the order batters would bunt runners over. Batting statistics in the Sunday papers would list sacrifice bunts but not home runs. Cutshaw led the National League in sacrifices with 37 in 1920. George also led the National League in fewest strikeouts in 1914, 1916, and 1918. He played all of his team's games in 1915, 1918, and 1919.

Baseball Magazine was one of most authoritative baseball publications during the first half of the 20th Century. For a number of years, they selected an "All-American" Baseball Team. Made up of Major Leaguers, in the days before the All Star Game, this would equate to today's version of league all-star teams. Cutshaw was selected to the First Team in 1918 and second team (to Rogers Hornsby) in 1921.

George finished his Major League career with the Tigers in 1922 and 1923. Manager Ty Cobb called Cutshaw a "master of the position . . . he worked unceasingly with the other infielders . . . George was simply great, in ways that didn't show to the fans and sportswriters." Cutshaw worked as a San Diego citrus grower when his playing career ended. His son, a physician, said that everyone agreed his dad was a "great guy to be around." Dr. Cutshaw said the happiest days of his youth were spent hanging around Ty Cobb and the other Tigers while serving as a bat boy for his dad's team.

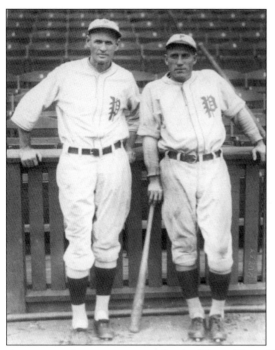

CY WILLIAMS AND TEAMMATE CHUCK KLEIN. Klein was a Hall of Famer who supplanted Cy as the Phillie's top slugger.

Fred "Cy" Williams was born in Wadena, Indiana in December of 1887. He was a tall slender farm boy when he went to Notre Dame, in 1908. He excelled in athletics at college, winning letters in track and playing back-up left end for the 1910 Notre Dame Football Team. A June 5, 1915 story in the *South Bend Tribune* stated that Williams had bypassed an opportunity to compete in the 1912 Stockholm Olympics, as a hurdler and broad jumper and was "said by many competent judges to be the fastest runner in the national game."

It was in baseball, however, where Williams made his name. His long hurdlers-stride served him well as a center fielder. "Daddy Longlegs" was what one wag called him. With a big sweeping swing he achieved a lot of home run power. Around the turn of the century, it was customary for the Notre Dame Baseball Team to play exhibition games against Midwestern Minor league and Major League teams. During one such exhibition, with the Chicago Cubs, Cy attracted the attention of Cub management. After graduating from Notre Dame with a degree in architecture Cy went immediately to the Cubs.

Cy's first three years were uneventful, but during 1915 he played regularly and slugged thirteen home runs. Cy was also a superb fielder, touted by Joe Tinker and John McGraw as among the best in the game. In 1916, Williams tied for the league lead in homers, with twelve.

The Cubs were not convinced that the gangling left-handed performer was what they needed to rejuvenate their sagging fortune so they traded him to the Philadelphia Phillies, for Dode Paskert, after the 1917 season. Paskert was nearly washed up and this trade became one of the worst in Cub history. In 1920, Cy found his groove as a hitter. He belted fifteen home runs to take the league lead and hit .325. He followed that up with three hundred seasons in five of the next six years and double figures in home runs for nine years in a row. This was quite a feat in an era when the home run was just being discovered.

In 1923 Cy had his biggest year with forty-one home runs and 114 RBIs. This led the National League and tied Babe Ruth for the Major League lead. That performance also enabled Cy to take over the National League career home run record (from Roger Connor). Cy would spend the next six years second only to Ruth on the career home run list.

Cy was an effective performer in the outfield as well, with a league leading twenty-nine assists in 1921. Although he was near the end of the trail in 1927, at age 39, he still managed 30 home runs to go with 98 RBIs as he tied for the home run title. The remaining Phils managed only 27 homers, as Cy hit more than half of the team's home runs. Cy's pull swing was very well suited to Baker Bowl's short right field.

Cy was such a dead pull hitter that National League managers recognized the best defense would be to play him extremely deep and around toward right field. His obituary in *The Sporting News* quoted Bill McKechnie as saying "I can't remember seeing him hit to left unless it was by accident." Williams himself was quoted as saying "I couldn't hit a ball to left if my life depended on it." For him was born the first "Williams shift." More than twenty years later, this term would be made a household word when Lou Boudreau developed a similar maneuver to defense Ted Williams.

According to a diagram in *The Sporting News* the shift for Cy Williams featured the third baseman playing near the shortstop spot, with the other three infielders on the right side of the infield. The left fielder played a normal center field position, with the center fielder playing right center and the right fielder on the line.

Cy was the National League record holder for career home runs (251) until passed by Rogers Hornsby during the 1929 season. Cy held the National League left-handed home run record until it was broken by Mel Ott. Ott and Cy Williams remain the only home run champions who did not play in the Minor Leagues before winning their titles.

An oddity about Williams' career was that he served under fourteen different managers in his first fourteen years in the Major Leagues, a record which will be very difficult to surpass. Among his managers was the entire Chicago Cubs Tinker to Evers to Chance double-play combination.

During his final three seasons in the major leagues, Cy was one of the top pinch hitters in baseball. He held the career pinch-hit home run record (11) from 1928 until surpassed by George Crowe during the 1960 season. Cy hit seven grand slams; five extra-inning homers; and 17 homers after the age of 40. He had 20 two-homer games. From 1916-1927, Cy finished in the top three in National League homers 11 times. For many years, Cy held the National League record for the most home runs in May (15) and through the month of May (18). He hit 15 home runs in the first 23 games of May, 1923. *Baseball Magazine* selected Cy Williams as a First Team "All American" in both 1915 and 1916.

After retiring from the Major Leagues, Cy spent the 1931 season as the player-manager of Richmond (VA) of the Eastern League. The next year he returned to his several-hundred acre farm in Wisconsin where he served as an architect and in the construction business. Ted Williams told this writer that he often hunted and fished with Cy and found him to be a "great gentleman." When I told Ted that it was reported that Cy was unable to hit a ball to left field, Ted replied, "What makes you think I could!"

Some of the finest buildings in the Upper Peninsula of Wisconsin stand today as a tribute to the architectural capabilities of Cy Williams. According to his obituary in the *Vilas County News Review* Cy pioneered the resort business in his area and also operated a dairy farm. Ironically, while he was a left-handed athlete all the way, he was a successful artist as a right-hander. On July 24, 1966, the city of Three Lakes, Wisconsin, dedicated Cy Williams Park, not far from the Lake Terrace Estates resort development created by the Williams Construction Company.

ROGERS HORNSBY AND CY WILLIAMS. These players were the two most feared National League home run hitters of the 1920s. During the 1929 season, the Rajah passed Cy for the National League career home run record.

BERT DANIELS.

Bertram Edward Daniels was a turn of the century "tramp athlete" who used his athletic ability in football and baseball to play college ball for three colleges over six years and earn a degree in engineering. Prior to attending college, Bert also played semi-pro sports for four years.

When he was first spotted by New York Highlanders' (Yankees) scout Art Irwin, Bert was described as "the next Ty Cobb," because of his hitting, base running, and fielding. Alas, Bert was in his late 20s and all the football he had played had taken a toll on his body. In spite of this late entry into the Majors, Bert still had a productive four year career. Bert's rookie year with New York was 1910. He was the first sub outfielder. He earned a starting slot for 1911. Those two seasons saw the Yankees run wild on the bases, with their 288 steals in 1910 still standing as their all time record, and the ninth best team total of all time. Despite being a part-time player, Bert led the team in steals with 41, one more than player-coach Hal Chase, noted for slick fielding and skullduggery.

After four years in New York, Bert was released to Minor League Baltimore. On April 22, 1914, he was playing right field when a young local pitcher named George Herman Ruth made his professional debut. According to Ernie Lanigan, in *The Baseball Cyclopedia*, there were only 200 fans present for this game, owing to competition from the Federal League. Bert and The Babe each went 2-4, as the Babe defeated Buffalo, 6-0. Bert holds the American Association for triples in a season, with 28, for Louisville, in 1915.

Bert's primary claim to fame was being one of the top players at getting hit by a pitched ball. This held true for semi pro, college, the Minors, and Major Leagues. In the history of Major League Baseball, only Ron Hunt was hit by a pitch at a greater rate than Daniels. Hunt's ratio of HBP/games played was .144. Daniels ratio was .138. The only other players with ratios above .100 were Don Baylor (.118) and Minnie Minoso (.104). On June 20, 1913, Washington Senator pitchers bruised Bert three times. This is the American League record for a doubleheader.

On ten different occasions, Bert was hit by a pitch twice during the same game. He was willing to stand in there no matter who was on the mound. Research by Alex Haas showed that the two pitchers who hit Bert the most were Walter Johnson (5) and Smoky Joe Wood (4), arguably the two hardest throwers in the American League. An oddity of Bert's specialty is that the final American League pitcher who plunked him was former Notre Dame teammate Jean Dubuc and the final National League pitcher to do the trick was Ed Reulbach, another Notre Dame man. Dubuc had been largely responsible for steering Daniels to Notre Dame, when they played together in Connecticut, telling him about Notre Dame's need for a first baseman and their excellent baseball facilities.

Bert was also known for the number of aliases he used. Although he later pointed out that he always used his real name when he played in college (at Villanova and Bucknell, with Notre Dame in between), he was known as Walsh, Barrett, Bothwick, Berger, and Ayres from 1906 through 1909. Bert's coached the baseball team at Manhattan College for eight years during the 1930s.

Albert Michael "Red" Kelly transferred to Notre Dame from St. Viateur's College. He was a star athlete in baseball and football. His biggest fame came on November 6, 1909, when the Notre Dame Football Team defeated Michigan, 11-3, in Ann Arbor. This was the first time Notre Dame had ever defeated the Wolverines. It was the first significant win for the Fighting Irish Football program. Red was the second team left halfback, behind Harry "Red" Miller, of the famous Miller clan who played football for Notre Dame.

Louis M. Nageleisen entered St. Joseph's College, of Rensselaer, Indiana, in 1903. He was a student for six years, graduating with a an A.B., a designation which was used "rather loosely in those days" according to Rev. Dominic B. Gerlach, C.PP.S., Archivist at St. Joseph's. While at St. Joseph's, Lou won the Gold Medal, for highest honors in his class. He also was Vice President of the Columbian Literary Society and a Major in the campus "military team." When Lou transferred to Notre Dame, in 1909, he was enrolled in the prep school for one year. Sometime after his time in pro ball, Lou's name changed to Lou Nagelson, perhaps because of the anti-German sentiment which grew out of World War I. In the box scores for Lou's two Major League games, his name is spelled as "Naeg'son" (*The Sporting News*), "Nagelson" (*The Sporting News*), and "Naegleson" (*The Cleveland Plain Dealer*). In his own handwriting, in 1960, he listed his name as Louis Marcelus Nagelsen, when he responded to a questionnaire from the Hall of Fame. His middle name has been variously written as Marcelius (Notre Dame) and Marcellus (*Baseball Encyclopedia*). It is no wonder that Bill Carle, and the other members of SABR's Biographical Research Committee have such a difficult time completing their work.

Nagelsen made his Major League debut with the Cleveland Naps on September 9, 1912. He was hitless in two at bats against Carl Cashion of the Washington Nationals. Playing right field for the Naps was Shoeless Joe Jackson. Playing first base for the Senators was Chick Gandil. Seven years later, Jackson and Gandil would be on the Pennant Winning Chicago White Sox team that threw the World Series to the Cincinnati Reds, earning the Black Sox name. Six days later, against the Philadelphia Athletics and Hall of Famer Eddie Plank, the Cleveland Plain Dealer reported "Hopelessly beaten, Manager (Joe) Birmingham of the Naps thrust a few recruits into the battle during the last two innings." Lou made his final appearance in that game. In Lou's first game, the usually sure-handed Nap Lajoie made two errors. The future Hall of Famer made three more errors in Lou's second game. Shortstop Ray Chapman also made two errors on September 15. Even Stuffy McInnis (of Gloucester), who held the Major League single season fielding record for first basemen (.999) for 63 years, also made an error in the game.

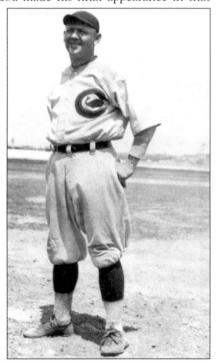

Clemens Lambert Ulatowski played Major League Baseball under the name Clem Clemens. His first athletic claim to fame at Notre Dame came in basketball. He earned monograms for the 1910 and 1911 Notre Dame teams, which won 17 and lost 7. He had a tougher time breaking in as a backstop with the baseball team. In 1909, Notre Dame had Ed McDonough and Ray "Dike" Scanlon behind the plate, two men who would also play pro ball. "Ulli" played a little right field before earning the backstop position for 1910, perhaps aided by two other future Major League (Earle Mack and Lou Nagelson) catchers dropping out of school before the season to sign pro contracts.

CLEM CLEMENS WITH THE CHICAGO WHALES OF THE FEDERAL LEAGUE IN 1914.

Clem spent his later years in St. Petersburg, Florida with a small legal practice. Among his friends in St. Pete was legendary sports writer Fred Lieb, who coined the phrase "The House that Ruth built." Lieb wrote me that Clem ". . . was a member of Branch Rickey's Browns in 1914, the first Big League team that ever trained in St. Pete." Lieb mentioned that the Browns stayed in the Fifth Avenue Hotel, which was then located "way out in the woods." According to Lieb, "The players slept in a sort of balcony, which had little protection from rain and which was frequently visited by beavers, groundhogs, rabbits, snakes, and lizards, from the adjoining woods." Clemens later told his grandson that alligators snapped at the players' feet as they crossed bridges in St. Pete.

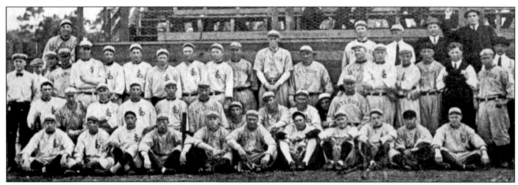

CLEM CLEMENS AND THE 1914 ST. LOUIS BROWNS IN ST. PETERSBURG.

Clemens left the Browns before the 1914 season began when the Chicago Whales, of the Federal League, offered a contract that Rickey could not match. Clem played for two years, including on the 1915 Championship team, which sought unsuccessfully to be included in a round-robin World Series with the Red Sox and Phillies. After the off-season demise of the Federal League, The Whales merged with the Cubs in the peace agreement. Of interest to current fans is that the Cubs took over the Whales ballpark, then called Weegham Park. It was later re-named as Wrigley Field and stands today as the second oldest Major League ballpark still in use, behind Fenway Park.

Clem was active in Chicago legal and political circles, once running unsuccessfully for Alderman. He was a Navy Chief Yeoman during World War I and the Security Chief of a Munitions Plant during World War II. Clem moved to St. Petersburg in 1962, where he appeared at some Oldtimer's Games with the many former Major Leaguers who lived in the area.

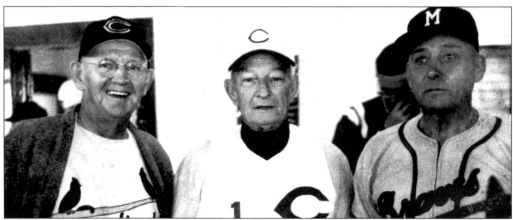

CLEM CLEMENS WITH HALL OF FAMERS JESSE "POP" HAINES (LEFT) AND BILL MCKECHNIE (CENTER), AT AN OLD TIMERS MARCH OF DIMES GAME (JAN. 23, 1960) IN ST. PETERSBURG.

Herbert Barrett Kelly remains the all-time winning percentage pitcher from Notre Dame. During his three years (1912–1914), Herb won 22 and lost only two (.917). He also pitched six shutouts for Notre Dame, still for the second best total in that category.

The Dome described him as "a fastballer with a nice assortment of curves," who could "bat like a fiend," and who "ran the bases with the best. . . . He comes from the South where congeniality started and he has brought a good supply of it to Notre Dame with him."

In 1915, pitching for Atlanta, of the Southern Association, Herb just missed baseball immortality. For nine innings, the left-handed Kelly held Birmingham hitless, with the only base runner reaching on an error. Unfortunately, Herb's team also failed to score. He lost 1-0 in the tenth, despite giving up only one hit.

Coming out of Notre Dame, Kelley attracted the attention of John McGraw (the quintessential New Yorker), who wanted to sign him for his Giants, but Kelley's father was a strong-willed man from Mobile, Alabama, who did not take to McGraw, so he resisted. Herb returned to Notre Dame, graduating with a degree in electrical engineering, after starting his pro career.

In the early days of college baseball, it was common for players to pick up money on semi-pro teams, playing under an alias. Herb ventured across the border to Niles (MI) using the hotel register name of John Smith. After Kelly graduated from Notre Dame and signed with the Pittsburgh Pirates, the *St. Joseph (MI) Evening Herald* printed a clever poem about his departure:

"Good Bye Smith, old top,
Sorry to see you Go"

Good Bye Old Hoss
We'll feel the loss
But then we cannot help it.

We wish you well
You pitched like "Kell"
That's all there is about it.

Your fast one; slow one;
Out and drop
Have made us learn
To love you.

And at the season's
Close we hope
There'll none
Appear above you.

Herb Kelly.

Alfred Henry "Dutch" Bergman would be on any short list to be labeled as one of Notre Dame's greatest athletes. During his Junior year (1913–1914), he became the first man to earn four monograms (varsity letters) in a single year. He was a star in football, basketball, baseball, and track. Only four Notre Dame athletes have accomplished this feat. The following year, Bergman did it again. He's the only man to accomplish the feat twice. The other three men to do it were Bergman's classmate Rupe Mills and two football stars, Johnny Lujack (1943–1944) and George Ratterman (1944–1945). Ratterman substituted tennis for track.

Bergman earned his four monograms as the football quarterback; a basketball forward; a left fielder in baseball; and a sprinter in track. His second four-letter season, he moved to shortstop. Bergman captained the Notre Dame Track Team in 1915. He ran a ten second hundred yard dash, a very fast time for that period. He held the Notre Dame record in the 220 (21.6) for two decades.

Alfred, called "Big Dutch" was the first of three Bergman's to attend Notre Dame. They earned 18 monograms. Arthur, called "Little Dutch," later achieved more fame as Head Coach of the University of Minnesota and the Washington Redskins. Joe, called simply "Dutch," was the final Bergman to play for the Irish. The Bergman boys came to Notre Dame from Peru, Indiana, a farming community located about halfway between South Bend and Indianapolis. Peru has long been known as "The Circus City" because of the number of circuses housed there back in the heyday of the traveling circus. Peru's proximity to rail lines brought circuses and tourists in the early days of the town. Peru is home of the Circus Hall of Fame.

Peru boasts that it is the birthplace of Cole Porter (b. June 9, 1891). Two men who made a mark for themselves grew up as neighbors of Porter. Dutch Bergman (b. September 27, 1889) grew up on West Fifth Street in Peru. Porter grew up on East Third Street. The street between them, called Main, was the early home of John Dillon O'Hara (b. May 1, 1888). Although born in Ann Arbor, Michigan, O'Hara moved to Peru at an early age and lived on West Main Street. O'Hara later enrolled at Notre Dame, became a C.S.C. Priest, served as President of Notre Dame, and became the Archbishop of Philadelphia and a member of the College of Cardinals. While Porter chose Yale for his education, he was named after Lewis Cole, his uncle who had attended Notre Dame.

Bergman holds an unusual and unbreakable Notre Dame Football record. On October 28, 1911, playing at home on Cartier Field, he fielded a Loyola (IL) kickoff, one foot behind the goal line. He returned the kick to the Loyola five yard line before being tackled. Because the field was 110 yards long in 1911, the return was measured at 105 yards, yet it did not end in a score. Ironically, this is only the second longest "run" in Notre Dame annals, to Frank Shaughnessy,'s 107 yard fumble return. In today's record keeping, any ball returned from the end zone would count as a 100-yard run.

Bergman used his speed to steal 25 bases in only 22 games during the 1914 college season. *The Dome* described Bergman as "a light hitter, but as lead-off man, he often worked the opposing pitchers for four wide ones, and to give him first usually meant to see him on third a moment later."

After graduating, Bergman was pursued by the Cleveland Indians. He initially resisted their overtures, returning to Peru, where he ran a meat market and served as the playing manager on his own baseball club. These two businesses gave him enough financial leverage to hold out for more money from the Indians. He finally signed on August 26, 1916, making his Major League debut three days later, as a second baseman against the Washington Senators. He batted seventh in the lineup, behind first baseman (and later Black Sox crook) Chick Gandil, and shortstop (and later beaning-death victim) Ray Chapman. Hall of Famer Tris Speaker played center field and hit third. Dutch garnered a triple in three at bats, scored two runs and handled two putouts and two assists. He went one for four in each of the next two games.

Dutch played for Greensboro (NC) of the North Carolina State League for the 1917 season. He played third and short. He stole 25 bases in only 37 games, scoring 27 runs. The League folded on May 30, because of World War I. Dutch enlisted and served as an Artillery Captain. After his death, in 1961, newspaper accounts referred to him as Notre Dame's greatest all around athlete. His feat of earning 11 varsity letters still has not been approached.

Rupert Frank Mills is one of the great stories in ND annals. He was a teammate of Dutch Bergman when both starred in football, basketball, baseball, and track. Rupe was the starting center on the basketball team for three seasons, leading the team to records of 13-2, 11-5, and 15-2.

Rupe played in the Major Leagues, with the NEWFEDS (or "Peps") of the Federal League. He was the only Jersey-born player on the Newark (NJ) team. He had studied law at ND and he put that training to good use when he signed a two-year "ironclad" contract with Newark in 1915. When the league folded after the season, the owners told him that he would not be paid because he wasn't playing. Rupe replied that it was not his fault the League folded and that he was prepared to play as his contract stated. He then became the only player in the Federal League, showing up at the ballpark each day to work out. The press had fun with his antics and quotes: "I report every morning at 9:30 o'clock for morning practice and work out until 11 o'clock. I do mostly pitching in the morning to get wise to my curves for the afternoon game and when the umpire—that's me too—calls "Play" I just go out and bang the ball all around the lot." Finally, after a month or so, Harry Sinclair, the wealthy Tulsa-based team owner, relented and paid off the wiley Mills.

Because of his close friendship with Coach Knute Rockne, Rupe always hosted the Irish on their Eastern trips. In 1927, Mills flew to the Navy game in Baltimore, attracting a lot of press coverage for his dedication to the Irish. He was very prominent in Newark political circles, serving as Undersheriff of Essex County and running for Sheriff at the time of his death. His death is one of the most heroic of any former pro athlete. He was canoeing with a friend on July 20, 1929. Their canoe capsized and Mills dove in to save his friend, who could not swim. As he passed his friend up to rescuers on the bank, Mills apparently suffered a heart attack, and while submerged, drowned.

ALFRED "DUTCH" BERGMAN.

RUPE MILLS (CENTER.)

RUPE MILLS. An athletic star, he died a hero.

1914 Chicago White Sox Pitching Staff. Ed Cicotte is on left. He was on the way to a Hall of Fame career when he participated in the 1919 "Black Sox" scandal. Hall of Famer Urban "Red" Faber is fourth from left. "Death Valley" Jim Scott is sixth from left. Ewell "Reb" Russell is to his right. Hall of Famer "Big Ed" Walsh, at the end of his career, is second from the right, next to Bill Lathrop.

William George "Rusty" Lathrop, a side-arming spitballer, was signed off the Notre Dame campus by the Chicago White Sox, after posting a 4-1 record during the 1912 season. Bill's brother, Ralph "Zipper" Lathrop, accompanied him to Notre Dame. Zipper gained fame as the starting right tackle on the 1913 Notre Dame Football Team, which traveled to West Point and defeated the Army, 35-13. It was in this game that Quarterback Gus Dorais and left end Knute Rockne introduced the forward pass as a significant weapon.

Lathrop grabbed his only Big League win in 1914, pitching in a rotation which included future Hall of Famers Ed Walsh and Red Faber, as well as future Black Sox star Ed Cicotte. Bill was a fine position player as well as hurler, playing the outfield while pitching for both Kansas City and St. Paul of the American Association. He later served as President of the Class D Janesville Cubs of the Wisconsin State League, before and after World War II.

He later became one of the most successful agents for the Travelers' Insurance Company. The Travelers named him the top agent in Wisconsin in 1954 and 6th best in the country. Bill was also a fine golfer. He won 19 country club championships, and in 1930 set a Janesville (WI) Country Club record with a 69, which held up until the immortal Walter Hagen shot a 68 there. Lathrop was also Wisconsin State Senior Golf Champ and twice city handball champion.

Adrian Ryan Lynch was born in Laurens, Iowa, a small town near Dyersville, location of the baseball diamond where Field of Dreams was filmed. In 1916, The *Scholastic* reported that "Slim Lynch" was the "best pitcher in Interhall Baseball." Another good one was Pat Murray, "The Smiling Sphinx." Lynch fulfilled his Major League dream in perfect fashion, having a 2-0 record to show for his stint with the 1920 St. Louis Browns.

His first Major League win was on August 10th, a 6-4 complete game against the Red Sox. He yielded eight hits, but the *St. Louis Globe Democrat* exclaimed, "Lynch hurls excellent contest." Five of the hits were in the infield and one was caused by a mixup on a popup. He was called "Slim" Lynch in the game story. His final win came on September 17, a 17-8 slugfest over the Philadelphia Athletics. George Sisler backed him with two triples and two singles. An interesting oddity is that in the former win, Stuffy McInnes was held hitless by Lynch, while Cy Perkins received the collar in the second. Both men went to Gloucester High School, 50 years before this scribe.

Lynch won 125 games in his Minor League career, mostly in fast company. His top years for wins were 1919 (18 with Wichita); 1923 (18 with Des Moines); and 1925 (19 with Denver). Lynch's father, J.J. Lynch was from one of the founding families of Pocahontas County, in 1883, the year the railroad moved there. This is the same year that Red Morgan was born in Neola, a similar town also situated on the railroad line. Lynch died in a car crash on March 16, 1934. On the same day that his obituary appeared in the South Bend papers, it was reported that Clarence Jake Kline was named Head Baseball Coach for Notre Dame.

PAT MURRAY. Patrick Joseph Murray was 14-3 during his time with the Irish, earning the left handed pitcher an immediate promotion to the Philadelphia Phillies after graduating, in 1919. He pitched in eight games during the final three months of the season. He suffered a career ending injury during 1920 Spring Training. He became a high school math teacher and principal.

THREE

The Rockne Years

No person exerted more influence over Notre Dame athletics (and arguably college football in general) than Knute Kenneth Rockne. Rockne came to Notre Dame in 1909 as a 21-year-old track athlete (pole vault), with an aptitude for football and chemistry. He had worked in a Chicago post office to earn enough money to attend school. During the summer of his senior year he got together with classmate Gus Dorais while both were working as lifeguards at Cedar Point, Ohio. It was there that they took advantage of the liberalized forward passing rules. Dorais learned how to throw a spiral and Rockne learned how to run a pass route where Dorais would hit him in stride, instead of the short and stationary "buttonhook" passes which were then state of the art. That fall, the 35-13 dismantling of West Point changed the game of football, put the tiny Catholic school on the national radar, and established Rockne and Dorais as brilliant football minds. After graduating, Rockne worked at Notre Dame as an instructor in chemistry, track coach, and assistant football coach. He replaced Jess Harper as head football coach for the 1918 season and served in that job until his death in a plane crash on March 31, 1931.

The early 1920s saw a slight decline in Notre Dame's baseball fortunes, due to several factors. Until Jake Kline was hired for the 1934 season the coaching was not first-rate, as football began to get all of the attention on campus. The warm-weather schools started developing their programs and appealing to players who may have previously gone to Notre Dame. Stricter adherence to academic standards also meant the end of "tramp athletes" who would come and go for a year or two.

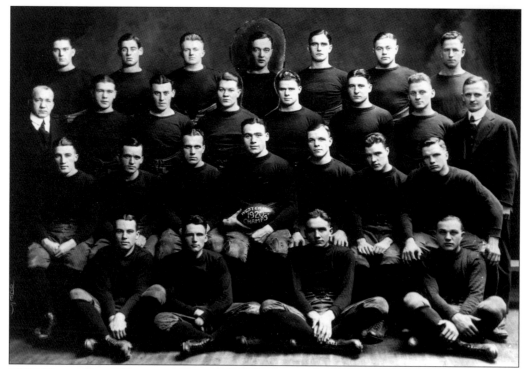

1920 Notre Dame Football Team. Note the doctored image in the middle of the back row. George Gipp had already died when this team photo was taken. A stand-in was placed in his spot and Gipp's head was (badly) added.

The above photo is a "who's who" of famous athletes, coaches, writers, and Notre Dame legends. Among the great coaches in the photo besides Knute Rockne are Buck Shaw, Harry Mehre, Jim Phelan, Clipper Smith, and Dr. Eddie Anderson. Hunk Anderson was Rockne's hand-picked successor. John Mohardt and Paul Castner played minor league baseball. Gipp and Roger Kiley were 1920 football All-Americans. Kiley, the two Andersons, and Mohardt, Castner, and Shaw would be named on various football All-American teams in 1921. Chet Wynne was a track and field All-American. Gipp and Hunk Anderson are in the College Football Hall of Fame. Chet Grant wrote *Before Rockne at Notre Dame*, and Paul Castner wrote *We Remember Rockne*. The assistant football coach in the photo is Walter Halas, brother of George.

As the story goes, Gipp came to Notre Dame primarily to play baseball (and perhaps shoot pool and play poker). He played only three basketball games for the Irish. His highlight game was against Michigan Agricultural College (now Michigan State), on May 8, 1920. He walked with the bases full in the top of the ninth, bringing in the winning run in an 11-10 defeat of the "Aggies." The Chicago papers, at the time leading up to Gipp's death, reported that Bill Veeck, Sr. had made him an offer to play for the Cubs.

Several of the Notre Dame baseball stars of this period also had football roots at Notre Dame.

Thomas Joseph Whelan was one of the first pro two-sporters. He was in the NFL in its founding year and also played Major League Baseball. Whelan came to Notre Dame in 1914. This was not a good time to break into the football team. The Irish would be a dominant team for the next sixteen years. After a year, he dropped out to attend Dartmouth and then Georgetown, where he starred in football and baseball. He entered World War I as a Naval Aviator and instructor.

Whelan joined the immortal Jim Thorpe to play for the Canton Bulldogs when the NFL was founded. He was a one-gamer in the Major Leagues, playing for the Boston Braves on August 13, 1920. He had one walk and one strikeout in three trips to the plate. Tom had a long career in minor league and semi-pro baseball as player and coach. He also had a long career in football as player and coach. After his playing career ended, Tom became one of the most prominent high school coaches and principals in his hometown of Lynn, Massachusetts. He coached football, basketball, and baseball at Lynn English High School for 17 years and served as principal for sixteen more. His finest baseball discovery at Lynn English was longtime Major Leaguer Jim Hegan.

In 1925, Tom Whelan managed the Nashua Millionaires of the Boston Twilight League. Jean Dubuc was the playing manager of the Manchester Blue Sox. Whelan's team won the first half title; Dubuc's won the second. Whelan's team won the overall championship. There were many Big Leaguers in this league, including Chick Gagnon, Jocko Conlon, Jess Tessreau, Leon Cadore, and Otto Miller.

From 1927 to 1929 Whelan played first and third for Lynn of the New England League. Playing second and short alongside him was Joe Huarte, an eight-year Minor League star. They helped lead Lynn to the New England League championship in 1928. Huarte's son John was a bit of an athlete also, quarterbacking Notre Dame to within a minute of a National Championship, and earning the Heisman Trophy, in 1964.

Francis Joseph "Steve" O"Neill enrolled at Notre Dame in 1918, remaining for two years, before leaving to became active in his family's trucking and transportation business, which became Leaseway Transportation Corporation in 1961. Later he became a part owner of the New York Yankees and then majority owner of the Cleveland Indians.

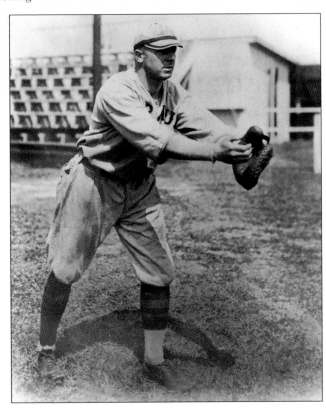

THOMAS WHELAN.

John Henry Mohardt grew up in Gary, Indiana. He dropped out of high school in the 10th grade, to work in the steel mills, because his family was of extremely limited finances. After two years at hard labor, Mohardt decided to give college a try. He applied to Notre Dame. According to his son, Mohardt was given "two tests" by the University: running and throwing. Doing sufficiently well in his entrance exams, young Mohardt entered Notre Dame with the Class of 1922.

The Notre Dame Football cupboard was very well stocked with talent in those years, including men who would become coaching giants. A guy named Rockne (who was also a late enrollee to Notre Dame) was in his first season as Head Coach. Among the players on the team were Hunk Anderson, Eddie Anderson, Clipper Smith, Curly Lambeau, Edward "Slip" Madigan, Jimmy Phelan, and Harry Mehre. Future coaching greats Lawrence "Buck" Shaw and Frank Thomas were a year or so away from enrolling. Hunk Anderson was Rockne's handpicked choice to succeed him at Notre Dame. Dr. Eddie Anderson would win 210 games in his Hall of Fame college coaching career. Smith won 108, Lambeau was the long time coach of the Packers, whose field is named in his honor. Madigan won 125. Phelan won 136. Mehre won 98. Shaw won 66, before going on to the NFL. Thomas won 137.

George Gipp (who also was a late enrollee at Notre Dame) was the starter at left half. Mohardt was the third string right half. The following year Mohardt was third team behind Gipp. The next year he was second team behind Gipp. For his Senior year, after Gipps' death, John was the starter. He led the Irish in rushing (781 yards) and passing (53/98, with nine TD's). This was the best Notre Dame passing record until Angelo Bertelli's 1941 season. Mohardt's 12 TD's were a Notre Dame record that stood for 22 years. In John's final three years on the football team, the Irish were 28-1. John was also the star of the baseball and track teams.

During the summer of 1920, John and the entire Notre Dame Baseball team played semi-pro ball in New Hampton, Iowa. This was against the college regulations of the time, but enforcement was not strong. When someone would ask a player what the "ND" on their caps stood for, they replied "North Dakota." Each of the players used an alias. More than 60 years later, Coach Clarence "Jake"

Kline could recall for this writer the real names and aliases and batting order of the "ND-New Hampton" team. Mohardt assumed the name of John Cavanaugh. During the romantic summer in the cornfields, Mohardt became smitten with a young lass, and she with him. Although he divulged that he was a Notre Dame student, he did not confess to his real name. She later wrote him a love note, to "John Cavanaugh," at Notre Dame. When the real John Cavanaugh, C.S.C., got the note, he took a dim view, from his position as President of the university. Fortunately for young Mohardt, his excellent academic standing saved him.

FATHER JOHN W. CAVANNAUGH.

When Jake Kline recounted this story, he was quick to add, with a twinkle in his eye, that he hit .394 (as Joe Culline) while Cavanaugh/Mohardt hit only .309. Kline grew up in Williamsport, Pennsylvania, the home of the Little League World Series. He was born on February 18, 1895, the very same day as George Gipp. According to legendary *South Bend Tribune* writer Joe Doyle, Jake was persuaded to attend Notre Dame by childhood friend Vince Eck. Vince's son, Frank, graduated from Notre Dame in the 40s and has since donated four buildings on the Notre Dame campus, including Eck Baseball Stadium, the location of Jake Kline Field.

Williamsport contributed another illustrious native to Notre Dame. Frank Hering, Notre Dame's first baseball coach, was born in Williamsport and came to Notre Dame as a quarterback, 19 months after Jake was born. As Doyle pointed out, Hering was the man in charge of Notre Dame's athletics when football shifted from mostly an intramural program to being an intercollegiate sport, thus earning Hering the title of "Father of Notre Dame Football." Hering also introduced basketball to Notre Dame, in 1898.

Frank Hering was Notre Dame's first baseball coach. He held that title for the seasons of 1897–1899. His duties ended once the team started playing games, at which time the team captain would take over. Hering was the football coach during those seasons. An 1898 Notre Dame grad, Hering officially dedicated the Notre Dame Stadium, in 1930. His other claim to fame occurred when President Woodrow Wilson inaugurated Mother's Day in 1914. Hering had made a February 7, 1904 speech pushing for just such a day.

In the 1920s, while serving on the Notre Dame faculty, Hering and his wife Claribel also played an important role in the civic affairs of South Bend. According to research by David Healy, of the South Bend Historical Society, Hering purchased a building at 726 Western Avenue, and donated it to the African-American community of South Bend, as a community center. It was called Hering House. The building, modeled on the settlement house concept, opened to much fanfare on March 9, 1925. The facility contained rooms for games, music, study, and sports, according to Healy. The clubs helped develop leadership, mentoring, and a sense of community among African Americans in South Bend. The various classes also taught useful job skills.

JAKE KLINE. Coach Jake Kline told this writer he was proud of his relationship with all four of Notre Dame's 4-sport men; having played with Bergamn and Mills and coached Johnny Lujack and George Ratterman when they accomplished the feat.

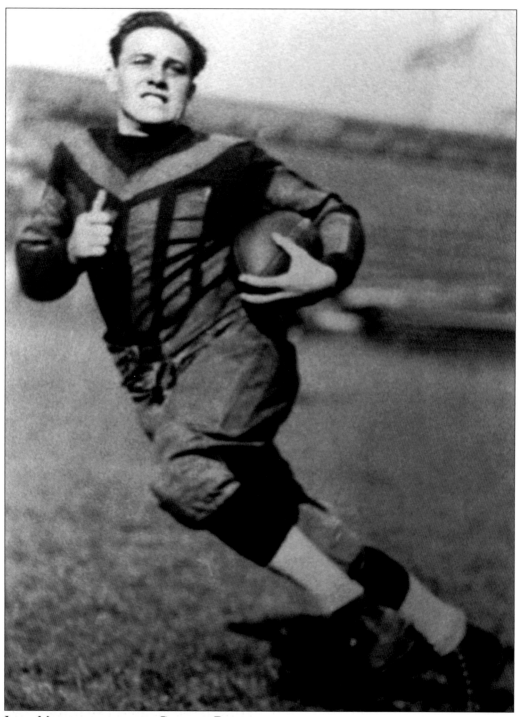

JOHN MOHARDT WITH THE CHICAGO BEARS.

Mohardt graduated from Notre Dame, cum laude, in 1922, with a science curriculum suitable for pre med. Johnny decided to attend Northwestern Medical School, but lacked sufficient funds to pay his way. He accepted various professional sports offers to pay the bills. From 1921 through 1926, he played football for the Dayton Triangles, Chicago Cardinals, Racine Legion, Chicago Bears, and Chicago Bulls, representing all three pro leagues at that time. With the 1925 Bears, Mohardt played in the same backfield with Red Grange, "the Galloping Ghost."

Mohardt signed with the Detroit Tigers on February 6, 1922. He also played with Denver and Syracuse in the Minors. His final season of baseball was with Greenville (SC), in 1923. John's Major League career consisted of five games, from April 15 through the 22nd, of 1922. He appeared as an outfield defensive substitute in all three fields. He accomplished two noteworthy feats, however. In his only plate appearance, he got a base hit, giving him a lifetime Major League average of 1.000, and in his final game, he was sent in to pinch run for the great Ty Cobb, universally acclaimed as the greatest base runner in the first 100 years of baseball. Thus we have the only man in history who played with Gipp, Grange, and Cobb, three of the legendary figures of sport's Golden Age.

John figured in a major football scandal in 1922. Town Ball in various sports was quite common then. The central Illinois towns of Taylorsville and Carlinsville took it very seriously. They carried on such a bitter rivalry that when they arranged a match, approximately $100,000 was bet on the outcome, a staggering sum for 1922. Each team recruited some collegians as ringers. Taylorsville picked up nine members of the Illini Football Team and Carlinsville added ten members of the Notre Dame Football Team. Mohardt was alleged to have been one of the members of the losing Carlinsville eleven. The players were allegedly paid $200 for the game. Eight star Notre Dame players were disqualified for participation in the game. Although Mohardt was exonerated of this charge, he was later disqualified for other Notre Dame sports when it was discovered that he had played for Racine against Curly Lambeau's Green Bay

Packers. In all, 12 Notre Dame players were kicked off the team. Thus, having his team decimated, Rockne's 1923 team finished a disappointing 8-1-1. The following year, the Four Horsemen-led became what many considered the greatest college team of all time.

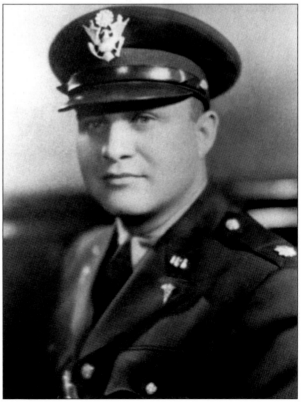

MOHARDT AS AN ARMY OFFICER, POST-PLAYING DAYS. For good measure, Mohardt also served his country. He enlisted in the Army at the opening of World War II. He served overseas in North Africa and Italy with the 12th General Hospital Unit. He was discharged as a Lieutenant Colonel. He later returned to government service as Chief Surgeon of a V.A. Hospital and later as Assistant Director of the V.A. Surgical Service. Few athletes combined John Mohardt's collegiate athletic and academic achievement and professional and athletic career after college.

When Mohardt was later asked to compare Gipp and Grange, he said "Gipp was unquestionably the greatest all around halfback. He could do more things—run, pass, punt, and drop kick like you never saw in your life. Of course, Red had no equals in running in the open." Grantland Rice, who gave the Four Horseman nickname to the 1924 backfield also wrote a poem called "Rockne." It's second stanza spoke about some great Notre Dame backs:

> *"First Eichenlaub—and then upon his way*
> *The brilliant Gipp careens above the turf,*
> *A flaring comet none might hold at bay*
> *As your front wall sweeps forward like the surf,*
> *And Johnny Mohardt flips a pass once more*
> *Where Anderson or Kiley wait to score."*

After completing his Northwestern Medical Degree in 1927, Mohardt gave up sports for medicine. Bears Owner George Halas called him ". . . a man with a mission. He dedicated himself to the medical profession soon after he joined the Bears . . . and never wavered."

From April 1, 1928 through April 1, 1933, John was a "Fellow in Surgery" with the Mayo Foundation, at the Mayo Clinic, of Rochester, Minnesota. He perfected several medical specialties during that time. When Knute Rockne needed treatment on his legs, he sought out Mohardt. Rockne took along with him a young tackle whose leg injuries would end his career. The young tackle shared a room with Rock at the Mayo Clinic, and aspiring to become a coach, he asked lots of questions of Coach Rockne, who still holds the all time career winning percentage for college coaches. Standing in second place is Frank Leahy, who owed a debt to John Mohardt for the hospital pairing.

Paul Henry Castner was a lefty as a kicker, punter, stick handler, hurler, and author. He

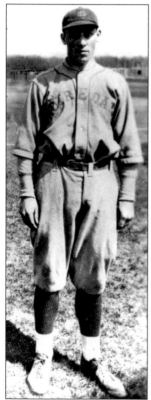

attracted many Major League scouts with many stunning pitching performances during his senior year at Notre Dame. On May 17, 1922, Castner threw a 4-0 no-hitter at Purdue, on front of 4,000 fans at Lafayette Park. He fanned seven and walked only one. This writer thanks Notre Dame football expert Bill Farmer for the gift of the ball used in this game.

Castner's name is also found often in Notre Dame Football records. He led the team in scoring (64) during the 1922 season, with eight touchdowns, two field goals, and 10 extra points. He also led in kickoff returns, with 11 for 490 yards for a 44.5 average, still the Notre Dame record. He is also the career kickoff return leader, as his 767 yards were gained on a 36.5 per return average. On November 4, 1922, against Indiana University, Paul scored on touchdowns of 40, 35, and 46 yards from his fullback spot.

PAUL CASTNER.

84

Although he pitched only ten innings for the Chicago White Sox in the Major Leagues, Paul linked himself with the two most storied players in the game's history. In *Ty Cobb*, John D. McCallum recounted how Ty doubled and later stole home off Castner, "a nervous youngster." In an article in the 1985 edition of SABR's *Baseball Research Journal*, Al Kermisch described a bit of Ruthian legend. On August 20, 1923, the Yankees were winning a "laugher" against the White Sox. A small dog ran onto the field and Babe Ruth took to clowning around with the pup. "He got down on all fours to follow the dog around and then threw his glove at the animal. The pup grabbed the glove and took off with it. At the same time, Paul Castner, a White Sox rookie pitcher out of Notre Dame, hit a fly ball to left field, and the Babe nonchalantly caught the ball barehanded." Paul Gallico, covering the game for the *New York Daily News*, reported that, after the catch, "…four strong men were assisted from the park with hysterics."

In a strange coincidence, McCallum collaborated with Castner in Paul's 1975 book about Knute Rockne. *We Remember Rockne* was described by Paul as "a portrait of a beautiful man which will provide guidance and inspiration for youth and youth leaders of today as he did for those of us who knew him." The book contains interviews Paul taped with other former players and associates of Rockne.

Paul was quite active during his student days. He served as President of his freshman class and President of the Advertising Club. He captained the baseball team and was considered the best hockey player in the "West," scoring approximately two thirds of the teams 55 goals during the 1922 season. He both captained and coached the Notre Dame Hockey Team. Notre Dame football players would continue to play baseball. Ambrose "Bud" Dudley, who would found the Liberty Bowl, played outfield in 1942. Angelo Bertelli, who won the Heisman Trophy in 1943, was a back-up catcher and first baseman that spring.

Bert V. Dunne was a .300 hitting outfielder on Notre Dame's 1924 and 1925 teams, and a good enough player to hit over .300 in his single season in the Minors. His Minor League accomplishments would not stack up nearly high enough to make this book, were it not for some extra creativity Bert demonstrated two decades later. While working as an advertising executive, Bert wrote a book, *Play Ball, Son!* (Serra Publishing Company, San Francisco, 1945) about his theories of baseball hitting and play. The book sold so well that it was made into a movie. Henry Ford II saw the picture and used it to promote the Ford-American Legion Junior Baseball Program. The State Department also used the movie to show to youth in Germany, Austria, Japan, and Korea.

Dunne then had another brainstorm. He took a toilet plunger and sawed off the top. He then took a small segment of garden hose and fitted it over the tip of the plunger. Voila, the "batting tee" was born. No less a batter than Ted Williams became enamored with Dunne's invention. Writing in Dunne's next book (*Play Ball*, Doubleday, New York, 1947), Williams said, "I saw the picture "Play Ball, Son!" in a Philadelphia hotel suite in May, with Joe Cronin, Dave Ferriss, Bobby Doerr, and several others. In fact, I saw it three times. I believe "Play Ball, Son!" is the greatest teaching picture ever made." Williams went on to recount that he bought three "plumber's helpers" and made his own batting tees to different heights. Bert later produced "Swing King," in 1946, using Ted Williams as his demonstrator.

Richard Paul "Red" Smith was one of two young men named Smith, from small towns in Wisconsin, who enrolled in the class of 1927 at Notre Dame. Both were nicknamed "Red." Although they grew up within a few miles of each other, the two men did not meet until they came to ND. Richard Paul Smith starred on both the football and baseball teams. He would be active in sports for nearly 50 years. Walter Wellesley Smith was the most famous sports writer in American Journalism ("there's no heavy lifting"), becoming the first sportswriter to win a Pulitzer Prize.

Dick Smith graduated from Kaukauna High School, in Combined Locks (WI), in 1922. He spent a year at Lawrence University, playing guard on their undefeated football team, before transferring to Notre Dame. Red played both guard and fullback for the Irish. In another "Smith oddity," the second team guards for Knute Rockne's 1925 team were Richard "Red" Smith and John "Clipper" Smith. Both men later served many years as college football coaches. Both men had to share their nicknames, since John was the "Little Clipper," to Maurice "Big Clipper" Smith, who preceded him by seven years at Notre Dame.

Red Smith the Player made his Major League debut, on May 31, 1927, against the Philadelphia Phillies, only one day after arriving from his graduation from Notre Dame. He was a defensive replacement, for catcher Mickey O'Neill, in the 9th inning of a 13-4 win. Red's Major League stat line consisted of one putout.

The 1927 Giants had a star-studded lineup. Only George Harper of the first seven men in the lineup failed to make the Hall of Fame—and he hit .331 in 1927. Harper was starting only because of the terminal illness that would claim the life of future Hall of Famer Ross Youngs. Despite having Edd Roush (cf), Freddie Lindstrom (3b), Harper (rf), Rogers Hornsby (2b), Bill Terry (1b), Mel Ott (lf), and Travis Jackson (ss), the Giants finished in third place. And Hall of Fame pitcher Burleigh Grimes was also on that team. Tough league!

Red caught for the Giants against St. Bonaventure College, the day after his debut, in the dedication game for McGraw-Jennings Field. A week later, in Toledo, he was the catcher in an exhibition game honoring Roger Bresnahan. Casey Stengel was the Toledo right fielder. After the baseball season, Red began his pro football career, playing mostly fullback:

Year	Team	Games	Notes
1927	Green Bay Packers	5	Coached by Curly Lambeau (ND)
1928	New York Giants	1	Teammates: Red Badgro
1928	New York Yankees	11	Teammates: Ox Eckhart, Cal Hubbard
1929	Green Bay Packers	5	Teammates: Johnny Blood McNally (ND)
1930	Newark Tornadoes	7	
1931	New York Giants	9	Coached by Steve Owen

Red coached football at Georgetown University in 1930. He served as Athletic Director for Seton Hall, 1931-32. From 1933 through 1935, he was the line coach at the University of Wisconsin. From 1936 through 1943, he was the line coach of the Green Bay Packers, followed by six years in the same capacity with the New York Giants.

Along with those football duties, Red was in Minor League Baseball most summers. His top Minor League seasons were 1928, when he hit .292 for Montreal and 1936, when he hit .357 in 45 games as Playing Manager for Fieldale (VA). A weak throwing arm ended Red's chances for a longer playing career. On May 14, 1936, Indianapolis base runners stole 10 bases off him, when he served as a fill-in catcher. For 464 Minor League games, Red had a combined batting average of .284.

Red discovered future Major League star Kenny Keltner, playing sandlot ball in Milwaukee. Red won his first pennant as a player-manager, with Hopkinsville (KY) of the KITTY League, in 1938. He piloted Green Bay to a 76-35 (.685) record in 1941. This was the highest winning percentage in the history of the Wisconsin State League. He advanced to the American Association, as a coach with Milwaukee, for 1943 and 1944.

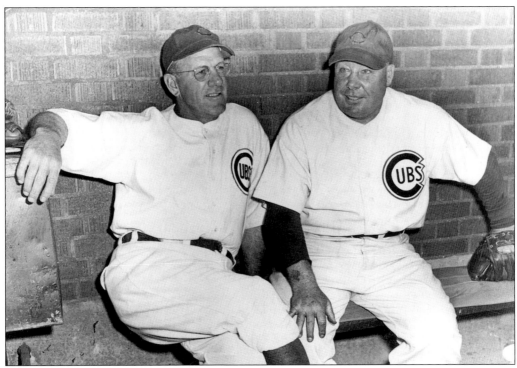

RED SMITH (RIGHT) WITH CHARLIE GRIMM IN THE CUBS DUGOUT.

Red was a coach with the Chicago Cubs from 1945 through 1949, under manager Charlie Grimm. He returned to Milwaukee for the next three years, as President and General Manager of the American Association Brewers, before moving to Toledo in the same capacity, when Milwaukee was awarded a Major League team. His 1953 Toledo Sox set the 1953 Minor League attendance record. Red became General Manager of Buckeye Brewing in 1955, moving up through the ranks to President and Chairman of the Board, during the next 12 years. When the company was purchased by Meister Brau, in 1966, Red was named Assistant to the President, in charge of coordinating sports promotions. He received many honors for his contribution to sports, including the Distinguished Service Award from the National Football Foundation.

The two Red Smith's crossed paths often over the years. Red the Writer always referred to his classmate as "the Imposter." Writing in *To Absent Friends*, he described his classmate as ". . . large and round and companionable and patient. Because he was less explosive temperamentally than Jim Gallagher, the Cubs' general manager, and could consumer even more beer than Charlie Grimm, the manager, he was assigned to sit up nights with executives of other clubs in the hope that they might grow mellow enough to trade him a 20-game winner or .325 hitter for a round of drinks and a player to be named later." According to Red the Writer, The Imposter "...was the last survivor of a jocund company that doubled the flavor and doubled the fun of the sports beat in his time. Owlish Steve Owen, his burly boss; Jack Lavelle, the incomparable raconteur who scouted pro teams for the Giants and undergraduates for Notre Dame; Herman Hickman, waggish and scholarly, who was Red Blaik's assistant at West Point before he became head coach at Yale; and Toots Shor, host to all of them—they were immense and mirthful and almost inseparable, and together they had the weight to stop an express train."

Notre Dame has always had a strong program in Journalism, but the 20s was a particularly strong period. In addition to Red Smith, other famous sports journalists who studied during the 20s were Bert Dunne, mentioned above; Jimmy Gallagher, unique among Major League General Managers, because he was taken directly from the sports pages; Frank Wallace, who worked as Knute Rockne's publicity director during his first two years after graduation, covering the Four Horseman team of 1924; and Arch Ward, who preceded Wallace in Notre Dame Sports Publicity. Ward was quite an inventive fellow. Among his brainchilds were the College Football All Star Game; The Golden Gloves; and the All American Football Conference, which was a rival of the National Football League. After the AAFC folded, three of its teams (the Cleveland Browns, the Baltimore Colts, and the San Francisco 49ers) joined the NFL. Ward's most famous creation was the Baseball All Star Game. Ward's newspaper, *The Chicago Tribune*, was one of the primary sponsors of the 1933 Chicago World's Fair. Ward dreamed up the All Star game to coincide with the World's Fair.

Forty years after this "golden age" for Notre Dame journalists, the Communication Arts Department at Notre Dame (successor to Journalism) enrolled some famous sports names: Jon Spoelstra, who would go on to become President and General Manager of two NBA teams, was the son of Watson Spoelstra, most famous either for creating the Baseball Chapel or for having Denny McLain dump a bucket of water on his head.; Rex Lardner, who was the grandson of Ring Lardner, who got his start writing baseball across the border in Niles (MI) and South Bend; and two men who fancied themselves as baseball and basketball players at Notre Dame; Bill Dwyre and Don Ohlmeyer. Neither was good enough to break in on the playing fields, but Dwyre, as Sports Editor of the "Los Angeles Times," has earned many awards for his work; and Ohlmeyer, who has served as Head of ABC Sports and NBC Television, is best known as the creator of "trash sports," such as "Battle of the Superstars" and "The Skins Game" and as the Emmy-winning producer of Monday Night Football. Dan McGinn was the best athlete in the small group of 30 Communication Arts Majors in the Class of 1966. One of the worst athletes in the group is proud to chronicle the efforts of his more talented brethren.

Another Notre Dame Journalism graduate who did well in sports was J. Walter Kennedy, '32, who served as head of Sports Publicity before going to the NBA as Commissioner.

William Joseph Sullivan's Major League career was hindered somewhat by his quest for a law degree, an uncertainty about which position he should play, and perhaps some immaturity. Somewhat of a prodigy, he entered high school at 12, college at 16, and completed his legal studies and passed the bar exam while in his third Major League season, at age 22.

Because of law school, he was not able to go to Spring Training or join the White Sox until June, in each of his first three seasons. This did not keep him from solving Big League pitching almost from the first moment he faced it. After a few successful pinch-hitting assignments, and a couple games in the outfield, he was put at third base, by Manager Donie Bush. Billy always thought that first base was his best position, but throughout his career he was blocked at the initial sack by such stars as Lu Blue, Hal Trosky, Rudy York, Hank Greenberg, Jim Bottomley, and Dolph Camilli.

BILLY SULLIVAN.

A good bat kept Billy in the Sox lineup at third, even though one sportswriter compared his fielding style to soccer. In 1933, new manager Lew Fonseca wanted Billy to catch and be more of a utility man, as the addition of Jimmy Dykes spelled the end of Billy's tenure at third, but he originally balked, asking for more money for the new assignment. The White Sox were probably getting tired of Billy's negotiations since he had already cost them a lavish $10,000 signing bonus in addition to a princely yearly wage of about $6,000. Eventually Billy agreed to take up his father's old position on his old team (the "legacy" someone called it), but after a dismal hitting performance in '33, Billy was optioned to Milwaukee of the American Association for 1934.

Being with the Brewers for a complete season and training period helped Billy considerably. His 222 hits and .343 batting average led the league and he was in a strong negotiating position for 1935. He was also determined never to return to the White Sox (end of "legacy"). When the Sox suggested St. Paul for 1935, Billy said "no thanks" and threatened retirement.

When Chuck Dressen of the Reds offered the chance to understudy "Sunny Jim" Bottomley at first base, Billy was back in action. He also subbed a little at second and third. He hit well and fielded considerably better. After a year in the Rhineland, he was swapped to the Indians. This proved to be a good break. His manager was Steve O'Neill, an old friend and a former catcher. O'Neill platooned Billy behind the plate with Frankie Pytlak and also showed him some of the finer points of backstopping. After learning the "catcher's peg," in short order he was playing like a veteran.

The Indians had plenty of big lumber in their lineup. Their team average was a robust .304. Pytlak swatted .321, with no power, and was given to hypochondriac tendencies. Billy hit .351 and rapped 32 doubles in 319 at bats. Frankie recovered his health in '37 and being the superior receiver, was able to keep Sullivan on the pines, by hitting .315 to Billy's .286. In the off-season, the Browns traded four players for Billy, now entering his 8th big league season, but barely 27 years old. He led the American League catchers in fielding, hit well and guided Bobo Newsome to his first 20 win season (no mean feat because the whole ballclub won only 55). The next year, Billy found himself in the outfield, while Newsome, his favorite battery mate was peddled to the Tigers.

Bob Feller probably wished that Billy had gone to Detroit along with his friend, because Billy laid down a bunt single against Rapid Robert for the only hit in what became one of his numerous one hitters. In 1940, the Tigers did trade for Billy to reunite the two buddies, and the result was a third consecutive 20-win season for Bobo and a pennant for the Bengals. Newsome was the ace of the staff with a 21-5 record and Billy shared the catching with Birdie Tebbetts (who had been signed by John Dubuc). Billy hit .309 and performed satisfactorily behind the plate for such hurling stars as Tommy Bridges, "Schoolboy" Rowe, Hal Newhouser, Dizzy Trout and Fred Hutchinson.

Billy held out after the '41 season and was banished back to the senior circuit. This exile almost put him in another series, as his Dodgers held a 10-game lead over the Cardinals in mid-August. Unfortunately, the Cardinals put on a great late-season rush and beat the Bums by two games. Billy was Mickey Owen's backup catcher. Billy served for three years on active duty with the Navy, but after a five-year hiatus, returned to the majors in 1947, fully sixteen years after he broke in. He caught a few games for the Pirates, his 7th team in the bigs. One of the reasons for Billy's friendship with the peripatetic Newsome might have been the similarities of their career wanderings, although Bobo was traded more than twice as often as his friend.

Billy reversed roles with his "good-field, no-hit" father. Billy's career average of .289 topped his "hitless" dad by 77 points. Billy also became one of the most difficult strikeouts in baseball history (118 whiffs in 2,840 at bats). An excellent pinch hitter, he had 5 pinch homers among his 55 pinch safeties. He later prospered in the construction trade as a homebuilder.

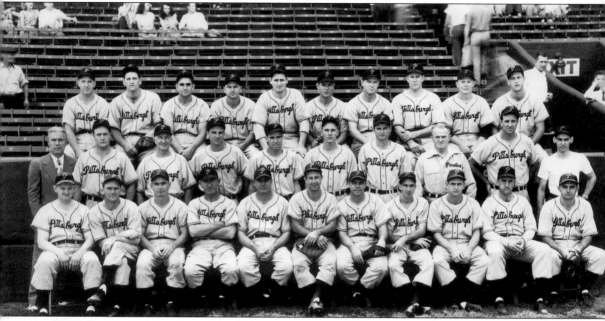

BILLY SULLIVAN (TOP ROW, FAR LEFT) WITH THE 1947 PITTSBURGH PIRATES. Hank Greenburg (middle row, second from right) ranks as one of the great home run hitters. Although the hometown Yankees wanted him, Greenburg signed with the Detroit Tigers and scout Jean Dubuc.

Edward Arthur Walsh was the son of one of the all-time greatest pitchers. In the early years of the American League, the Chicago White Sox produced one of the most remarkable teams in baseball history. The team couldn't hit, but featured good defense and incredible pitching. The bulwark of the mound staff was a former coal miner named Big Ed Walsh. He was the best spitballer who ever played. Another key ingredient was catcher Billy Sullivan. In 1906, in the only World Series ever played entirely in Chicago, Walsh and Sullivan led the "hitless wonders" to an upset of the most winning team in baseball history.

Charles Comiskey, owner of the White Sox, was a man known to keep a firm grip on his wallet, but when Walsh and Sullivan each had two sons with baseball talent; he saw an opportunity to reap some promotional value. Consequently, it was reported that he paid the tuition for all four boys to go to Notre Dame. (Incidentally, another famous Chicagoan sent his son to ND a few years later, although Al Capone Jr. used his father's alias of Al Brown and lasted only a year in college. Young Capone was featured prominently in a photo with his dad and Chicago Cub Catcher Gabby Hartnett, during the 1932 World Series. Baseball Commissioner Landis was not amused.)

As was common in those days, Ed and Bob Walsh used aliases to play semi-pro baseball during their student days. While playing in the Blackstone Valley League, in Western Massachusetts, their Hall of Fame father once came, with much fanfare, to watch them pitch. The field announcer notified the crowd that "Big Ed" Walsh, father of the two "Johnson" boys was in the crowd. During the time Bob and Ed were at Notre Dame, their father served as an informal pitching coach for the Irish. Unfortunately, neither of his sons had the old mans' arm or competitiveness.

On May 1, 1930, Grantland Rice penned a poem to the Walsh boys:

"An Inside Tip"
(to Bob and Ed Walsh, Jr.)

If you two kids would like to wear
A pitching crown upon your hair—

If you would like to reach for fame
And wind up with a winning name

By turning hitters into wrecks
And standing them upon their necks,

With more zip than the human eye
Can follow as the ball sails by—

If you, in short, would like to be
The whiz bangs of this jamboree—

I'll hand you out an inside tip
That I can guarantee won't rip:

Don't waste your time on some new fad,
Just use the stuff your old man had.

BILLY SULLIVAN AND ED WALSH WITH THE CHICAGO WHITE SOX.

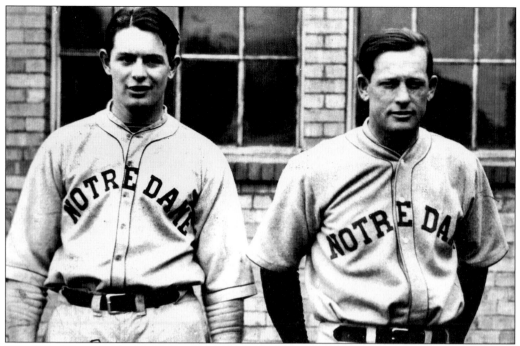

"Big" Ed Walsh. The Hall of Famer helped coach the pitchers at Notre Dame while his sons Ed and Bob were there. Bob Walsh attended Notre Dame after his brother Ed. He won both of his career decisions for the Irish. On April 3, 1929, he defeated Daniel Baker 1-0, despite hitting five opposing batsmen. This is believed to be an unequaled feat!

On September 11, 1932, as a publicity stunt, Comiskey got his one and only publicity value from a reunion of the Walsh-Sullivan battery. The sons hooked up in a meaningless, late season game, which marked the only time in major league baseball history that sons of a battery also appeared in the Majors as a battery, and for the same team as their dads.

On July 26, 1933, Young Ed ended the 61 game consecutive game hitting streak of Joe DiMaggio. This streak preceded by eight years (and exceeded by five games) the Major League record which Joe would later establish. During this Pacific Coast League game, DiMaggio led off for the first time instead of hitting in his usual cleanup slot. Walsh gave Joe an oh-for-four collar, although his sacrifice fly in the ninth won the game after Walsh walked a man to get to Joe. DiMaggio grounded to short in the first and to third in the second. He reached on a force out, on a grounder to second in the fourth, and flied to left in the seventh. His winning fly was caught by the right fielder. The day after the game, DiMaggio said, "I'll say one thing for Ed Walsh, he gave me good balls to hit yesterday, but I just couldn't get the wood on them right."

Ed was traded to Dallas after the 1933 season, for Henry John "Zeke" Bonura. This was a great trade for the Sox. Ed never made it back to the Majors and was dead, in four years. Bonura went on to become a power hitting slugger (.307, 119, 704) for seven big League seasons. Bonura was briefly a "suspect" for this book. The 1936 edition of "Who's Who in Baseball" implied that Bonura had attended Notre Dame, pointing out that "...Knute Rockne, glimpsing this husky youth under a shower at Notre Dame, promptly remarked: 'Get a load of that fellow's physique,' whereupon Henry John was named 'Zeke'." I was able to track down Bonura, at his home in New Orleans and put the question to him by mail. He explained that Knute Rockne had given him his nickname after attempting to recruit him as a track, football, baseball, and basketball star from St. Stanislaus High School, of Bay St. Louis, Mississippi, but that he had not gone to Notre Dame as Rockne had hoped.

The Walsh Brothers were not the only sons of Big Leaguers at Notre Dame in the late 20s. Four other "sons" were out for the baseball team in 1929. Norman Bradley, whose dad Bill was a star third baseman for the Indians was a candidate for that position for the Irish. Ed O'Connor, an outfield candidate, was the son of Paddy, who caught in the American, National, and Federal Leagues. Billy and Joe Sullivan were the other two. Joe was an accomplished college third baseman who would later coach the Irish. Billy played mostly first, for Notre Dame though he would go on to play every position except pitcher and shortstop in the Majors. Billy was the best Major Leaguer from Notre Dame between Cy Williams and Carl Yastrzemski.

Edwin Joseph Lagger was Notre Dame's first Major Leaguer from Joliet, Illinois. Chris Michalak is the latest. In between, Notre Dame enrolled some famous sports figures from Joliet. Chuck Lennon was an outfielder, enrolling with Carl Yastrzemski. Daniel "Rudy" Ruetteger was short on stature but long on grit and determination.

Lagger was 2-2 with Notre Dame before going 2-1, with one save (against Notre Dame) after he transferred to Northwestern. Connie Mack always liked collegians. When he scouted Lagger against the University of Chicago, he saw the 6'3 right hander pitch a 12-strikeout two-hitter. That earned Lagger a direct promotion to the A's and a $300 per month Major League contract. In a 1978 interview, Lagger told the *Joliet Bee* that his Major League highlight occurred each time he was sitting in the left field bullpen when the Yankees were in town. Babe Ruth was nearing the end of his career. In games when he was not likely to bat in the following inning, Ruth would sit in the bullpen. Lagger related "I made it a point to be down there when the Babe was down there."

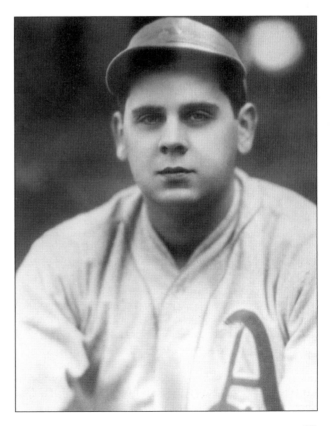

ED LAGGER.

Anton James "Andy" Pilney's major league career consisted of two unsuccessful pinch hitting attempts, but he will forever be remembered as the star of one of the greatest college football games ever played. At the end of 1935, U.P.I. polled 185 sports editors to rate the biggest sports thrills of 1935. Andy Pilney finished first for his performance against Ohio State.

In the first ever meeting between the two Midwestern powers, the Buckeyes took a 13-0 lead into the fourth quarter, "Then the Notre Dame spirit asserted itself," according to Chuck Sweeney, a reserve end that day. Pilney first returned a short punt 28 yards to the Ohio State 12 yard line, from where he completed a pass to the one. The Irish punched it over, but missed the extra point. Notre Dame started their next drive on their own 22. Pilney completed three passes and caught one, for all but three of the 78 yards needed to score. The extra point was again missed.

The Irish recovered an Ohio State fumble at midfield with less than a minute remaining. Pilney was forced into passing on each down, with the Buckeyes waiting for him. He retreated into the backfield, but could find nobody open. He slashed up field and began evading tacklers. Thirty-two yards later, he was knocked out of bounds, and out of the game, by a hard tackle. The team was stunned as he was tended to on the sidelines, but seemed to respond from his inspiration. With only 15 seconds left, Bill Shakespeare (who certainly should have understood the dramatic) replaced Pilney. A play was brought in from Coach Layden by sub Jim McKenna, who had allegedly sneaked aboard the team train. (Notre Dame sports legends are full of anecdotes like this). Shakespeare dropped back and spotted Wayne Millner in the end zone. The pass was true; the grab was sure; the game was over. Pilney had a good view of the reception, from his stretcher at the back of the end zone. Pilney's leg never responded to treatment, so his football playing career was over. Fifty years later, he said, "That knee's been bothering me for 50 years. But it was definitely worth it."

Andy began a 36-year career as a high school and college football coach in 1941, at Chicago's Weber High School. From 1946 through 1961 he was at Tulane University, serving as Head Football Coach 1954–1961. He was named Southeastern Conference Coach of the Year for 1956.

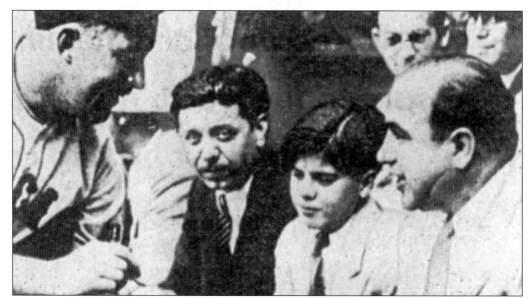

HARTNETT AND CAPONE. In 1931, a young boy, who would enroll at Notre Dame five years later, was part of a sensational story. This photo captured Cubs catcher Gabby Hartnett chatting with mobster Al Capone in a first-row box seat at Comiskey (White Sox) Park during a benefit game. The 12 year-old was Al's son, Albert Francis "Sonny" Capone. He enrolled at Notre Dame under a false name, but dropped out after one year.

FOUR
The Jake Klein Era

Clarence "Jake" Kline took over the baseball program at his alma mater for the 1934 season. Notre Dame baseball was uneven on the playing field, and weak in producing Major Leaguers, for the first two decades of his tenure. War time restrictions limited the number of games played and tight finances limited the amount of aid given to the program.

Jake would remain as Notre Dame's head coach for 42 seasons (558-449-5, .554) and the university would have to wrestle the fungo bat out of his hands to get him to step down, at age 80.

In 1934, Jake inherited a team which had gone 16-17-2 in its previous three seasons. He immediately lost his first seven games and nine of his first ten. He righted the ship, and won seven of his final nine.

The Irish were 20-8 in 1948 and earned their first NCAA Tournament berth, winning District 4, but losing in the first round of the Tournament.

JAKE KLEIN.

Louis Eugene Bevil(acqua) attended Notre Dame as an all around high school athlete. He attended Dixon (IL) High School 10 years after future Chicago Cubs broadcaster, Ronald "Dutch" Reagan. (Reagan is best known for playing George Gipp in the movie "Knute Rockne All American" and for holding a couple political offices in later life.) Bevil's sister Gilda remembered Reagan as "the handsome lifeguard at the Lowell Park Swimming Area on Rock River, who had all the leads in the high school plays." Dixon was also the home of Bob Cahill, Reagan's high school classmate, and Herb Jones. From 1927 through 1976, either Herb or Bob or both worked in the Notre Dame Athletic Department as either Ticket Manager or Business Manager of Athletics.

A speedster and switch hitter, Bevil had an extremely versatile career in professional baseball, excelling as hitter, pitcher, and manager. On July 26, 1942, he pitched a seven inning, 3-0 no hitter, against Atlanta for the Chattanooga Lookouts. He was also the winning pitcher in the Southern Association All Star game, driving in and scoring a run on two hits in tow at bats. This performance earned him a September 2 start with the Senators against the Chicago White Sox. He failed to survive the first inning. His next appearance, four days later, was in relief against the New York Yankees. His fellow Italian, Joe DiMaggio, touched him for a two-run double. Five days later, Lou pitched four shutout innings against the St. Louis Browns. His final appearance was on September 13, against the Detroit Tigers, surrendering no runs in two and one third innings. There have been very few Major Leagues whose careers ended with six and one third shutout innings, but three years of wartime service as a Tank Commander with the Army's 13th Armored Division interrupted his career.

In 1948, Bevil managed Orlando (90-50) to the Championship of the Florida State League. He also led the league in hitting (.365) and won 19 games as a pitcher, with an era of 2.39. For good measure, he played every position except catcher. The following spring he failed to make the Senators as a utility player and retired from baseball.

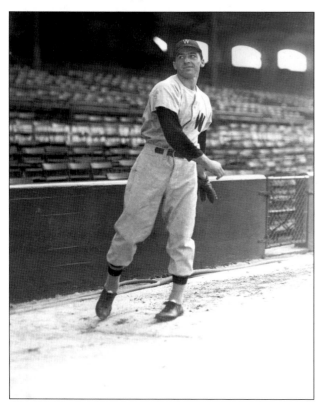

Edward Michael Hanyzewski was the only graduate of a South Bend high school who attended Notre Dame before making his mark in Major League baseball. Ed graduated from Washington High School in 1940. He starred as the left end on the football team which won the State Championship. He was also a basketball star, but it was in baseball where he made his mark, leading the Panthers to three conference championships and leading American Legion Post 357 to the national championship game in 1941.

On June 26, 1941, the Chicago Cubs came down to South Bend for an exhibition game with the Studebaker Athletics, a team made up primarily of collegians who worked for Studebaker in the summers. Ed had fanned nine White Sox batters in a similar contest two years earlier.

Louis Bevil.

ED HANYZEWSKI AS A CHICAGO CUB.

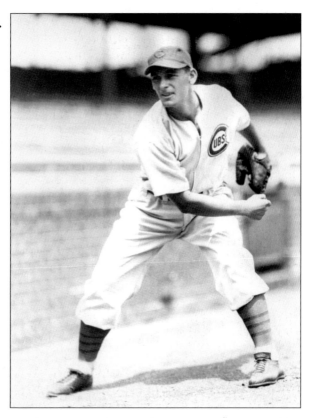

The game was played in Lippincott Park, on West Ewing Street. Two of the Studebakers stars were Hanyzewski, a Notre Dame freshman, and catcher Ray Thomas, who had a cup of coffee with the 1938 Brooklyn Dodgers.

"The big Pole" threw his hummer past 14 of the Cubbies (racking up Swish Nicholson three times). Ed lost 2-0, because he and his mates could muster only three hits off winning pitcher Dizzy Dean and his relief, Paul Erickson. The Studebaker hits were made by Ed and Ray, and another Notre Dame star, third basemen Ernie Wrobleski.

According to the South Bend Tribune, "7,500 baseball addicts" witnessed the night game, the largest crowd in South Bend baseball history. Dean was the favorite of the fans. Although he was now just a Cub Coach, he was able to throw his "nuthin' ball" for three innings and baffled the locals. After his stint was over, Dean took up the position he was to make a career of. From the Press Box, he taunted his teammates and regaled the crowd on the public address microphone. Later, Ed and mound opponent Erickson struck up a friendship and later became Major League roommates and lifetime friends.

Thirty years prior to this game, the Chicago Cubs signed Cy Williams off the Notre Dame campus after watching him in a similar exhibition game. History would repeat itself, as the Cubs signed Ed the next Spring, after General Manager Jimmy Gallagher (himself an ND grad) invited Hanyzewski for a tryout. The scout who signed Ed was legendary Tony Lucadello. A few years later, Lucadello signed Tom Simpson, who spent a short time at Notre Dame before entering the Army . In the same March 31, 1942 press release from Notre Dame announcing Hanyzewski's progress with the Cubs, it was pointed out that Notre Dame had recently attracted the sons of three Big League Umpires as students: Bill Stewart, Jr., Bill Summers, Jr., and Ray and Roy Pinelli.

It took Ed parts of two seasons with the Milwaukee Brewers in the American Association to prove he was ready for the Majors. His two 1942 highlights were pitching a one-hitter against Van Lingle Mungo and the Minneapolis Millers on July 17 and following that nine days later with a 15-strikeout win against the Columbus Redbirds. After starting out at 5-1, in 1943, Ed was elevated to the Cubs where he roomed with Eddie Stanky. Ed appeared in 33 games with the Bruins. Forty-seven pitchers threw 100+ innings that year. Ed finished ninth in ERA (2.56) among them. He won eight and lost seven.

Ed would later recount to Bill Moor of the *South Bend Tribune* that one of his Cubs' highlights was being sent to the mound by skipper Charlie Grimm to stop a club record 13 game losing streak, during 1944. Ed said Grimm gave him a four-leaf clover that a fan had sent. According to Moor, "nine innings later, the slump was over and Hanyzewski had pitched the Cubs to a 5-3 victory over Philadelphia."

ED HANYZEWSKI. After his pro career ended because of an arm injury, Ed returned to his hometown and joined the South Bend Police Department, rising to the rank of Captain. In 1980, he was chosen for the prestigious Russ Oliver Award, given to members of the St. Joseph Valley Athletic Officials Association.

After his pro career ended because of an arm injury, Ed returned to his hometown and joined the South Bend Police Department, rising to the rank of Captain. In 1980, he was chosen for the prestigious Russ Oliver Award, given to members of the St. Joseph Valley Athletic Officials Association.

Lancelot Yank Terry is the most colorfully named man to make the Majors from Notre Dame. He was recruited out of Bedford, Indiana, by George Keogan, to play basketball for the Irish. Keogan won 327 games and posted a .771 winning percentage during his 20 seasons at the helm. Terry was the sixth man on the top ranked Bedford basketball team in 1928–1929, scoring two baskets in an overtime win as the Bedford Stonecutters defeated the Martinsville Artesians in the State Tournament. An all around athlete, Terry was also a star pole vaulter in high school and became a fine bowler.

Terry went out for the Notre Dame Baseball team, as a shortstop, for the 1930 season. He recalled being cut on the very first day of practice by Keogan, whose record was not nearly as good on the diamond (.539) as it was on the hardwood. After dropping out of Notre Dame in 1931, Terry played a lot of semi pro basketball in Southern Indiana and Northern Kentucky. His father, who had been a professional pitcher, urged him to try his hand at pitching. Yank's top semi-pro highlight was a 1-0, 14-inning, no hitter for the 1934 semi-pro championship of the Tri-State Area, leading the Ken-Rad Tubemakers of Owensboro (KY) over the Evansville (IN) Servels, who brought in Minor League pitcher Al Reitz as a ringer for the game. Yank helped his own cause with 12 assists and six whiffs.

He had a 16-12 1935 season with Terre Haute of the Three I League. For the next five years, he pitched for the Louisville Redbirds of the American Association. His most famous teammate was local product Harold "Pee Wee" Reese. Yank won the 1937 season opener over future big league star Dizzy Trout. Although Yank's overall record was well below .500, he impressed the Boston Red Sox, with his highlights, which included a 1938 seven-inning no hitter over Columbus, for the first no-hitter ever thrown in Louisville's Parkway Field. Hank also tossed a 1938, two-hit, 4-0 win over the Milwaukee Brewers and a 1940, 15-strikeout game versus Milwaukee. He was given a shot to pitch for the Sox at the tail end of the 1940 season, defeating the Washington Senators, 12-9. Terry was helped by the Hall of Fame lineup the Sox put behind him. His catcher was Jimmy Foxx. Ted Williams was in right field. Manager Joe Cronin stationed himself at short. Dom DiMiggio patrolled center. Foxx led the 18 hit attack with his sixth home run in five games. Ted had two doubles and a triple. Cronin and DiMaggio each had a homer.

One of the Boston papers reported on the big fan attraction of the game: "Most of Saturday's great baseball-loving throng . . . are coming to boo . . . perhaps cheer . . . the tall, unhappy youngster who plays right field for the Red Sox. That lad, Ted Williams, has talked again once too often, but the Red Sox management, if they have a fondness for gate receipts, shouldn't care too much."

Terry struggled in three other appearances and Pitching Coach Frank Shellenback told him he was tipping off his pitches. Sent down to San Diego of the powerful Pacific Coast League, Yank started the season with a 5-6 record, before his catcher, George Detore, Manager Cedric Durst, and pitching coach Herman Pillette, worked with him on a new pivot in his delivery to better hide his pitches. The new delivery was a slight modification of Freddy Fitzsimmons' motion. Coincidentally, Fitzsimmons was born in Mishawaka (IN), the neighboring town to South Bend.

Once "Twister" Terry "turned his back on hitters," he burned up the league, winning 21 of his final 23 games. With a league leading 26-8 (.705) record and 172 strikeouts, and .231 ERA, he was the runaway League MVP. In one of his incomplete games, Terry pitched 16 innings before being relieved. He also pitched two 13-inning games. That assured a return to Beantown for the 1942 season.

His best Major League season was 1943, when his 22 starts, made him the number two Sox pitcher, behind Tex Hughson. Although he preferred starting to relieving, Yank had a career relief ERA of 3.37. In 1944, he was 2-1 with a 1.36 ERA in 10 games out of the pen. Yank's Major League highlights included two wins in 1942 against the defending World Champion Yankees, wins that are always dear to Red Sox fans. One was a 5-1 three-hitter, which he backed up with a double. The other was an 11-3 win, where he held each member of the famous Yankee outfield of King Kong Keller, Joe DiMaggio, and Tommy Henrich to 0-4 collars. During the 1943 season, Yank defeated the Browns 3-2 in a 10-inning four hitter. He also lost a 1-0 four hitter. After defeating the Tigers, 7-3, on July 25, 1944, a reporter called him the "Squire

of West Roxbury," a better moniker than the "Bedford Buddha" nickname given him many years earlier.

Tony Lupien, star Red Sox first sacker and baseball author, played with Yank in Scranton (PA), Louisville, and Boston. He remembered Terry as ". . . a fine gentleman and good friend" . . . with "a curve ball far superior to many I observe today. . . ." It is not known if Tony and Yank ever spoke about their given first names of Ulysses and Lancelot.

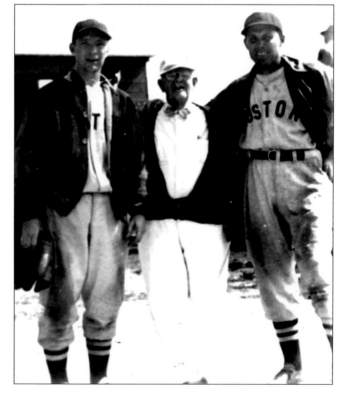

Yank Terry and Battery-mate Bill Conroy at Red Sox Spring Training in 1943 in Sarasota, Florida.

John Joseph McHale came to Notre Dame as a football/baseball star. He was the second team center on the 1940 Irish. His top football game for the Irish was the 7-0, 1940 defeat of Army, when he played both ways for nearly the entire game. Before the 1941 college baseball season, Detroit Tiger scout Wish Egan signed the hometown boy to a professional contract. During his eight-year professional career, McHale kept returning to Notre Dame to earn his degree, perseverance that Jake Kline used as an example to his other players.

John's top Minor League season was 1946, with Buffalo (NY) of the International League. He clubbed 25 home runs, three more than the previous season, in only 92 games. John played for the Tigers during all or parts of the 1943-45 and 1947-48 seasons. McHale hit two homers in one game.

McHale served four decades in Major League baseball administration, starting as Assistant Farm Director of the Tigers, moving up to General Manager in 1957. At 35, he was the youngest G.M. in the Major Leagues. He moved to the same job with the Braves in 1959, moving up to Club President in 1961. He was later named Assistant Commissioner of Baseball. On August 14, 1968 he was named the President and Chief Operating Officer of the expansion Montreal Expos. Frank Shaughnessy's dream of a Major League franchise for Montreal was finally realized, and with a fellow Notre Dame man at the helm. McHale's accomplishments in baseball are too numerous to mention, but two of the top were "Canada's Baseball Man of the Year" (1979) and Executive of the Year, named by "The Sporting News" (1980).

McHale lists his own highlight as pinch-hitting three times in the 1945 World Series. As General Manager, he signed Notre Dame men Jim Brady for the Tigers and Ron Reed for the Braves.

In 1970, I was selected as a "Young Alumni" representative to serve a one-year term on the Advisory Board for the Arts and Letters College of Notre Dame. It was a little intimidating to be surrounded by older men who had all advanced to the pinnacle of their professions. When

I took my seat at the conference table, the tall, distinguished man on my right made me feel immediately at home, "Hi, I'm John McHale." I decided not to mention that I had sent him a fan letter, with suggestions on trades the Tigers should make, 12 years before (see page 128).

Johnny's two best pals at Notre Dame were Frank Gilhooley and Buddy Hassett, each of whom was also a two-sport star (baseball and basketball) at Notre Dame. Gilhooley was the son of Frank "Flash" Gilhooley, nine year Major Leaguer; Hassett was the brother of Buddy Hassett, who played first base for seven years in the Bigs. Gilhooley went on to broadcast the Toledo Mud Hens games for five decades, while Hassett played in the NBA.

JOHN McHALE.

JERRY DENNY.

Notre Dame has enrolled many sons of Major League Baseball Players. One of the first was Harry Denny, '21, who led the campus dance band when he was in school. His father, Jeremiah Denny, a fine third baseman in the 1890s, was reputed to be the last man to play bare-handed in the Majors. The best Major Leaguer to send his son to Notre Dame was Stan Musial. I knew this fact when I applied to Notre Dame, helping cinch the decision for me. Nick Etten, American League home run champ in 1944, saw his son start at tackle for the Irish in the early '60s. Bob Scheffing's son was a classmate of Etten's. Joe Garagiola's son was a walk on baseball player at Notre Dame, under Assistant Coach John Counsell, Notre Dame's 1964 Baseball Captain.

As General Manager of the Arizona Diamondbacks, Joe Garagiola, Jr. not only contracted with the South Bend Silverhawks for his Low A Minor League team affiliation, but also signed Craig Counsell to play for the Snakes. John and Craig Counsell are the only father and sons to Captain the same major sport at Notre Dame.

Jack Snow was a fine high school baseball player, but concentrated on football at Notre Dame, earning All American honors and fifth place in Heisman Trophy voting in 1964. His son J.T. has had a long Major League career. Jack caught all his passes in 1964 from John Huarte, a fellow Southern Californian, who won the 1964 Heisman. Huarte is the son of Joe Huarte, who had a long career as a Minor League player.

From 1943 through 1954, the All American Girls Baseball League operated in several Midwestern cities. Chet Grant Managed the South Bend team during the 1946–1947 seasons. Chet was a Notre Dame quarterback, during 1916, 1920, and 1921, playing in the same backfields with Mohardt and Castner in the latter two years. Chet's uncle, Angus Grant was the Manager of the South Bend Greenstockings of the first decade of the 20th Century.

During 1946, a wealthy Mexico City family of brothers, the Pasquel's, started up a league they intended to compete with the Majors. This was the first challenge to the American and National League dominance since the Federal League, more than 30 years before. There were two Notre Dame connections to the Mexican League. The oldest of the Pasquel brothers, Mario Alejo, enrolled at Notre Dame for the first semester, 1939. He remained less than ten days,

creating some amusement for his fellow students because as a rich dilettante, his background was unlike the blue-collar roots of virtually all of his classmates. Dode Birmingham was serving as an umpire in the League when he died, on April 24, 1946, in Tampico.

Notre Dame employed two former Major Leaguers known to this writer. Ollie Bejma worked as a security officer in the 1960s and '70s. He was a four-year American League infielder, but may have achieved his greatest notoriety when Charles Schultz featured him as a trivia answer in a Peanuts cartoon (Who was the 1938 American Association MVP while playing shortstop for St. Paul?). Former Cubs hurler Gene Fodge worked at the Morris Inn on campus. Fodge was a favorite speaker at South Bend SABR meetings.

JOE GARAGIOLA, JR.

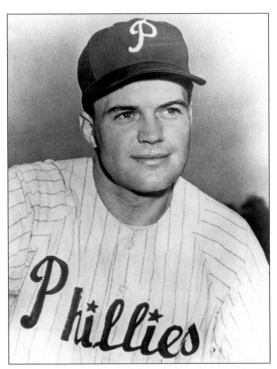

"JACKIE" MAYO.

John Lewis "Jackie" Mayo was a member of the 1950 Philadelphia Phillies "Whiz Kids" team. Mayo was the left field defensive replacement for Dick Sisler, on October 1st, after Sisler hit the three-run 10th inning home run to defeat the Brooklyn Dodgers and put the Phillies in their first World Series in 35 years. Mayo's father was an organizer with the United Mine Workers, accounting for John being named for the long time labor leader.

Jackie came to Notre Dame in July of 1943, as a Marine, in the Navy's V-12 Training Program. His baseball playing impressed Notre Dame Baseball Coach Jake Kline. Mayo captained Notre Dame's 1947 team. He was signed by the Phils on the same day they inked Robin Roberts, who played his collegiate ball at Michigan State. Mayo was known for his determination. Kline told a story about Jackie injuring his throwing arm and practicing throwing left handed an hour a day for a couple months.

William Joseph Reed is still regarded as the greatest athlete ever produced in Shawano, Wisconsin and one of the greatest in Wisconsin schoolboy annals. He earned that distinction for the 15 letters he earned as a four sport star for the Shawano Indians. Because Billy's high school did not have a baseball team, none of his high school accomplishments included the sport where he would have a 10 year pro career.

Billy was the state high school singles tennis champion four times. It was not unusual for Billy to win a tennis match and then head over to the track to compete in the 100, 220, and broad jump. He won three conference scoring titles in basketball and two in football, where he was a single wing tailback. In one of his most memorable athletic moments, he threw a touchdown pass to his brother Johnny to win the Championship Game of the Northeastern Wisconsin Conference. The losing team was coached by his brother Al.

After high school, Reed went to Notre Dame briefly, before heading home to a ROTC unit at Ripon College. When his unit got called up, Billy served four years in the Army, playing football, basketball, and baseball at Camp Grant. He finished his college career at St. Norbert's College. During the 1946-47 season, he played pro basketball with the Oshkosh All Stars.

He began his pro baseball career with Green Bay, in 1946, hitting .363 as a shortstop. Two years later, he led the Eastern League in hitting (.338), while playing second base for Hartford. He returned home to Wisconsin for the next three years, hitting between .311 and .313 for Triple A Milwaukee. Milwaukee, under Manager Charlie Grimm, won the 1951 Little World Series, over Walt Alston's Montreal Club.

In the 1952 season opener, Billy was the starting second baseman for the Boston Braves, getting two hits off Preacher Roe. Although he hit .250, Billy was sent down to make way for Jack Dittmer's .193 average. Billy said that the Braves had too many lefties in the lineup. For the 1953 season, the Braves were now in Milwaukee, but Billy was sent to their new top farm club, in Toledo. He hit .290, .296, and .307 before retiring after the 1955 season. His composite Minor League average was .314. He was also a pretty good glove man, leading five different leagues in fielding, with one title at short, one at third, and three at the keystone spot.

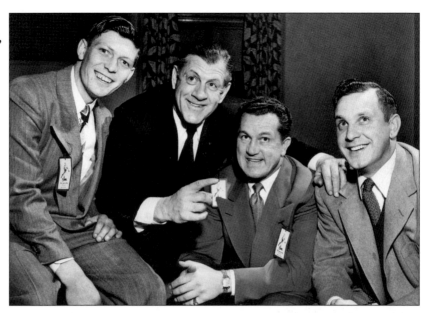

Twenty-five years ago I made friends with Joe Casey, longtime Chief of Police of Nashville. When I learned he was a Minor League baseball pitcher, I told him of my research. He asked if Notre Dame had any players he might have played against. I asked him about Reed. Casey replied "He was my roommate at Hartford." On Monday, May 24, 1948, Casey tossed a 1-0, three-hitter against Scranton, aiding by two game-saving fielding gems turned in by his roommate.

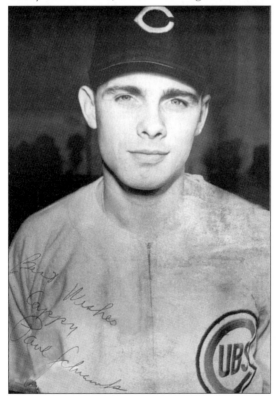

Paul Edward Schramka spent a semester at Notre Dame before transferring to the University of San Francisco. He would go on to be named to the USF Sports Hall of Fame. He was signed by the Cubs after graduation. He had two solid years at Des Moines in the Western League before serving two years in the Army during the Korean War. During Spring Training of 1953, Paul got off to a hot start and was slated to begin the year as the Cubs left fielder, in place of Hank Sauer, who was recovering from a broken finger. Unfortunately, rain and cold caused the postponement of a few games and Sauer reclaimed his spot in the lineup. Schramka wore #14 during his brief time with the Cubs. The next man to wear that number made it part of his personal identification as Mr. Cub.

PAUL SCHRAMKA.

Thomas Leo "Duke" Simpson completed one semester at Notre Dame during the summer of 1945, before reporting for military training. Tom joined the Army with Notre Dame pals George Kelly and Jim Gillis. Kelly went on to a long career in football coaching and Athletic Department administration after finishing his football eligibility at Notre Dame. Jim starred in baseball for the Irish before playing one year of Minor League baseball and then serving in the FBI before beginning a long career in the broadcast industry. Tom holds a distinction for his Army career. Because of his athletic prowess, Tom was placed on Army teams in football, basketball, and baseball, and never made it to basic training during his entire military hitch. Despite their obvious athletic skills, George and Jim slogged through basic training while Tom was passing, dribbling, and pitching.

After completing his military service, Tom attended a state college in his home town of Columbus. Tom's top Minor League season was in 1950, with Savannah (GA) of the Sally League. He was 14-9, with a 3.58 ERA. The following year, at Buffalo, of the International League, Tom started off strong. He recalled he was 7-1 after defeating Toronto, 3-0, in a July 22, 7-inning no hitter. He was brought in to relieve the following day and hurt his arm. In Simpson's words, "The Cubs bought me after the season and with their usual luck, they bought a sore armed pitcher." Tom was called up to the Cubs for the '53 season based upon a strong finish during the tail end of the 1952 season with Springfield of the International League. He appeared in 30 games with the Cubs, in mop-up roles.

Tom is connected to the Notre Dame Football program in another manner. Dick Slager was an all sports rival of Tom when they grew up in Columbus. Dick went on to play quarterback for Ohio State before becoming a prominent orthopedic surgeon. Dick's son Rick quarterbacked the Irish during the 1975 and 1976 seasons. The elder Slager likes to remind Tom that he loaned him a pair of black shoes for his 1949 wedding. Although Simpson retorts that the shoes were two sizes too big, he acknowledges that he did not own a pair of his own. Tom's final year in pro ball was 1954, with the Los Angeles Angels of the PCL. He later was a successful beverage distributor in Southern California.

The Cubs had a terrific radio broadcaster in the 1950s and '60s in Jack Quinlan of Notre Dame.

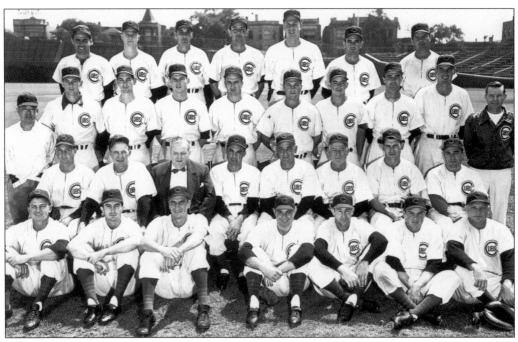

TOM SIMPSON WITH THE 1953 CHICAGO CUBS.

FIVE

Bonus Babies and the Draft

Major League Baseball created "bonus baby" rules in the 1950s and the player draft in the 1960s. Each act was intended to depress salaries. The bonus baby rules required teams to retain on the Major League roster for two years all players signed for more than a certain amount of money. The draft limited a high school or college player to signing with the single team who drafted him.

During Jake Kline's first 28 years as coach, only John McHale and Jack Mayo played on the varsity and later went on to play in the Major Leagues. The bonus rule and player draft would take several more players from the Notre Dame varsity.

Thomas Edward Carroll, Jr. a New York Yankee bonus baby, was the final player signed by fabled Yankee Scout Paul Kritchell. Under the bonus rules at the time, Carroll's bonus (variously reported as $30,000; $40,000; and $60,000) meant he had to remain on the Major League roster of the deepest team of the 1950s for two seasons. The Yankees won the American League pennant 1955 through 1958, with Manager Casey Stengel utilizing a variety of middle infielders. On April 4, 1956, writing for *The Sporting News*, Dan Daniel quoted Stengel as saying "I am in a position to do something no other major league manager can do." "In fact, it is something that no other baseball manager in history could do. I can name the Yankee infield of 1959. I won't be around to manage that infield. But it is going to be a beauty. Marvin Throneberry, first base; Bobby Richardson, second base; Tony Kubek, shortstop; and Tommy Carroll, third base."

Casey went on to extol the virtues of each of young players. He said "Carroll can't miss. Watch him during a workout. When he bats, he won't just walk off after his turn. He will run to first and then pretend he is in a game and continue on around the bases. He watches intently, learns fast, and is as good a hustler as you will find in any camp. The kid has great power now. Watch him in another year."

Casey was correct about two of his picks, as Kubek and Richardson eventually took over the keystone combo, but he was wrong on three of his predictions. For one thing, the Old Perfessor himself stayed with the Yankees through the 1959 season. Marvelous Marv got a shot with the Yanks, but couldn't dislodge Bill Skowron. Marv ended up impersonating a first baseman with Stengel's Mets and starring in beer commercials. Tommy Carroll, though batting .343 in limited appearances during the 1955 and 56 seasons, was not able to stick with the Yanks and was eventually shipped off to the Kansas City Athletics, a team the Yankees abused in trades. This was the 13th trade between these teams during a four-year period. Eight months and three trades later, Roger Maris would be playing right field for the Yankees.

Carroll appeared in a 1955 World Series game, as a pinch runner. He was 19 years and one month old. At that time, only Freddy Lindstrom of the 1924 Giants had appeared in a World Series game at a younger age. Several factors contributed to Carroll's baseball career not reaching the predicted stardom. The bonus rule no doubt hindered his progress. The glut of talent ahead of him on the Yankees was also a factor. Finally, Carroll always returned to Notre Dame in the off-season, to finish his college degree. This did not endear him to Stengel who did not seem to care much for bonus babies or collegians.

TOMMY CARROLL AND PHIL RIZZUTO. New York Yankees bonus baby Tommy Carroll poses with future Hall of Famer shortstop Phil Rizzuto in front of a photo of Yankee Stadium after Carroll signed his contract with the Yanks. Tommy played his first four Major League games filling in for the Scooter.

While at Notre Dame, Carroll became friends with History Professor Marshal Smelser. Smelser wrote an acclaimed biography, *The Life that Ruth Built*, about the greatest player ever to play for the Yankees. The title is a play on words for the photo of Yankee Stadium in the background of the above photo. After Yankee Stadium was build, legendary sportswriter Fred Lieb nicknamed it "the house that Ruth built."

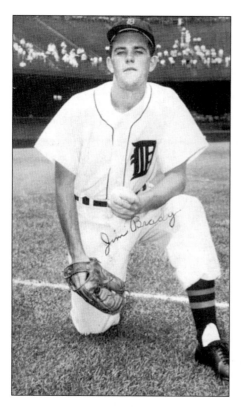

JIM BRADY.

James Joseph "Diamond Jim" Brady was another "bonus baby" of the 50s. Under the Bonus Baby Rule of Brady's time, he had to remain on the Major League roster for two seasons. He got his nickname because his $37,500 bonus was a lot of money for the time. Brady was with the Detroit Tigers for 1955 and 1956, seeing no action in his first year and mopping up in six games in his second. In his first two Major League outings, he got five routine outs (including future Hall of Famers Nellie Fox and George Kell), walking only Bob Boyd, who he promptly picked off first.

Brady had been a left handed fireballer in high school and his first year at Notre Dame. Wildness plagued his career. His top Minor League season was 1957 at Augusta (GA) in the Sally League. In 102 innings, he gave up only 65 hits, while striking out 90. He had a 3.00 ERA. and posted a 6-5 record.

Fortunately for Jim, his widowed father, a longshoreman, knew the value of a college education. He gave his son permission to sign with the Tigers only on the condition that he would finish his Notre Dame degree. Jim did his dad one better, earning three degrees in Economics from Notre Dame. Dr. Brady was an Assistant Professor at Notre Dame and department chair at Old Dominion University before being recruited to Jacksonsonville University where he served as Dean of the College of Arts and Sciences and Dean of the College of Business, before moving into the Presidency of the University. He was widely known as a labor economist.

William John Froats was another left handed pitcher from Notre Dame who found his way to the Tigers in 1955. Like Brady, Froats had control problems and was hard to hit. His top Minor League season was 1951, at Durham (NC), of the Carolina League, where he pitched 143 innings, yielding only 112 hits and fanning 107. He had a 3.27 ERA and posted an 8-5 record.

After the 1955 college season ended, third baseman Donald Sniegowski was awarded one of the 32 Rhodes Scholarships that year.

BILL FROATS.

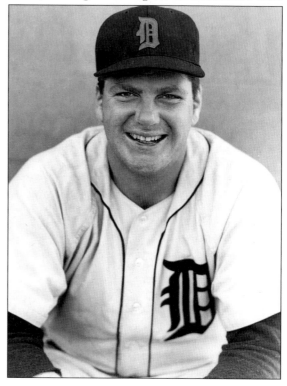

Notre Dame made its first trip to the College World Series in 1957. The Irish were paced by two-time All American Elmer Cohorst at catcher and Jim Morris at first base. Morris went 10 for 14 in the Series to set a CWS batting average record, which still stands. The Irish also set a record for runs scored, with a 23-2 win over Colorado State. The Irish would have been even stronger if Carroll and Brady had not been swept off the campus. Even so, 1958 promised to be another stronger year for Kline's nine, and there was a terrific shortstop recruit in the freshman class. The bonus rule was about to strike again, taking the star shortstop and the top hurler, before the 1959 season could get underway.

Carl Michael Yastrzemski was signed as a shortstop off the Notre Dame campus in February, 1959, before he was to begin his varsity career. He would replace Ted Williams in left field for the Boston Red Sox, in 1961, and follow him into the Hall of Fame in 1988. When he retired after 23 years, Carl ranked first in career games (3308), third in at bats (11,988) and walks (1845), sixth in total bases (5539), seventh in hits (3419) and doubles (646) and ninth in runs batted in (1844). He's the only American league player with more than 3000 hits and 400 homers.

Although he won three batting titles, played in 18 All-Star games and was acknowledged as the finest defensive left fielder of his time, King Carl will be primarily remembered by Red Sox Rooters for his 1967 season, the year of "The Impossible Dream." Starved for a pennant for 21 seasons, Fenway partisans had no reason to think that '67 would be any different from the miserable ninth place finish of 1966, but going into the final week, four teams were still in the race and three teams would finish within a game of one another.

Yaz almost single handedly carried the club during the last month. In the final 12 games, he had 23 hits in 44 at bats (.523), with five home runs, 14 runs and 16 RBIs. The Sox needed to win the last two games with the Twins to avoid a three way tie with them and Detroit. Carl went seven for eight with five RBIs, including a three run homer in the first game. He also snuffed out a twin rally by gunning down Bob Allison at second base on what looked like a sure double.

Carl hit .400 with three homers in the Series. He had gone 4-4 with two walks in the All-Star game. He won the Triple Crown (.326, 44, 121). He also led the league in hits (189), runs (112), total bases (360), and slugging average (.622). He missed one MVP first place vote to a sportswriter who thought that Cesar Tovar (.267, 6, 47) of the Twins was more valuable.) In 12 years as a left fielder, Carl won seven gold gloves and led in assists seven times. On July 21, 1982 he played center field, and went two for three with a run and an RBI. Nearing 43 years, he was likely the oldest Major Leaguer to play center.

YAZ.

Frank Dominic Carpin was one of only three Notre Dame students who entered during the middle of the school year, in 1957. The other two also had sports connections. Albert Perini was the son of Lou Perini, former owner of the Boston Braves. Ron Gregory, a track star, was the brother of comedian, author, and social activist Dick.

On April 16, 1958, lefty Carpin defeated Indiana University with a Ruthian performance. Although knocked around by the Hoosiers, Carpin struck out 19 and hit a dramatic, two-out, three run homer to win the game, 12-10, in the bottom of the 10th inning. The game was covered by *South Bend Tribune* reporter Forrest "Woody" Miller, who has been doing a terrific job covering Irish baseball for five decades.

Carpin once won a Major League game without throwing a pitch. Brought into a tie game to face a lefty, he threw out Adolpho Phillips trying to steal home. He got the win when his mates scored in the bottom of the inning. In 1959, Frank pitched for Greensboro of the Carolina League. Yaz played second base for Raleigh. Both made the Carolina League All Star team. Had they not signed bonus contracts, each would have been leading the Notre Dame varsity instead. Frank's major league career record was 4-1, a "higher winning percentage than Whitey Ford" as he jokingly points out.

In 1959, Frank pitched for Greensboro of the Carolina League. Yaz played second base bor Raleigh. Both made the League All-Star team. Had they not signed bonus contracts, each would have been leading the Notre Dame varsity instead.

Jake and the Irish posted a 22-7 record without the two stars. (This would be the most wins by a Notre Dame team until 1980.) It is not difficult to project a trip to the College World Series had Yaz and Carpin remained in school.

FRANK CARPIN. Carpin heads to class in front of Notre Dame's fabled Gold Dome.

JIM HANNAN.

James John Hannan came to Notre Dame in the footprints of Jim Brady. Each had been start twirlers for St. Peter's Prep School, in Jersey City, NJ. Jim began his senior year at Notre Dame as the ace of the staff. Handicapped by wildness and injury, he ended the year as the eighth man, with a 1-1 record in three appearances. Major League scouts lost interest in him and he returned home to pitch in the Essex County (NJ) Summer League. After tearing up that league, several teams tried to sign him. He inked his name with Bill McCarren of the Red Sox for a $10,000 bonus, with a stipulation for an additional $20,000 if he made the Majors. He burned up the New York Penn League, at Olean (NY), leading the league in wins (17) and strikeouts (254). When the Red Sox did not protect him on their 40-man Big League roster, the expansion Washington Senators (the real Senators had moved to the Land of 10,000 lakes) plucked him.

Manager Mickey Vernon brought Hannan to the Majors for the 1962 season. This made Hannan the final Major Leaguer to make the jump from Class D to the Majors because the Minor League classifications were renamed after the season, putting an "A" in all the League Designations. Hannan once pitched 23 consecutive scoreless innings, over a 12-game stretch as Vernon's "short man." While with the Senators, Jim pitched for some pretty good batsmen. Vernon was followed by Gil Hodges, Jim Lemon, and Ted Williams. His best year for the Senators was 1968, under Lemon, when his 10-6 record contrasted sharply with the team's 55-90 mark without him. Jim stated that the turning point in the season occurred in June, playing against the Indians in Municipal Stadium, in front of a huge bat-day crowd. He said he got off to a rocky start, yielding a leadoff double followed by a homer to Lee Maye. (NOTE: Arthur Lee Maye was also a doo-wop singer who was featured on lead with the Crowns.) The next three batters all hit gargantuan drives which managed to remain in the cavernous park and get recorded as outs. Manager Lemon told him that he was going to be yanked, but when the bullpen coach said that reliever Barry Moore wasn't ready, Jim went out for the second inning, and more punishment. Instead, he retired 26 in a row, perhaps the top Washington pitching performance since the days of Walter Johnson. Maye broke the perfect streak with a two out double. After yielding a single, Jim got the final out for the win. For the remainder of the season, he was the number three man in the Senator rotation, behind Joe Coleman and Camilo Pascual.

Jim's biggest impact on Major League Baseball has been off the field. He wrote his Master's Thesis, at NYU, on the Major League Baseball Pension Plan. Jim was the Player Rep of the Senators and one of only two players, along with two owners, who served on the Major League Pension Committee. One of Jim's advisors for his thesis was Larry Ritter, a renowned Finance Professor, but better known in baseball as the author of *The Glory of Their Times*, one of the finest baseball books ever written. When Marvin Miller was hired away from the steel industry to become the Major League Players' Association Representative, Jim's thesis was one of the first documents he read to familiarize himself with the workings of the Pension Plan. Many years later, Jim would be the Founding Director of the Major League Baseball Alumni Association.

DICK RUSTECK.

Richard Frank Rusteck made his Major League pitching debut on June 10, 1966. He started for the Mets against the Cincinnati Reds, in front of 33,977 fans. Things had been looking bleak for the Mets, in their fifth year as an expansion team. The had lost 17 of their previous 23 games and they were facing hard throwing Jim Maloney, whose 6-1 record included an earlier two-hitter against the Mets. The Mets were also playing without Cleon Jones, one of their few good hitters. The Mets also rested shortstop Roy McMillan (and his .164 batting average), putting veteran Ed Bressoud in his place. Despite the odds, Rusteck showed no fear in shutting out the Reds, 5-0, on a four hitter, striking out an equal number and walking only Pete Rose. No Reds batter reached second base. Bressoud gave Dick all the offensive support he needed by hitting two home runs. The two homers gave the light-hitting Bressoud a new record for home runs by a Mets shortstop (3).

On September 28, the Mets split a doubleheader with the Cubs. Ron Santo hit his 30th homer to power the winners in game one. Only 2,431 paying customers crossed the turnstiles, for the smallest crowd in Mets history to see Rusteck and Shaun Fitzmaurice, his former Notre Dame teammate, play together in the Majors for the only time.

Like all of the Notre Dame Major League pitchers of the '50s and '60s, Rusteck had an unremarkable record for the Irish. He was 5-6 for his three varsity seasons. Only in his senior year (3-4) did he crack the top three of the pitching rotation. Dick's top Minor League season was 1971. He was 17-8, with a league leading 2.40 ERA, for Charlotte in the Southern League. Eddie Bressoud should have pushed for more pitching time for Rusteck. In the eight games he played with Rusteck in the game, Bressoud became Honus Wagner. His batting average was .286, more than 60 points higher than his average in 1966. He also hit three home runs in those eight games, scoring six runs and knocking in eight. For good measure, he also started a triple play in one of the games,

Shaun Earle Fitzmaurice was one of the top baseball players in New England when he graduated from high school in 1961, one of only three New Englanders on the Hearst All Star Team that played in Yankee Stadium. He was a gazelle in center field and on the base paths, had a cannon for an arm, and hit for power.

One of Shaun's baseball highlights was a 500 foot home run against Illinois Wesleyan, on May 4, 1963. Shaun was named the 1964 Most Valuable Player of the Basin League, a South Dakota semi-pro circuit. He hit over .400 for Sturgis. Rod Dedeaux, Head Coach of the University of Southern California Baseball Team, selected Shaun as the center fielder and leadoff batter for the 1984 Tokyo Olympics demonstration baseball team.

Shaun was the Topps Minor League Player of the Month for August of 1966. This earned him a September promotion to the Mets. He joined the club on the same day as Nolan Ryan. Shaun made his Major League debut on September 9, two days before Ryan. Shaun was the leadoff batter and center fielder. The Mets lost the game, with the loss tying the record for most losses by a Major League team in five consecutive seasons. Shaun pinch ran the next day, as the Mets broke the record. Before the game, Marvin Miller, the new Counsel to the Major League Players' Association, spoke to the Mets players.

Among Shaun's nine games in the Majors, mostly as a pinch runner, was one play which helped cost the San Francisco Giants a shot at the pennant. On September 16, the Giants led the Mets 3-2 heading into the ninth, having taken the lead on a Willie Mays single in the home half of the eighth. Chuck Hiller led off the Mets ninth with a walk. Fitzie ran for him. After two pinch batters struck out, Shaun stole second. He scored the tying run on Hawk Taylor's pinch single. Johnny Lewis, running for Taylor scored what proved to be the winning run on Bud Harrelson's second triple of the game. Had the Giants won this game, they would have been only one game back of the Pennant Winning Dodgers. Because the Giants had a rainout, which could have been played, a win in that game would have meant a playoff for the National League Pennant.

Shaun was a successful pinch hitter on October 2, remaining in the game in center field. Two of his Notre Dame pals also played that day. Rich Rusteck appeared in relief for the Mets, giving up only one hit while fanning three in three scoreless innings. At the same time, Ron Reed won his first Major League game, against the Reds, pitching six scoreless innings, giving up only three hits.

Ronald Lee Reed became the third man from Notre Dame to make a 1966 Major League debut, on September 26. Three years earlier, he made a dramatic entry into Notre Dame Athletics. On December 1, 1963, the Notre Dame Basketball team opened its season against the Pumas of St. Joseph College (IN). Some fans may have been apprehensive about the inexperience of the Irish lineup that featured four sophomores. As soon as the men in green passed the ball to a lanky forward from nearby LaPorte, the packed Field House knew that Notre Dame had something special in Ron Reed. He led both teams with 35 points and 19 rebounds.

Possessing a soft shooting touch, great leaping ability, and a flair for spectacular dunks years before it became customary, Reed was a big crowd favorite. He received honorable mention All American recognition after his senior season. He was one of the top college rebounders and scorers (21.2). His three-year scoring average of 18.9 put him second on the Notre Dame career list at that time.

Reed did not enjoy the same success in college baseball. Freshmen were ineligible for varsity competition in those days and he missed the next two seasons to concentrate on his schoolwork. His 1965 season did not suggest any hints about future success. He was no better than the third ace on the team behind stylish left hander Ed Lupton (who pitched in the Senators system) and Dan McGinn, a hard throwing lefty who also toiled for the Irish gridders. Lupton's 8-4 record and McGinn's 4-3 mark overshadowed Reed's modest 2-1 ledger.

Reed had some success in summer leagues and attracted some attention from Major League scouts. This writer once took a phone message for Reed, in Morrissey Hall, from Kansas City A's Owner Charley Finley (who lived in Reed's hometown of LaPorte). Despite the baseball interest, there was no doubting that basketball was the sport where Reed's future lay. He was drafted by the Detroit Pistons. With no Major League teams showing interest, in the first year of the player draft, he agreed to terms with them on the condition that he could attend a baseball training camp as a free agent. Reed later reminisced with *South Bend Tribune* writer Joe Doyle about his first tryout camp. Finley had Pitching Coach Eddie Lopat watch him throw. After a few pitches, Lopat told Reed, "Forget it, you won't make it."

The Pistons recommended Reed to Johnny McHale, the General Manager of the Atlanta Braves. Reed showed some potential and was signed for the Braves farm team in West Palm Beach (FL), of the Florida State League, where he finished the season with a 3-2 record. He joined the Pistons at the end of the baseball season and settled in as the Piston's sixth man. Ron began the 1966 baseball season by losing his first start. He then won 13 of his next 17 decisions as he moved from the Class A Carolina League (Kinston, NC) to the Double A Texas League (Austin, TX) and the Triple A International League (Richmond, VA). New Braves General Manager Paul Richards happened to be in the stands one night while Ron was pitching a four hitter for Austin. When he made his Major League debut, Reed felt a range of emotions. "I simply couldn't imagine facing Willie Mays, who I idolized for as long as I could remember." Mays presented no problem, rolling out to the infield. The other Willie (McCovey) was a little tougher, hitting a blast that gave Ron his first big league loss. On the final day of the 1966 season, against the Cincinnati Reds, Ron pitched a three-hit win. Ron was back at Richmond for most of the 1967 season, winning 14 games including 5 shutouts in his first 10 wins, before another September call-up. He was in the Majors for good for the 1968 season.

By the time Ron reached the Majors, he had joined a select group of around two dozen men who had played both Major League baseball and NBA Basketball. This group included Dave DeBusschere, the Pistons Coach, who opted to head in the other direction. Everywhere he played people compared him to Gene Conley, probably the most successful of the two sporters. For Conley's six NBA seasons, he average 5.9 points per game. Reed averaged 8.1 points per game for his two seasons. His NBA stats, prorated to 48 minutes per game, were 16.5 rebounds and 20.8 points per game. After two years as an NBA sixth man, Ron yielded to a two-year contract with the Braves that contained a provision that he abandon the hardwood. In the 1968 All Star Game, there was nearly a Notre Dame "match-up." Reed was on the mound in the ninth when Carl Yastrzemski came to the plate with two out. National League Manager Red Schoendienst did not want to risk Yaz tying the game with one swing, so played the percentages and brought in lefty Jerry Koosman. Ironically, on February 16, 1984, the Chicago White Sox would send Jerry Koosman to the Phillies to complete the deal where they obtained Reed the previous December.

In 1969, Reed won 18 games and appeared in his first League Championship Game. A series of injuries hurt his progress as a starting pitcher. On the night of April 8, 1974, Henry Aaron made baseball history by hitting his 715th home run, eclipsing Babe Ruth's "unbreakable" career home run record. Reed bested the Dodger's Al Downing for the win. Ron went to the Cardinals for the second half of the 1975 season, winning 13 games and yielding only five home runs for the two clubs. In the off-season, he was traded to the Phillies, where his career achieved its greatest fame. Converted to the bullpen by Manager Danny Ozark, Ron teamed with Tug McGraw for the next eight years to give the Phils an effective lefty-righty tandem. In 1976, Ron had a remarkable inning/hits ratio or 128/88. He pitched in five more League Championship Series (1976–1978, 1980 and 1983) and two World Series (1980 and 1983). His save in game two of the 1980 Series helped earn him his World Series Championship ring. Coming out of the pen perfectly suited Reed's attributes. He had pinpoint control, the ability to change speeds, a sweeping motion, and the stamina to pitch 60 games a year. He was also unflappable.

In 1979, Reed led the Majors in relief wins with 13. When he retired after the 1984 season, he stood 15th on the all time games pitched list with 751 (one more than Warren Spahn). He was also in the top 40 in relief games (515), saves (103), and saves plus wins in relief (157). Gene Conley finished his 11-year Major League career with a record of 91-96. Reed's tally was 146-140.

Richard Crispin Thoenen was a fine athlete at Mexico (Mo.) High School, playing football, basketball, and baseball. Like Reed, he was a 6'6" baseball-basketball standout and 1961 recruit. During his first three years as a pro, Dick was a hard throwing starting pitcher, relieving in only 4 games of his first 79 pitching appearances. Experiencing only moderate success, he was switched to the pen in 1966, with Macon. He compiled a 7-1 record and a 2.61 ERA, earning a promotion to San Diego, where he dropped his ERA to 2.10. After winning 6 and losing 2, with a 1.67 ERA, the following year, the Phils decided elevated him to their bullpen. Up to this point, he had compiled a 14-3 relief record, allowing only 144 hits in 173 innings.

Thoenen's big league career consisted of one inning in relief of Rick Wise, on September 16, 1967. Brought in to face the Dodgers in the fourth inning, he gave up two hits—a double to Bob Bailey and RBI single to Luis Alcaraz.

RICHARD THOENEN.

"DANGEROUS" DAN McGINN.

Daniel Michael McGinn produced two of the highlights of the 2-7 1963 Notre Dame Football season. In the year before Ara Parseghian returned Notre Dame Football to its previous glory, not many miracles occurred for the Irish. McGinn, the team's punter came in against Purdue and was forced to chase an errant snap pursued by half a ton of Boilermaker beef. While on the run, the athletic McGinn got off a 50-yard soccer-style boot. In a subsequent game, he completed a first down pass in similar circumstances; thus a nickname was born: "Dangerous Dan." To this day, some of his college classmates, like this reporter, still refer to him as "Dangerous Dan."

Jake Kline recalled that there was another place where the left handed McGinn was a danger. Each year, before the temperatures in South Bend permitted the Notre Dame baseball team to practice outdoors, they would spend weeks warming up in the old Field House. Jake said that catchers were always scarce when McGinn needed warming up. In that dimly lighted old building, Dan's 90-plus mile per hour fastball and uncertain control presented quite a challenge to the backstops.

McGinn's football ability may have hampered his baseball development. In addition to being the regular punter for three years, Dan also served as a backup quarterback and missed all of the fall baseball workouts and some spring work as well. Dan couldn't concentrate on baseball in high school either, since as a three sport star, he would as likely be dribbling or passing as hurling. McGinn received multiple athletic scholarship offers in each sport.

Dan had many fine accomplishments in his eight-year pro career, after being the Cincinnati Reds' first pick in the secondary phase of the 1966 draft. In his third pro season, the relief workhorse pitched in 88 combined games for Asheville and Cincinnati. Shortly after he made his September 3rd Major League debut, he was brought in to hold a one-run lead against the Pirates. Dan recalled that there were two on and one out, with Willie Stargell the batter. "I finished my warm-ups and Johnny Bench came out to the mound to go over the signals with me, just like I had seen on T.V.—'Johnny goes out to talk to his pitcher'. Bench looked at me and said, 'Mac, you're in trouble,' smiled and went back to home plate. I about wet my pants, but I got Stargell to pop up and Al Oliver to ground out to Perez. I got the save. And a smile from Johnny."

McGinn then set a rookie record, pitching in 74 games for the 1969 expansion Expos. Dan hit Montreal's first Major League homer on April 8, 1969, off future Hall of Famer Tom Seaver. Six days later, Dan got the win in relief, with five and one third innings of scoreless ball, in the first major league game played on foreign soil. Dan's single knocked in the winning run.

DAN MCGINN. McGinn is one of thirteen men from Notre Dame who have played for the Chicago Cubs.

On May 11, 1970, Manager Gene Mauch, in a surprise move, pulled Dan out of the bullpen for his second major league start, against the Mets. Perhaps Mauch thought that there was no sense wasting a regular starter against Tom Seaver, who had won 16 straight. Seaver pitched very well, holding the Expos to eight hits and three runs while fanning a dozen. McGinn was tougher, holding the defending major league champs to three hits and no runs. "I guess I was psyched up. Pitching against a guy like Seaver can do it." Four days later, Dan went the route again, with a five hit 2-1 win over the Pirates. He three hit the Pirates for his other shut out, late in the season.

Unlike many other hard-throwing left-handers, Dan never had arms miseries. He estimated that during 1969 he warmed up in more than 130 games. Despite the absence of injury woes, Dan did not achieve the stardom his live arm seemed to suggest. Part of the reason may have been control problems. Various pitching coaches experimented with three quarter and sidearm deliveries in an attempt to tame his flame.

At Notre Dame, the handsome McGinn was known as a jokester, keeping the team loose. He had perfected one of the better impersonations of Coach Kline, whose old-time sayings and gyrations cast him as a Casey Stengel-type figure.

For the late '60s Notre Dame's catcher was supposed to be a young man out of Chicago named Ken Plesha. The White Sox took Ken with their first pick in the 1965 draft and for a $20,000 bonus, Jake Kline was again deprived of a promising player.

Joseph E. Kernan caught for Notre Dame in 1967 and 1968. Joe did not play pro ball but he served his country in a much higher calling. He flew 26 combat missions over Vietnam and Laos as a Naval Aviator. After being shot down over North Vietnam, he was held as a prisoner of war for 11 months. He was awarded the Distinguished Flying Cross, two Air Medals and other decorations for his military service. He later served nine years as Mayor of South Bend, longer than any other person. After being elected to two terms as Lt. Governor, Kernan was sworn in as Governor Indiana on September 13, 2003, upon the death of Governor Frank O'Bannon.

Notre Dame came very close to putting another former Quarterback in a Major League game in 1970. Richard "Moose" Sauget had caught both Reed and McGinn at Notre Dame. Like his classmate McGinn, Sauget was a scholarship football player. Recruited as a quarterback, he ended up playing for the Irish as a linebacker.

In 1968, Sauget moved up the Minors in successive weeks, landing on the Braves. He spent one week in the Majors, but did not get into a game, so although he drew a Big League paycheck and wore a Braves uniform, he is not listed in the official playing records of the Majors. Sauget caught some famous pitchers in his career. He caught the immortal Satchel Paige in an exhibition game, with West Palm Beach (FL) shortly after signing his first pro contract. He also caught Bob Feller in an exhibition and Hoyt Wilhelm and Phil Niekro while with the Braves.

Sauget shares an academic distinction with Jim Hannan. Rich wrote his Masters Thesis on a baseball topic: "The Economic Impact of the 1967 World Series on the St. Louis area." Rich is a successful businessman, living in the eponymous town of Sauget (IL), where he owns the Gateway Grizzlies, an independent baseball team, and built his own ball diamond.

Long-time Cardinal Fan Rich Sauget, and His Wife Judee, Meet with the Head Cardinal.

Six

The Comeback

Notre Dame made a change on the coaching lines for the 1976 season. Tom Kelly brought youth and vigor, necessary qualifications since Notre Dame was still 20 years away from giving more than two grants in aid (far fewer than the NCAA permitted). Kelly and his successor, Larry Gallo, kept the Irish competitive until the arrival of Pat Murphy, in 1988.

Murphy brought a linebacker's intensity to the program. He proved to be a fine recruiter and great promoter. He initiated the Fall Baseball Classic, bringing in powerhouse teams Wichita State, Miami, and Southern Cal. Murphy had a .730 winning percentage and made Notre Dame a ranked team. His success got the attention of Arizona State, a perennial powerhouse since the mid-1960s, which hired Murphy for the 1995 season.

Notre Dame followed the Murphy hire with an even better one in Paul Manieri, son of the legendary Miami Dade Coach Demi Manieri. (Demi won more than 1,000 games and a national title for the most storied junior college program in baseball history.) Paul, following in that tradition, has won at least 40 games in each season at Notre Dame. In 2002, the Irish advanced to the College World Series. That same season they achieved the number one ranking for the first time and defeated both Florida State and Rice when those teams were ranked number one.

Manieri has shown the ability to recruit outstanding players and his first two coaching recruits, Brian O'Conner and Cory Mee, are now head coaches at Virginia and Toledo, respectively.

Daniel Edward Peltier left Notre Dame with a career average of .406, highest in school history. He also slugged .659 for the Irish, the second best mark. In 633 at bats, he drove in 202 runs, third best in Irish history. Dan's senior year (1989) triple-crown statistics were .446-15-93, the greatest single season in Notre Dame history. Showing that these numbers were not flukes, Dan also hit .400 in his first season in pro ball. Unfortunately, he suffered a shoulder injury diving for a ball in the outfield and he was never quite the same hitter.

Dan's Major League career was sidelined in 1995, because of Major League labor issues. After being a sub outfielder-first baseman during the 1992 and 1993 season, Dan spent the 1994 strike season with Oklahoma City. During Spring Training of 1995, Dan refused to cross the picket line to join the Rangers' Major League "replacements." After the strike was settled, Peltier was handed his release. After working out at the Free Agent Camp, in Homestead, Florida, he signed with the St. Paul Saints of the independent Northern League. After hitting .366, Dan got a call from the San Francisco Giants for the 1996 season. Assigned to Phoenix, Dan was brought up to replace injured Glenallen Hill on the basis of being the hottest hitter (.372) in the PCL.

Dan was a two time Academic All American for the Irish. When he played for the Rangers he bonded with Owner George W. Bush, who was impressed with Peltier's Notre Dame degree. Peltier recounted later that he told Bush, in 1993, that he should someday run for President. In a 2001 interview, Peltier told *South Bend Tribune* columnist David Haugh that Bush said that he got booed at a 1980 mock political convention at Notre Dame when he said he was a Yale graduate but won the crowd back with loud applause when he said "The only reason I went to Yale was that I couldn't get into Notre Dame."

GEORGE H.W. BUSH, GEORGE W. BUSH, AND DAN PELTIER. Texas Rangers outfielder Dan Peltier, with Ranger owner George W. Bush and Bush's father, who played in the first College World Series, for Yale, in 1947. Yale lost to Cal in the finals of the C.W.S. which was then held in Kalamazoo, Michigan.

TOMMY SHIELDS.

Thomas Charles Shields graduated from Notre Dame as a starting player with the ability to play several infield positions. He demonstrated that versatility by playing all positions on September 4, 1991, in the final regular season game with the Rochester (NY) Red Wings of the International League. He had Major League cups of coffee with the Orioles in 1992 and the Chicago Cubs in 1993. After his playing career ended, Tommy tried his hand at managing, serving in the SALLY League.

Craig Counsell appears on many of the all time batting lists at Notre Dame including for games, RBIs, doubles, runs, stolen bases, and bases on balls. He was recently voted by his Major League peers as the player who most "overachieves" with his talent. This lofty praise is well deserved. Everywhere he has played, he has been a crowd and Manager favorite, because of his attitude, hustle, versatility, and knowledge and love of the game. As a spindly 5'10, 145 pound recruit at Notre Dame, Counsell began his college baseball career, in 1989, as a left fielder. Eight years later he won his first World Series ring, with the Florida Marlins, as the starting second baseman. Craig knocked in the tying run and scored the winning run in the Series. He won his second ring, with the Arizona Diamondbacks, four years later, as the starting third baseman. He also played a lot of shortstop for the Diamondbacks.

CRAIG COUNSELL. Craig Counsell scores the winning run for the Florida Marlins in the 1997 World Series, as dejected Indians catcher Sandy Alomar walks off the field.

121

Christian Parker came to Notre Dame as a DH-Pitcher. After compiling a 12-8 record in two seasons as a starting pitcher, Parker and his mid-90s fastball, was taken in the 4th round of the 1996 Major League draft. Parker was sent to the New York Yankees in the trade that send Hideki Irabu to the Expos. Chris posted a 14-6 record and 3.13 ERA with the Norwich Navigators, earning him a trip to Spring Training and a shot at the fifth spot in the Yankee rotation. Among his competitors were former Big League stars Dwight Gooden and Sid Fernandez. Posting a 1-1 record in five spring appearances earned Parker the pitching slot. He made his Yankee debut on April 6, against the Toronto Blue Jays. Pitching in Yankee Stadium, Parker had a rough outing, losing to the Jays 13-4. Carlos Delgado and Jose Cruz, Jr. hit homers off Parker, in his three plus innings of work.

Christian Matthew Michalak, of Joliet (IL) graduated from Notre Dame ranked first in career games pitched (92, including 43 starts). The lefty had a 34-13 record, with 12 saves, seven shutouts, and a 3.21 ERA. Despite his college success, Chris may have felt he was a Major League version of fellow Joliet native Rudy when he finally made his Big League debut, for the Arizona Diamondbacks, on August 22, 1998. He was 27 when he got the call up and had toiled in the Minors without much fanfare for five years. After two additional years in the bushes, Chris got a chance to be a Major League starting pitcher, in 2001. There are not many pitchers who've gotten their first chance to be a Big League starter after age 30. Chris started out with three consecutive wins, after being a non-roster invitee with the Toronto Blue Jays. His first win was against the Yankees, on April 7, 2001, when he pitched $5^1/_3$ innings of shutout ball. Two months later, Chris got his first Major League at bat, and tripled. Chris also picked off his league leading sixth base runner. Earlier in the game, he had laid down two sacrifice bunts. While at Notre Dame, Chris also served as a DH and first baseman.

Like Rudy, Chris was a former football player, but Chris was a little more skilled, leading Rudy's former team (Joliet Catholic High School) to the state championship as their (right handed) quarterback.

Brad Lidge left Notre Dame in 1998, as the Big East pitcher of the year and Houston's number one draft selection. The Astros took Lidge with the 17th overall pick with a draft choice they received losing Darryl Kile to Colorado as a free agent. Lidge's Big League highlight game occurred on June 11, 2003. After Astros' pitching star Roy Oswalt injured himself during the first inning of an inter-league game against the Yankees in Yankee Stadium, the Astros decided to use their entire bullpen to finish out the game. One by one, each Astro pitcher was as good as the one before, none giving up a hit. A scorer's decision gave the win to Lidge, who pitched the sixth and seventh innings, not walking a batter, while striking out two.

After four seasons in the minor leagues, Lidge had four wins and three surgeries to show for the 100 innings of his career. Now that he is finally healthy, he has shown the ability to be a Major League set-up man and closer.

Aaron Heilman finished his four years at Notre Dame, graduating in 2001, as the schools all time leader in games won (43-7) and strikeouts (425), second in games pitched (83) and complete games (26). He is tied for second in saves (12), most of which were accumulated during his freshman year when he led the nation in ERA while working as a closer. Aaron led the Irish in ERA each of his four seasons and in wins in each of his three seasons as a starter. After turning down the offer of the Minnesota Twins as the first pick in the Sandwich Round Draft of 2000, Aaron returned to post a 15-0 record during his senior season, insuring his selection as a first round pick of the New York Mets.

Aaron made his Major League debut on June 26, 2003. He got his first win, on July 22, against the Phillies. Heilman would be the consensus choice as the starting pitcher on the All Time Notre Dame College team.

NOTRE DAME

STEVE STANLEY. Steve Stanley was a finalist for 2002 National Player of the Year. He was a consensus All-American who ended his Notre Dame career second in NCAA history for career hits (385). Steve was the first repeat winner as Big East Player of the Year, won the 2000 Thurman Munson Award for leading the Cape Cod Summer League in hitting, and was named 2001 MVP of the Great Lakes Summer League. Arriving at Notre Dame as an under-sized, under-recruited player, he made striking improvements in his hitting year after year (.326, .362, .400, and .439). A continual highlight film as defensive center fielder, Stanley ended his career as arguably the greatest player in Notre Dame history.

TWO LEFTIES. Brian Stavisky (right) and a writer of little note (left).

Who will be the next Notre Dame ballplayer to make it to the Major Leagues? It could be Steve Stanley or Brian Stavisky, the two men who led Notre Dame to Omaha in 2002. Stanley has made quick progress in the Oakland A's system, continuing to confound anyone who thinks he is too small. There are few Major Leaguers who can run down balls like he can. Stavisky's dramatic and gigantic walk-off home run defeated number-one ranked Rice in a 2002 College World Series elimination game, after Stanley's outfield play and batting sparked the comeback. Brian is also in the A's organization.

There are some pitchers with a good chance. Danny Tamayo is a top prospect in the Royals organization. J.P. Gagne, the grandson of Vern Gagne, the top college wrestler of the late 1940s and one of the leading professional wrestlers of all time, is Notre Dame's career leader in games pitched and saves. His consummate change-up is his feature pitch. He's in the Rockies system.

Chris Neisel has been a star for the Irish since his 2002 freshman year. Hie's a Greg Maddux-type hurler and a likely first round draft choice, as is classmate Grant Johnson, a big, hard thrower. Lanky Canadian John Axford already throws in the mid-90s and has the frame to gain weight and muscle. Ryan Doherty, at 7' 1^1/$_2$" is believed to be the tallest man ever to play baseball at a competitive level. He's already shown the ability to be a top closer. Jeff Manship was reputed to have the finest high school curve ball in 2003 when he enrolled at Notre Dame.

Among position players, three likely candidates are second basemen. Steve Sollman, one of Ohio's most versatile schoolboy stars, will finish his career among the Notre Dame leaders in most offensive categories. Matt Edwards' powerful bat led the Big East in RBIs (69 in 62 games) in 2003. And Matt Macri, the top-rated recruit in Notre Dame history, has a rifle arm from the left side of the infield and has great hitting potential.

Vince Naimoli graduated from Notre Dame in 1959, with a degree in Mechanical Engineering. He became a very successful businessman. Since 1998, he has served as the lead investor and Managing General Partner of the Tampa Bay Devil Rays Baseball team.

Other Notre Dame men in Major League Baseball include: Larry Dolan, '54, President and CEO of the Indians; Brian O'Gara, '89, Director of Special Events for Major League Baseball; and Ted Robinson, '78, the radio voice of the New York Mets. Tommy Hawkins, '59, is the Vice President of External Affairs for the Dodgers. Hawkins still ranks as one of the greatest basketball players in the annals of Notre Dame.

Notre Dame may also lay claim to the most infamous baseball fan of the 2003 season. Steve Bartman, a 1999 Notre Dame graduate and Cubs fan, while attending game six of the NLCS, unintentionally interfered with a foul ball on target for Moises Alou's glove, which would have put the Cubs four outs away from their first World Series appearance in decades.

NOTRE DAME'S 2002 TEAM. The 2002 team (50-18) returned to the College World Series for the first time in 45 years.

Nine decades after Fr. Sorin came across the Atlantic, Theodore Martin Hesburgh, from Syracuse (NY) came to Notre Dame to study. As Fr. Ted Hesburgh, he completed his 35th year as President of Notre Dame in 1987. During his Presidency, Fr. Edmund P. Joyce served as his strong right hand man, in the position of Executive Vice President. Notre Dame made incredible growth in facilities, prestige, building expansion, academic and athletic programs, and endowment during their tenure. As you might guess, there is a Major League Baseball connection here. New York Yankees Owner George Steinbrenner chose Fr. Ted and Fr. Ned to throw out the first ball, in Yankee Stadium, for the sixth game of the 1996 World Series. The Yankees won yet another World Championship a few hours later.

Hesburgh recalled that he enjoyed this experience and the Yankee win because his father rooted for only two teams: Notre Dame football and Yankees Baseball.

APPENDIX

Notre Dame Football Players
Who Later Played in the Majors

Player	Year	Position
Shaughnessy, Frank	1901	Left End
" "	1902	Left End
" "	1903	Right End
" "	1904	Right End and Captain
Daniels, Bert	1908	Reserve End
Kelly, Red	1909	Second Team, Left Half
Williams, Cy	1910	Second Team, Left End
Bergman, Dutch	1910	Third Team, Right Half
" "	1911	First Team, Right Half
" "	1913	Second Team, Right Half
Mills, Rupert	1913	Third Team, Right End
Bergman, Dutch	1914	First Team, Right End
Mills, Rupert	1914	First Team, Right End
Mohardt, John	1918	Third Team, Right Half
" "	1919	Third Team, Left Half
" "	1920	Second Team, Left Half
Castner, Paul	1920	Second Team, Fullback
Mohardt, John	1921	First Team, Left Half
Castner, Paul	1921	Second Team, Right Half
Smith, Red	1925	Second Team, Right Guard
" "	1926	Second Team, Right Guard, Third Team Fullback
Pilney, Andy	1933	Second Team, Left Half
" "	1934	Second Team, Left Half
" "	1935	Second Team, Left Half
McHale, John	1940	Second Team, Center
McGinn, Dan	1963	Punter
" "	1964	Punter
" "	1965	Punter

12018

WESTERN UNION

The filing time as shown in the date line on full-rate telegrams and day letters, and the time of receipt at destination as shown on all messages, is STANDARD TIME.

Received at Western Union Building, 455 Cherry St., Macon, Ga. 1931 APR 1 PM 1 47

QA261 55=TDC SOUTHBEND IND 1 1205P

MRS K K ROCKNE, DRAWING ROOM A CAR F 56=

CHICAGO & EASTERN ILLINOIS DIXIE LIMITED NORTH BOUND

MACON GA=

YOU HAVE MY HEARTFELT SYMPATHY AND I WANT DO EVERYTHING I

CAN HELP YOU STOP HAVE TALKED TO FATHER ODONNELL AM ARRANGING

HAVE AUTOMOBILES ENGLEWOOD STATION SIXTY THIRD STREET CHICAGO

DRIVE YOU DIRECTLY SOUTHBEND PLEASE HAVE SOMEONE ADVISE HOW

MANY THERE WILL BE IN PARTY AND IF THESE ARRANGEMENTS MEET

WITH YOUR WISHES VERY SINCERELY=

PAUL CASTNER. RS ARE AVAILABLE FOR THE DELIVERY OF NOTES AND PACKAGES.

TELEGRAM SENT TO MRS. ROCKNE FROM PAUL CASTNER. Castner played for Rockne and then worked with him when Rockne did some promotional work for Studebaker. Later, Paul wrote a book about Rockne.

DETROIT BASEBALL COMPANY
DETROIT, MICHIGAN

JOHN J. McHALE
GENERAL MANAGER August 25, 1958

Mr. Cappy Gagnon
21 Bray Street
Gloucester, Mass.

Dear Mr. Gagnon:

Thank you for your ideas and comments on the
Detroit Tigers.

We assure you that we are doing everything
possible to bring Detroit a winning club.

With best wishes, I remain

Cordially yours,

John J. McHale

JJMc:as

LETTER FROM JOHN MCHALE TO THE AUTHOR. The author, as a 14 year-old, wrote a letter to John McHale. Thirteen years later the two met at a Notre Dame function.